THE BOOK OF ART

 Grolier

INCORPORATED
NEW YORK

FLEMISH AND DUTCH ART

The art of painting in Flanders was cradled in an exceptionally well-developed culture. Long before its first flowering in painting in the late 14th and 15th centuries, the creative spirit had shown itself in a richly imaginative literature. Scholars were concerned with mysticism and were progressive thinkers as well. The development of polyphonic music, both secular and religious, led to the preeminent position that Flemish composers occupied in 15th-century European music.

The 13th-century Flemish manuscript illuminators were already freeing themselves of the conventions of medievalism, and were seeking to give shape to the growing interest in nature and human concerns. They were distinguished from French and Italian miniaturists by a keen perception of the realities of everyday life, a quality that is manifest in all Flemish art.

Many of the panel pictures that were painted in the 14th century were destroyed in the religious disturbances of the 16th. One of the few that escaped destruction is Melchior Broederlam's *Presentation in the Temple and the Flight into Egypt* (p. 14), painted to adorn a carved altarpiece. It is strongly influenced by the International Gothic style that had developed in Siena and spread throughout Europe. The fragile architecture, the delicate flowers at each side of the temple, and the decorative details of costume are all derived from the Sienese. The fig-

ures, however, have a solid reality that is characteristically northern, and the faces are painted with all the expressiveness of portraiture.

There is a wealth of detail in Robert Campin's *Annunciation* (p. 13) from the Mérode Altarpiece, painted with thoroughgoing Flemish realism. The artist has not yet mastered the principles of pictorial perspective, for his converging lines do not have a common meeting point.

Jan van Eyck, c. 1385–1441

In *The Adoration of the Holy Lamb* (p. 15), painted only a few years later, Jan van Eyck has produced not only the illusion of deep space, but also a sense of changing light values. In a small reproduction it is not possible to see the minute exactitude with which Van Eyck has rendered the details of distant buildings, the trees and the flowers in the grass, the rich brocades and gold adornments of costume. There are no mystical overtones in this painting, but the presence of divinity in all things is implied in its multitudinous and exact detail.

The details of the interior that is the setting for the *Portrait of Giovanni Arnolfini and His Wife* (p. 16) are depicted with accuracy, but their value is not simply that of domestic accessories. Every object has a symbolic meaning that is relevant to the specific nature of the portrait—the portrayal of a newly married couple. Even the little dog is a traditional symbol of wifely faithfulness.

Except for the Madonna and Child, who are conventional types, the faces in *The Madonna of Canon van der Paele* (p. 17) have the character and realism of portraits. As in all Van Eyck's painting, his control of the oil medium is manifest in a gemlike brilliance and purity of color, and in the effects of three-dimensional form he achieves through light and shadow.

Other 15th-century painters

There is an appealing simplicity in the luminous *Portrait of a Lady of the Talbot Family* (p. 18) by Petrus Christus, despite its Van Eyckian precision. A contemporary fashion in feminine beauty is revealed in the high plucked forehead and eyebrows, and the three-quarter view is characteristic of 15th-century Flemish portraits.

Technically Roger van der Weyden has as great proficiency as Van Eyck, although his paintings are less explicitly detailed. There is a deeper comprehension of the spiritual world in *The Last Judgment* (p. 19) than is evident in the literal descriptiveness of *The Adoration of the Holy Lamb* (p. 15). Van der Weyden has used an abstract gold background to emphasize still further the distinction between human nature and religious experience.

The Last Supper (p. 20) of Dieric Bouts shows the influence of Roger van der Weyden, especially in the drawing of the figures. Space is clearly defined, and the converging lines of ceiling and floor reach a common meeting point above the figure of Christ. The immobility of the figures is reminiscent of that of the Arnolfinis (p. 16), but the Bouts painting lacks the vitality and sense of life that pervade the Van Eyck portrait.

In Hugo van der Goes' *Adoration of the Shepherds* (p. 21) the artist has combined Van Eyck's precision of realistic detail with the monumental composition and spiritual expressiveness of Van der Weyden's *Last Judgment*. Each of the shepherds shows a distinct emotional reaction to the event, and Mary seems to regard her Child with a tragic premonition of the future. The colors are subdued in keeping with the somber implications of the Nativity. The Portinari Altarpiece was commissioned for a church in Florence, and on its completion was sent directly to Italy. It therefore exerted no influence on painting in the Netherlands, but its effect on a whole generation of late 15th-century Italian artists was incalculable.

Hans Memling at first worked under Roger van der Weyden and later collaborated with him. Memling's work, which consists of both religious subjects and portraits, followed the style of his master. His portraits, such as the one of Martin van Nieuwenhove (p. 23), were much in demand in his native city of Bruges. Owing to a lively trade between Bruges and the Italian ports, Memling's work was known and admired in Florence, and he received many commissions from that city. The clean draftsmanship and strong, decorative color of *The Adoration of the Magi* (p. 22) are typical both of Memling and of Flemish art before it came under the influence of the Italian Renaissance.

Joos van Ghent was a Flemish painter whose early works achieved a synthesis of Van Eyck's precision of detail and Van der Weyden's characterization. In 1473 he emigrated from Flanders and established himself in Italy, where he became a court painter to the Duke of Urbino. *The Institution of the Eucharist* (p. 24) is interesting in its combination of Italian formality and Renaissance color with the rather solemn, factual qualities of Flemish painting.

At the end of the century the center of industry as well as art shifted to Antwerp. In his early years Gerard David was engaged on a number of decorative paintings for

various public buildings in Bruges, but in 1515 he too moved to Antwerp. Here the Italianate influence of the Renaissance was stronger, and is reflected in the softened outlines and gentler expression of *The Madonna of the Milk Soup* (p. 25). It is a homely scene, and in the closeup of the mother feeding soup to her Child there is little suggestion of her heavenly role.

Geertgen tot Sint Jans spent most of his short life in Haarlem, and died when only 28 years of age. His paintings are notable for innovations in the use of a single light source, and also, as in *St. John the Baptist in the Wilderness* (p. 26), for deep landscapes. The slightly awkward position of St. John, and the small animals scattered about the landscape, lend a naive and touching air to the scene.

Hieronymus Bosch, c. 1450–1516

Hieronymus Bosch is unique among painters in the Flemish tradition, not so much for the content of his pictures as for his style. The continuing spirit of the Middle Ages in northern European painting had led to an almost morbid interest in the diseased and twisted malformations of the human body caused by the accidents of nature. Bosch's creatures are born of a profoundly pessimistic view of human nature; in them we see a repulsive bestiality, the result of minds no longer in control of themselves. The faces in *The Ship of Fools* (p. 27) have the frenetic, unthinking blankness of the very drunk, drained of all humanity. Any sense of the fundamental dignity and significance of man has vanished. In many of Bosch's paintings the figures are so small that the observer is forced to stand as close to the picture as possible. His eye is led from one hideous, grotesque form to the next in an unrelieved nightmare of gloom and despair.

The end of the 15th century and the early 16th saw a steady procession of artists who journeyed from the Netherlands to Italy to study Renaissance painting. The northern European, however, was temperamentally incapable of understanding the true spirit of the Italian Renaissance, although Italian mannerisms became frequent in Flemish painting. It was not until the 17th century, in the Baroque exuberance of Rubens, that a Netherlander met the Italians on common ground.

Quentin Massys (p. 28); Jan Gossaert, called Mabuse (p. 29); Joos van Cleve (p. 30); and Jan van Scorel (p. 31) are the best of the Italianate painters. All of them were excellent craftsmen and painted portraits, larger scenes of everyday life, and religious subjects. Massys, represented here by the subtly satirical *Moneylender and His Wife* (p. 28), came closest to assimilating Italian methods of using color and composition into his own personal style.

Pieter Bruegel, c. 1525–1569

Pieter Bruegel the Elder also made the journey to Italy, but the monumental figure painting of the Renaissance held no interest for him, and he returned to Antwerp untouched by it. The mountains and scenery of Italy, however, made a deep impression on him and were influential in the development of the landscape style seen in such a work as his *Landscape with the Fall of Icarus* (p. 32).

It is Bruegel's rollicking paintings of peasant life and activities that are best known and loved. *Hunters in the Snow* (p. 33) is one of a series of pictures of the months of the year, of which only five are known. In each the everyday occupations of ordinary people appropriate to the month are depicted, but the artist's concern extends to the physical facts of climate and weather that condition their activities. Many artists have used the months of the year as a theme for paintings, but Bruegel's conception of the interaction of man upon nature, and nature upon man, is unique.

The Peasant Wedding (p. 34) is typical of the gusto with which Bruegel depicts the gay and festive mood of peasant gatherings. He often joined in these celebrations, and records them with unsparing realism, but with a sympathy that communicates his own enjoyment. There is little modeling in the figures, and it is the freedom of movement and naturalness of gesture that give the scene its animation. The flat areas of strong color contribute not a little to the vigorous design.

The Parable of the Blind Leading the Blind (p. 35) has a specific relevance to the chaos and disorder of the times. The Netherlands were under Spanish rule, the Duke of Alva was ravaging the country, and the doctrinal decrees of the Council of Trent were being enforced. As the Netherlands saw it, men blind to true spiritual values were leading their equally blind and helpless victims to a common fate.

Winter Landscape (p. 36) is typical of the winter skating scenes that were a specialty of Hendrick Avercamp. They are characterized by a subdued atmosphere, enlivened by the brilliant accents of color in the figures, and by a deep perspective, inherited from Bruegel.

Pieter Aertsen worked in both Amsterdam and Ant-

werp, primarily as a religious painter. Most of his work for churches was destroyed in the Calvinist uprisings of 1566. Like many painters of his time he was also interested in the realistic representation of Dutch life. *The Egg Dance* (p. 37) contains details of vegetables and other food, which had a special fascination for Aertsen. The extreme height of the principal figure on the left side of the painting is also characteristic, and led to the nickname "Lange Pier" (freely translated, Tall Fellow), by which he is sometimes known.

Most of Sir Anthonis Mor's portraits were of the royalty and nobility of the English and Spanish courts. He occupied the position of court painter in Brussels, when Philip II succeeded to the sovereignty of the Spanish Netherlands, and later worked in the service of the Duke of Alva. The Italianate style of his *Portrait of a Goldsmith* (p. 38) is the result of his journey to Italy, where he was much influenced by Titian, but foreign styles and methods could not completely obliterate the precise drawing and realism of his native heritage.

Peter Paul Rubens, 1577–1640

The significant difference between 16th-century northern painters, who adopted the mannerisms of Italian painting but failed to use them in a constructive way, and their 17th-century successors lies in the fact that the latter effected a synthesis of Italian Renaissance principles with Flemish traditions that resulted in a new and integrated style. In the boundless energy and vitality of Peter Paul Rubens, Renaissance Baroque found its most enthusiastic disciple.

The portrait of *The Artist and His First Wife . . . in the Honeysuckle Bower* (p. 39) is an early work, painted with the straightforward realism of the Flemish tradition.

The Adoration of the Magi (p. 40) is one of Rubens' huge canvases that were in great demand as an expression of the religious sentiment created by the Counter-Reformation in the early years of the 17th century. The light and colors, the complex arrangement of the mass of figures, their carefully worked out expressions and gestures, all are developments of his Italian studies, interpreted with the clarity and forcefulness of his own style.

Portraiture was not a type of painting that appealed to Rubens, and he regarded his portraits more as curiosities than as serious works. *The Straw Hat* (p. 41) is painted with the highly decorative kind of realism that is the basis of both English and American 18th-century portraiture.

In 1630, four years after the death of his first wife, Rubens married Helena Fourment, then a girl of 16, and several years later he retired to the relative privacy of the country outside of Antwerp. The happiness of his personal life in the years before his death in 1640 is reflected in all the paintings of this period. He used Helena Fourment as a model in several formal paintings and made a number of informal studies such as *Helena Fourment and her Children* (p. 43).

In his earlier years landscape had had as little appeal for Rubens as portraiture, but in this last decade of his life he revealed a strong and sensitive feeling for the countryside where he lived. His landscape paintings, such as *Landscape with Rainbow* (p. 42), are filled with the vitality and boundless enjoyment of the living world that are typical of the man and all of his work.

Jacob Jordaens was not concerned with the formal organization of his picture *The King Drinks* (p. 44), but his eye for detail and feeling for the lusty conviviality of the merrymakers recalls Bruegel's paintings of similar scenes. The occasion is the Twelfth Night festival, marking the end of the Christmas season, a tradition in Flemish families. The person whose piece of cake contained a token was called the King—or Queen—and wore a golden paper crown.

Anthony van Dyck's *Portrait of the Painter Cornelius de Wael* (p. 45) was painted in the year of his return to Antwerp after a prolonged stay in Italy. His study of Titian is evident in his easy brushwork and in his color, which is rich and vibrant despite its almost somber restraint. After Van Dyck became court painter to Charles I of England, his popularity forced him into an assembly-line technique in which he worked from a quick sketch of the sitter and used professional models to finish up. His English patrons wanted flattery, not characterization, and many of Van Dyck's later portraits are little more than superficial likenesses.

Franz Hals, c. 1585–1666

The 17th-century Dutch portrait painter Franz Hals developed a painting technique that resulted in an almost photographic likeness of his subject. He painted directly from his model, in oils, without preliminary sketches. Shadows and modeling were created by tonal values of color—that is, by the varying amounts of black added to a given color. *The Merry Drinker* (p. 46) is painted with typical Hals bravura, and the streaks and blobs of color that, on close inspection, appear to be ap-

plied at random, from a slight distance create an impression of precise and carefully executed detail.

In the 17th century the increasing prosperity of the mercantile north produced a large, well-educated middle class, and a new type of portraiture. Citizens who formed social and civic organizations, local committees, and boards of directors had their portraits painted as a group, each member usually paying for himself. *The Lady Governors of the Old Men's Home at Haarlem* (p. 47) is one of many such group portraits that Hals was called upon to paint. It was done two years before his death and is quite different in both technique and atmosphere from his early work. It is painted with straightforward simplicity in somber colors and very thin paint. More individuality and character are revealed in the faces of these rather formidable ladies than in all the sprightly portraits of earlier years.

A taste for still-life paintings was another characteristic of the Dutch middle class. *Flowers and Fruit* (p. 48), the work of Balthasar van der Ast, is a rather elaborate composition combining fruit, flowers, insects, and shells, all depicted in minute and precise detail, and with a smooth, fine texture.

Hendrick Terbrugghen spent a considerable time in Italy and was the first to introduce Caravaggio's concepts of light and shadow in Utrecht. The strong light that falls on the table and illuminates the two figures on the right in *Jacob Reproaching Laban* (p. 49), leaving the faces of the other two figures in shadow, derives directly from Caravaggio's style.

Hercules Seghers' *Landscape* (p. 50) distinguishes him from the innumerable painters of the flat, unspectacular Dutch countryside. His interest in mountains and rock formations apparently stemmed from an acquaintance with the Swiss Alps.

Rembrandt van Ryn, 1606–1669

The outstanding figure of all Dutch art is Rembrandt van Ryn, whose name belongs with the few very great masters of European painting. Unlike his contemporaries, Rembrandt was no specialist. In over 700 paintings are found single and group portraits, mythological and religious themes, genre scenes and landscapes. Besides his paintings, some of his most notable work was in the medium of etching.

Rembrandt's style was shaped by an early exposure to Italianate influences that stimulated his study of the structural and expressive potentials of light. The romantic *Landscape with a Stone Bridge* (p. 51) is a study in the luminous quality of light and color and their power to create a sense of movement and rhythm.

The Anatomy Lesson (p. 52) is a somewhat earlier painting, one of his first important commissions in Amsterdam. The dramatic contrast of strong light and deep shadow is a reflection of the manner of Caravaggio without the Italian painter's color. Rembrandt's problem in this picture was to render each portrait with equal accuracy and definition. As a result the group lacks organization, for some of the listeners are intent on the cadaver that is the focal point of the painting, while others appear uninterested. The picture, however, was enthusiastically received and much admired for the accuracy of the portraits and the realistic rendering of details.

In the picture of his son, *Portrait of Titus* (p. 53), light has lost the dramatic harshness of *The Anatomy Lesson* and became a complex and mysterious interplay that reveals the contours and features of the face. The illusion of the warmth and resilience of youth is achieved by the light that brings out the subtle coloring.

The Flagellation (p. 54) is a work of Rembrandt's mature period, when many of his paintings portrayed moments of heavy melancholy and tragedy. The sharp spotlight effect of *The Anatomy Lesson* has been transformed into a rich harmony of transparent tones. The light comes from an undefined source, as if generated by the bound figure, and creates an atmosphere that awakens our most profound emotions.

As a young man Rembrandt started painting a series of self-portraits that continued throughout his life. He scrutinized his own face, seeking in its well-known form the complex secrets of the human spirit. From the proud self-assurance of his youth to the relaxed sober awareness of his fifties (p. 55) these portraits are an extraordinary record of a man's contemplation of his own inner self.

The entire list of existing works of Carel Fabritius numbers only ten, many of his pictures having been reportedly destroyed in an explosion in which he lost his life. He is known to have studied painting in the studio of Rembrandt, whose influence is evident in Fabritius' *Self-Portrait* (p. 56).

Genre painting

Nicolas Maes was another of Rembrandt's pupils and painted genre pictures in the style of his master. *Woman Spinning* (p. 57) is reminiscent of some of Rembrandt's early work that was influenced by Caravaggio.

Gerard Terborch was both a portrait and a genre painter. However, he was not attracted by the scenes of merriment that delighted many artists of his time, but was more concerned with the activities and elegant surroundings of the wealthy. He excelled in depicting satin and other rich fabrics, which he painted with such brilliance, as in *Paternal Advice* (p. 58), that the balance of the picture is destroyed.

Jan Steen (p. 59), Adriaen Brouwer (p. 60), and Adriaen van Ostade (p. 61) were alike in finding the habits and pastimes of peasants more interesting than those of the rich and respectable. All three were skillful craftsmen and painted a variety of subjects, but it was in their boisterous, often gross, tavern scenes that they were most successful. The sureness of their draftsmanship and pictorial organization, and their often brilliant use of color, make up to some extent for the sordidness of their subject matter.

Pieter de Hooch's tavern (p. 62) is far more restrained and altogether more elegant than those of Steen, Brouwer, and Van Ostade. It was a meeting place for the well-to-do Dutch bourgeoisie, who came for conversation or a quiet game of cards. De Hooch is most familiar as a painter of domestic scenes set in a typical Dutch courtyard or inside the house. As in the *Interior of a Tavern*, he faithfully recorded the details of interior decoration and, in his outdoor scenes he followed the design of Dutch domestic architecture.

Jan Vermeer, 1632–1675

The majority of Jan Vermeer's paintings are indoor scenes with a figure engaged in some household activity, such as *Maid Pouring Milk* (p. 63). Usually there is a window to the left, sometimes not visible, that provides illumination for the scene, as in *The Artist's Studio* (p. 65). These paintings have the quality of still-life arrangements. Every object, including the figures, is placed to create the utmost illusion of space, its shape and color carefully calculated in relation to the other elements in the formal design. Each object is studied with great care, and its physical characteristics are described through light, line, and color with equal precision. The textures of the fabrics in the maid's dress and on the table, the differences between glazed and unglazed pottery, the visual appearances of wood, plaster, metal, and flesh are so clearly and completely defined that there seems no way they could be made more convincing.

The View of Delft (p. 64) is composed with the same precision of design and color as the interiors. No atmosphere interferes with the perfect definition of every tower and spire, and even the figures in the foreground seem to exist in a state of suspended animation.

Since neither Church nor government was a source of patronage, Dutch painters in the latter half of the 17th, the 18th, and most of the 19th centuries continued to produce small paintings that could suitably be hung in private houses. There were no outstanding figures of the stature of Rubens, Rembrandt, and Vermeer, but there were a great many painters who approached their work with devotion and affection and executed it with skill and competence. There was a tendency to specialize, and a painter, having chosen his particular specialty, kept fairly strictly to it.

Pieter Saenredam (p. 66) was known for his interiors of churches. Pieter Claesz (p. 67) and Abraham Hendrickz van Beyeren (p. 69) were still-life painters of fruit, fish, and bread with various items of tableware. Jan Fyt (p. 68) specialized in hunting dogs and other animals and sporting still-lifes with game.

Even landscape painters became specialists. Jan van Goyen's best-known works are river scenes (p. 70), often under cloudy skies. Aert van der Neer (p. 71) painted poetic landscapes in moonlight, and Philips de Koninck (p. 72) delighted in dark, heavy clouds that caused patterns of sunlight and shadow in his sweeping views of the flat Dutch countryside.

Jakob van Ruisdael (p. 73) is noted for his rendering of the trees and waterfalls that frequently appear in his pictures. Van Ruisdael's landscapes are expressions of specific moods of nature that have no relation to man, a concept that is almost the opposite of Bruegel's view of the interactions of man and nature. For this reason Van Ruisdael had considerable influence on the Romantic school of landscape painting in the late 18th century.

Meindert Hobbema was a pupil of Van Ruisdael's, and they sometimes painted the same subject. Hobbema's interest in painting appears to have been short-lived, and his rather dry, factual style, seen in *The Avenue at Middelharnis* (p. 74), does not approach the lyrical expressiveness of his teacher.

Jan Josef Horemans painted scenes of aristocratic life in Antwerp (p. 75) in dark tonalities, and Cornelis Troost (p. 76) recorded similar occasions in the life of the bourgeoisie. Wouter Johannes van Troostwijk (p. 77) produced landscapes and views of towns in a style reminiscent of Jakob van Ruisdael.

Painting in the 19th century

François Joseph Navez (p. 78) was a Classicist whose portraits have a satiny texture very similar to the painting of the Frenchman Jacques Louis David, with whom he studied.

Hendrik Leys' *The Bird Catcher* (p. 79) is typical of a number of his pictures of scenes portraying social life in the 16th century, which had considerable influence on decorators in Antwerp. They are not genuine attempts to revive 16th-century styles, but a rather naive appropriation of their decorative qualities.

Alfred Stevens painted Parisian society in elegant dress and surroundings. *The Desperate Woman* (p. 80) is an example of exemplary technique and total lack of content.

Henri de Braekeleer's paintings (p. 81) were unpretentious and executed with great attention to detail. His colors were a little muddy and restricted to siennas, browns, ochers, and black, but his perception of light was subtle and he used it effectively.

The Maris brothers, Jakob (p. 82) and Matthijs (p. 83) painted scenes of Holland and Paris, Jakob with an impressionistic technique, and Matthijs in delicate linear patterns that fade into a diffused light.

Dutch painters of the late 19th century tend to be overlooked because of the enormous impact of the French Impressionists, but a number of them were active in the Impressionist movement and developed their own personal interpretations of it.

Johan Barthold Jongkind (p. 84) was an important figure in the development of Impressionism, particularly through his influence on the early work of the French painter Claude Monet.

Isaac Israels (p. 85) is often compared with French painters of his day because his subjects were drawn from the same worlds of the cabaret, the boulevard, the circus, and the café. His style, however, is personal and essentially different from that of any of his French contemporaries.

Félicien Rops was a graphic artist and book illustrator as well as a painter. A number of his paintings are similar in theme to *Death at the Ball* (p. 86), erotic and macabre mixtures of sexuality and death.

People in Masks Fighting over a Hanged Man (p. 87) is one of a series of pictures using masks that James Ensor painted over a period of years. In them he joins with Hogarth and Goya and, in his own Flemish tradition, with Bosch and Bruegel in their bitter indictments of contemporary social conditions.

The use of masks stemmed from Ensor's childhood in his parents' souvenir shop at Ostend, where toys and carnival masks were a stock in trade. His hideous masks provided the symbols through which Ensor expressed his angry criticism of contemporary art and society. They also left him free to distort his figures by deliberately awkward drawing, turning them into puppet-like caricatures. Ensor's mask motif with its emotional overtones was adopted by a number of 20th-century artists of the German Expressionist movement.

Vincent van Gogh, 1853–1890

In Vincent van Gogh, the Netherlands produced a painter who created an idiom so personal that it has never been imitated, and so expressive that it has never been equaled.

Van Gogh's short life was fraught with disappointments and periods of complete destitution and despair. In his early adult years he attempted to earn his living in several different fields and failed in each. It was not until the summer of 1880, when he was 27, in some of the darkest months of his life, that he decided on an artistic career. From that time until his suicide 10 years later, he devoted himself to painting with a passionate intensity that resulted in almost 600 paintings and over 800 known drawings and watercolors.

As the son of a Protestant minister—and also because, for several years, he had thought that he had a religious calling—Van Gogh was deeply concerned with the social problems existing in the Low Countries. For the first six years of his artistic life he chose to portray the squalid, poverty-stricken lives of the Dutch miners and weavers. In these paintings, as in all his work, he was less concerned with physical appearances—that is, realism—than with the essential character—that is, reality—of the lives of these workers. The reality he expressed was the misery of human existence, painted in dark, brooding blacks and browns with the bold, angular drawing and thickly applied paint that very early in his career became characteristic of his style.

On a visit to his brother Theo, an art dealer in Paris, Van Gogh saw for the first time the full range of Impressionist painting and discovered the expressive power of color. He extended his stay in Paris and gradually, under the Impressionist influence and his discovery of and enthusiasm for Japanese prints, his colors became brighter.

The last two years of Van Gogh's life were spent in the south of France, beset by hallucinations and periods of complete mental breakdown, yet this was the most fruitful and important period of his artistic life. His landscapes became highly symbolic as he strove to communicate his sense of the meaning of life as it is revealed in nature. He was obsessed by the sun, and its presence, if not visible, is always implied; by the stars at night, symbols of hope; or by lamplight, a symbol of calm and security. The twisted forms of the trees in *The Olive Grove* (p. 88) as they reach toward the restless sky may be interpreted as symbols of human aspiration, and the rich greens and blues as symbolic of the intensity of the search.

The silvery, gray-green of olive trees in a dusty countryside has been transformed in *The Olive Grove* into a world of living, moving color that has no connection with realism. Van Gogh described himself as an "arbitrary colorist." Believing that colors were expressive in themselves, he chose colors for their intrinsic power to communicate emotion, not for their ability to produce a realistic likeness.

The *Self-Portrait* (p. 89), painted in the year of his death, is as intense a search for self as any of Rembrandt's self-portraits. It is this passionate desire to penetrate surface appearances to the true reality that lies beneath that brings Van Gogh closer to Rembrandt than to any of the French painters with whom he is so often identified.

Floris Verster and George Hendrik Breitner arrived at different interpretations of Impressionism, Verster in the vivid colors of his *Still-Life with Bottles* (p. 90) and Breitner in the dark yet luminous colors of *The Dam at Night* (p. 91). Dutch realism is still evident under the free Impressionist brushwork and color.

Jacob Smits was of the Impressionist generation, but although widely traveled, he apparently never went to Paris and was not in close touch with French painting. *Evening Landscape* (p. 92) is a simple, strong, and firmly composed picture, painted with thick, granular pigment, and a good sense of light and atmosphere.

No other national school has produced so homogeneous an art as the Netherlands. Dutch artists painted their country, their possessions, and their people with an affectionate realism largely untouched by other European trends. The three outstanding geniuses, Rubens, Rembrandt, and Van Gogh, assimilated foreign influences so completely that they are more often identified with international styles than with the purely Dutch tradition.

Dutch engravers have long been noted for their expertise, and this medium was used not only for original works, but also to reproduce paintings. Through the far-flung commercial enterprises of Dutch merchants, and through the rather extensive travel of Dutch artists to other countries, their work became known throughout Europe. It was influential in promoting realistic painting in general, and in developing a taste for genre.

List of Color Plates

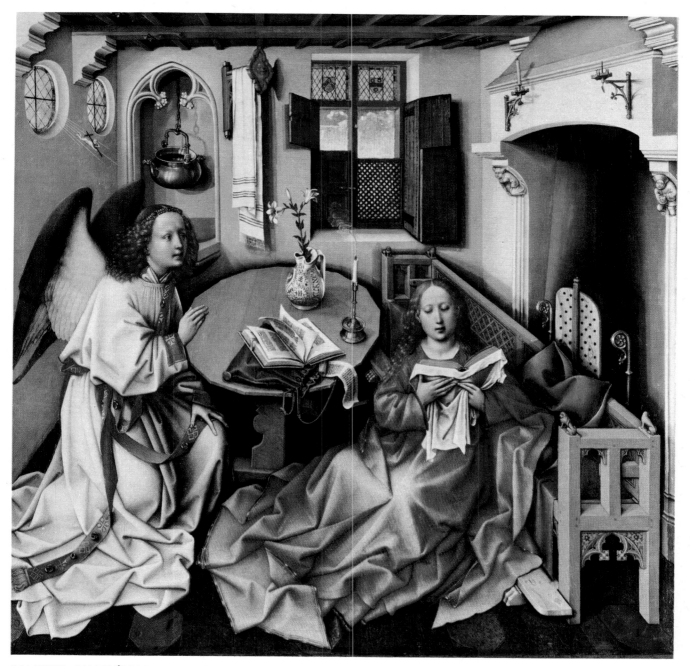

MASTER OF FLÉMALLE sometimes identified with ROBERT CAMPIN The Annunciation: central panel from the
Mérode Altarpiece, 1425-28 *oil on panel 25¼ × 24⅞ in.*
New York, Metropolitan Museum of Art, Cloisters Collection

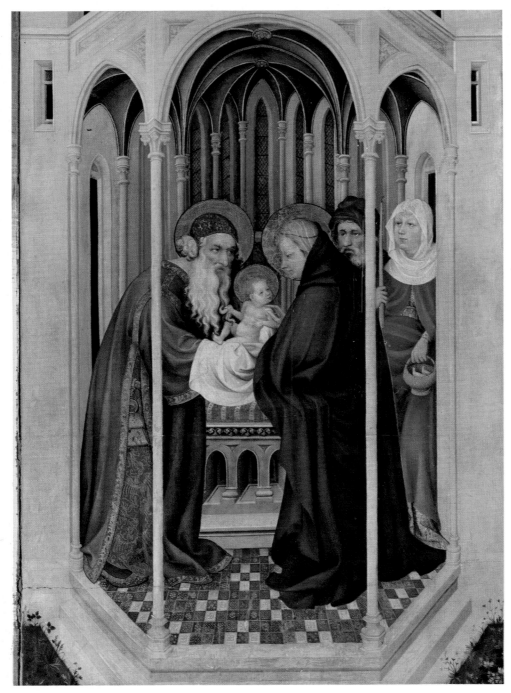

MELCHIOR BROEDERLAM The Presentation in the Temple and the Flight into Egypt
(detail) 1394-99 *oil on panel* $65\frac{3}{4} \times 49\frac{1}{4}$ *in.*
Dijon, Musée des Beaux-Arts

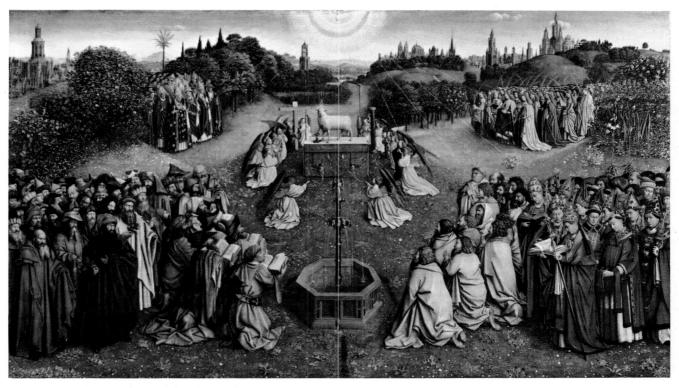

JAN VAN EYCK The Adoration of the Holy Lamb: center panel from the Ghent Altarpiece, 1432 *oil on panel* *53×93 in.*
Ghent, Cathedral of St. Bavon

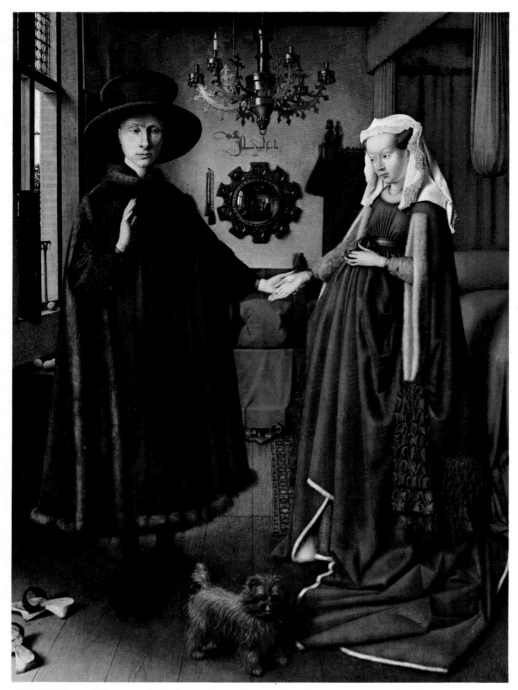

JAN VAN EYCK Portrait of Giovanni Arnolfini and his Wife, 1434 *oil on panel $32\frac{1}{4} \times 23\frac{1}{2}$ in.*
London, National Gallery

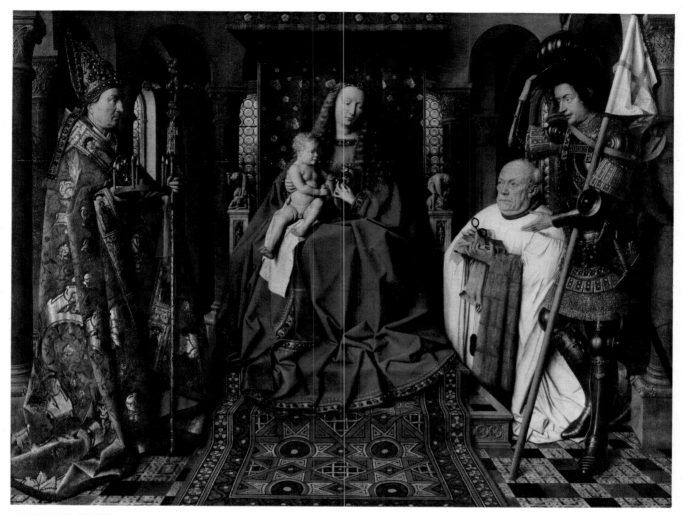

JAN VAN EYCK The Madonna of Canon van der Paele, 1436 *oil on panel* *48 × 62 in.*
Bruges, Musée Communal

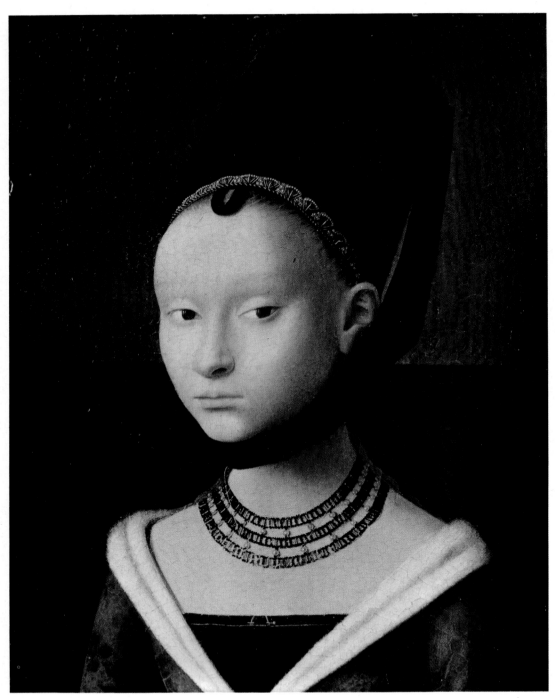

PETRUS CHRISTUS Portrait of a Lady of the Talbot Family, about 1446 *oil on panel* *11 × 8¼ in.*
West Berlin, Staatliche Museen

18

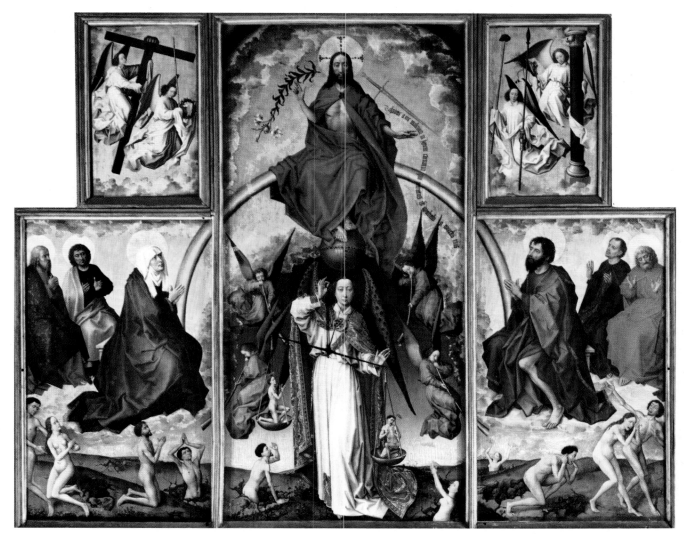

ROGER VAN DER WEYDEN The Last Judgment (center panels) about 1450 *tempera* *86 × 214½ in.*
Beaune, l'Hôtel-Dieu

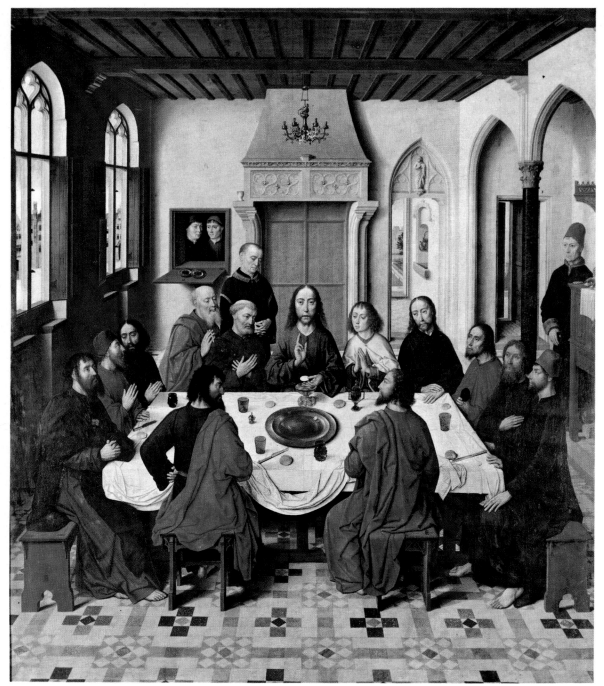

DIERIC BOUTS The Last Supper, about 1467 *oil on panel 114 × 71 in.*
Louvain, Belgium, St. Pierre

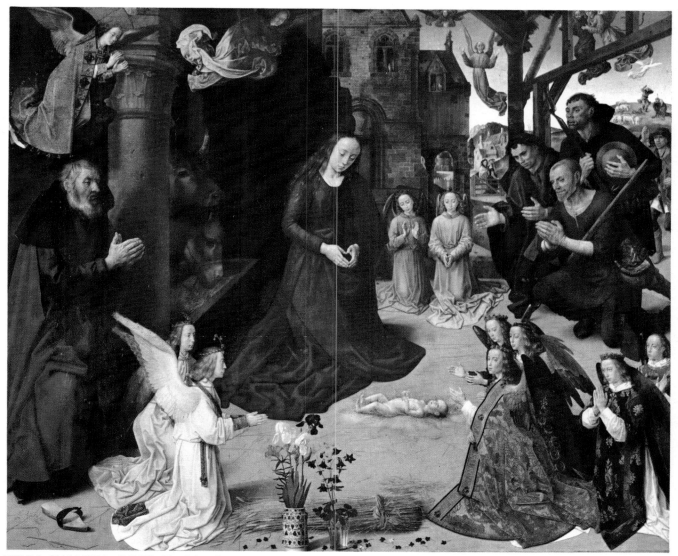

HUGO VAN DER GOES The Adoration of the Shepherds: central panel from the Portinari Altarpiece, about 1476
oil on panel 99⅜ × 119⅝ in.
Florence, Uffizi

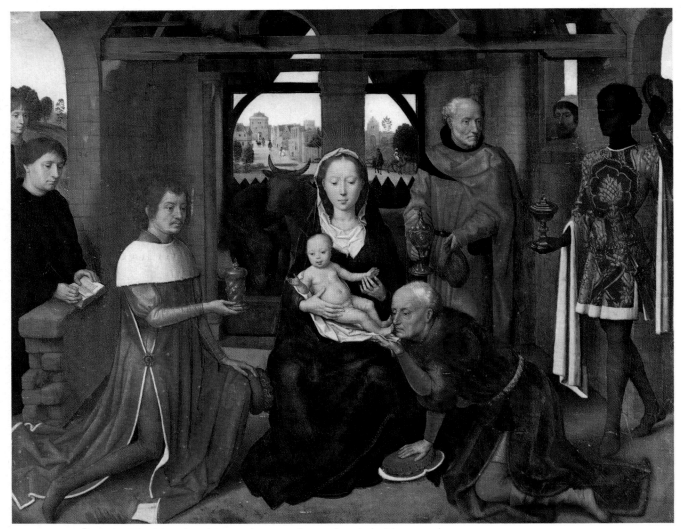

HANS MEMLING The Adoration of the Magi, 1479 *oil on panel* $18\frac{7}{8} \times 22\frac{1}{4}$ *in.*
Bruges, Hospital of St. John

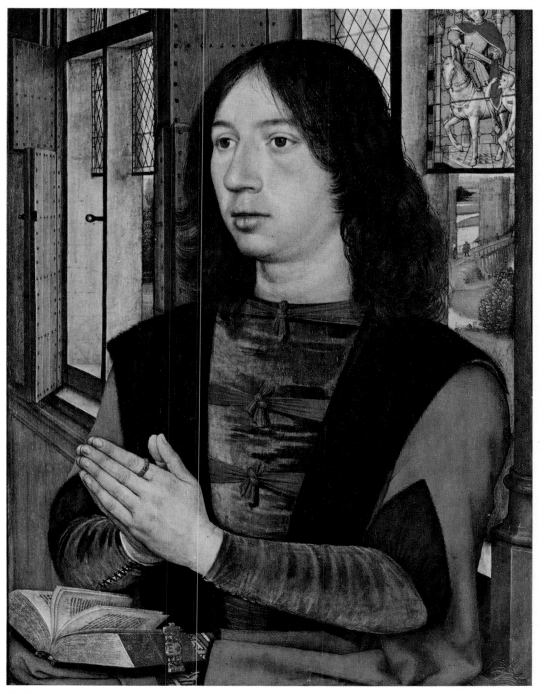

HANS MEMLING Portrait of Martin van Nieuwenhove, 1487 *oil on panel $17\frac{3}{8} \times 13$ in.*
Bruges, Hospital of St. John

JOOS VAN GHENT The Institution of the Eucharist, about 1474 *oil on panel 113 × 122⅞ in.*
Urbino, Italy, Ducal Palace, Gallery of the Marches

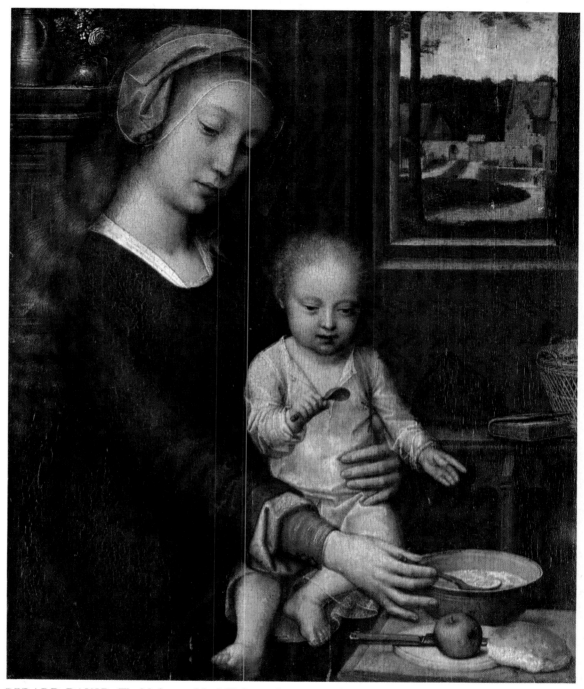

GERARD DAVID The Madonna of the Milk Soup, about 1520 *oil on panel* *14 × 11¼ in.*
Brussels, Musées Royaux des Beaux-Arts

25

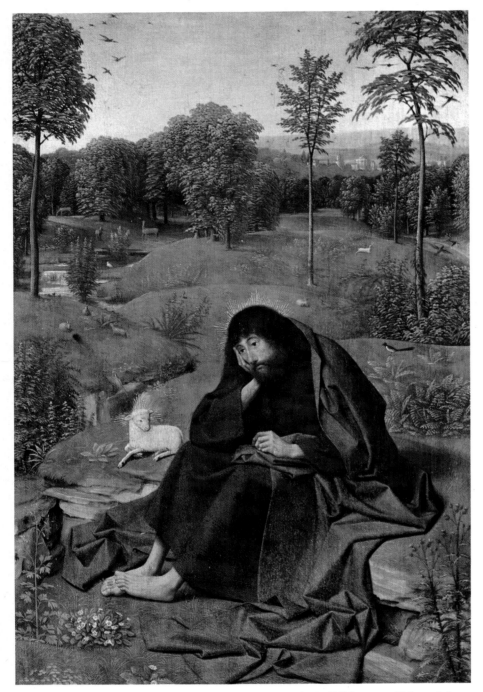

GEERTGEN TOT SINT JANS St. John the Baptist in the Wilderness, middle period
oil on panel $16\frac{1}{4} \times 11$ in.
West Berlin, Staatliche Museen

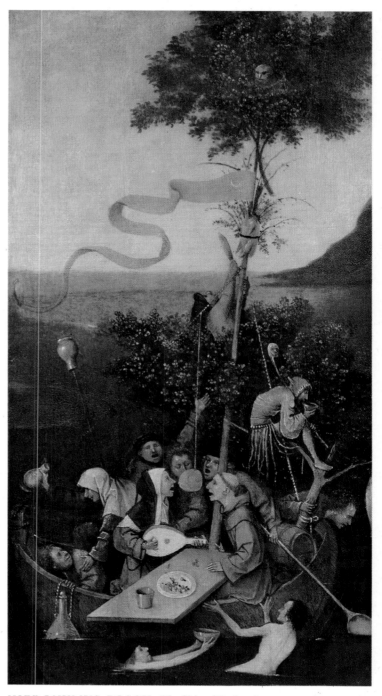

HIERONYMUS BOSCH The Ship of Fools, after 1500
oil on panel 22 × 12 in.
Paris, Louvre

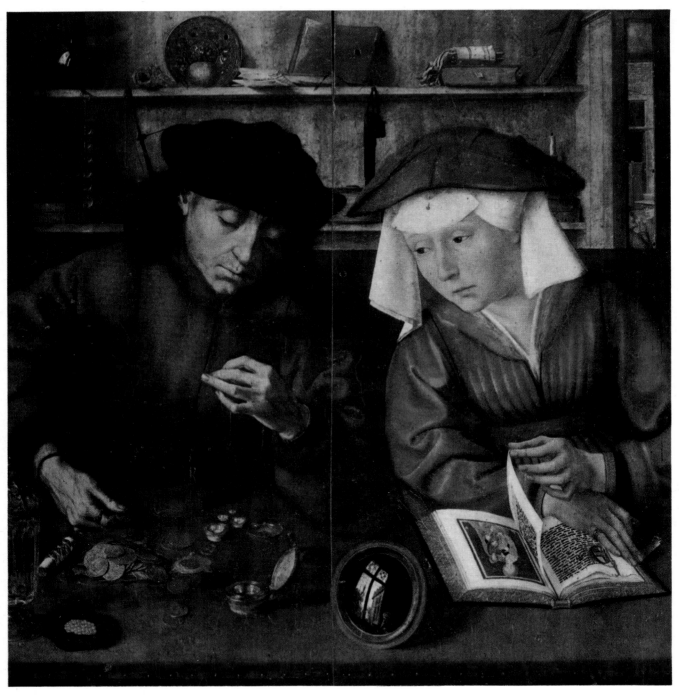

QUENTIN MASSYS The Moneylender and his Wife, 1514 *oil on panel 28 × 27 in.*
Paris, Louvre

JAN GOSSAERT called MABUSE Portrait of Baudouin of Burgundy *oil on panel* *21¼ × 15⅜ in.*
West Berlin, Staatliche Museen

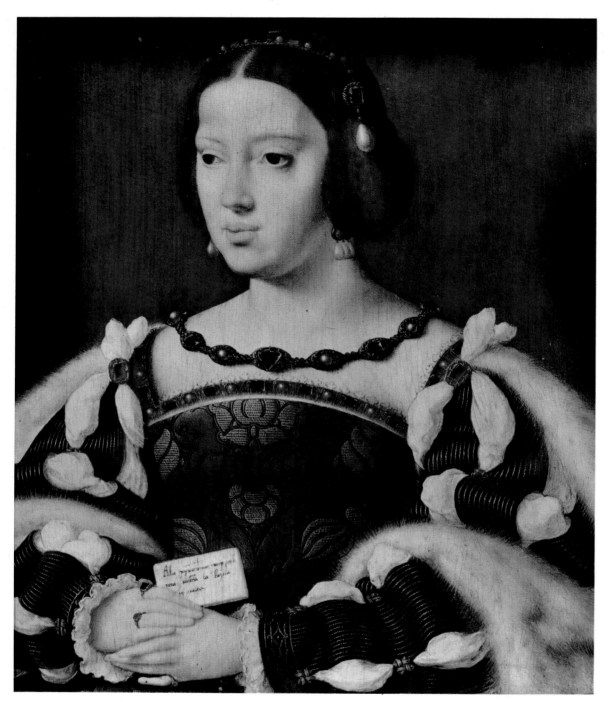

JOOS VAN CLEVE Portrait of Eleanora of Hapsburg, about 1530 *oil on panel* *14 × 11½ in.*
Vienna, Kunsthistorisches Museum

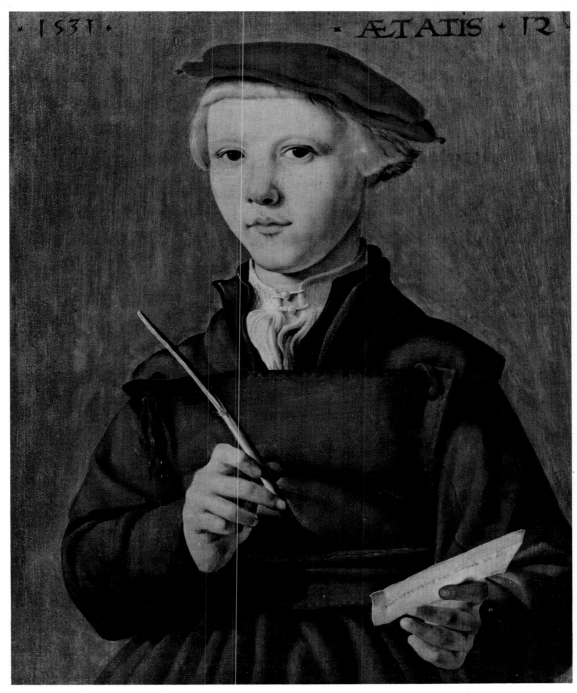

JAN VAN SCOREL Portrait of a Young Scholar, 1531 *oil on panel 14 × 14 in.*
Rotterdam, Museum Boymans-van Beuningen

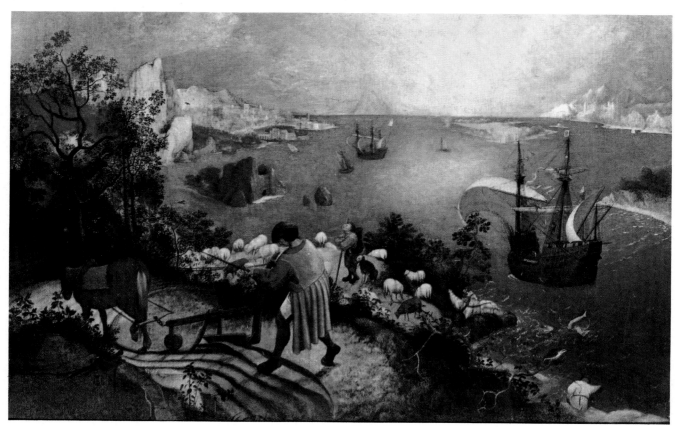

PIETER BRUEGEL the ELDER Landscape with the Fall of Icarus, about 1563 *oil on panel* *29 × 44⅛ in.*
Brussels, Musées Royaux des Beaux-Arts

32

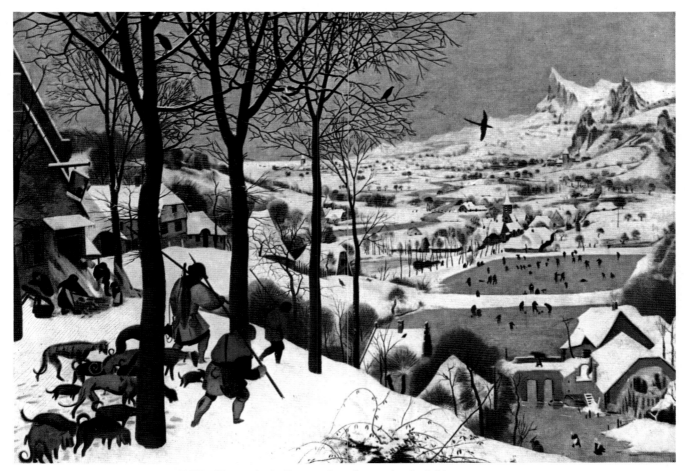

PIETER BRUEGEL the ELDER Hunters in the Snow, 1565 *oil on panel 46 × 63¾ in.*
Vienna, Kunsthistorisches Museum

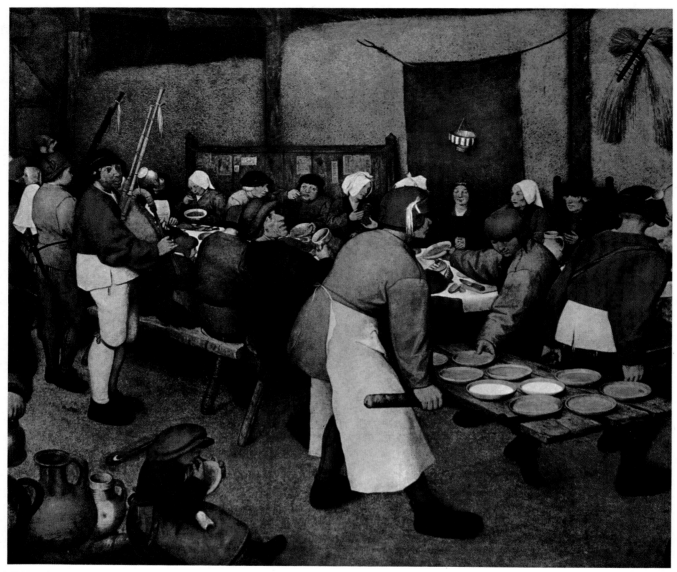

PIETER BRUEGEL the ELDER The Peasant Wedding (detail) about 1568 *oil on panel 44¾×64¼ in.*
Vienna, Kunsthistorisches Museum

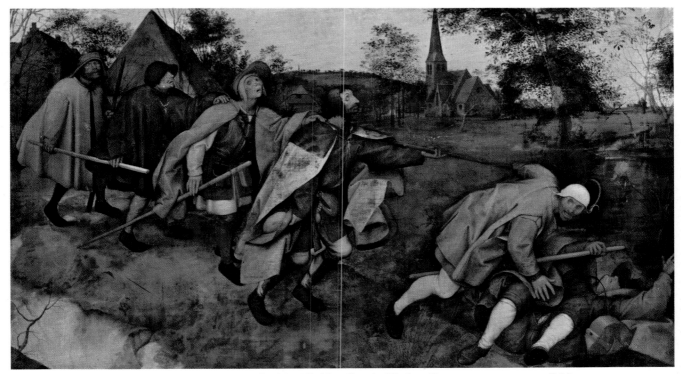

PIETER BRUEGEL the ELDER The Parable of the Blind Leading the Blind, 1568 *tempera on canvas* *34 × 60¼ in.*
Naples, Galleria Nazionale

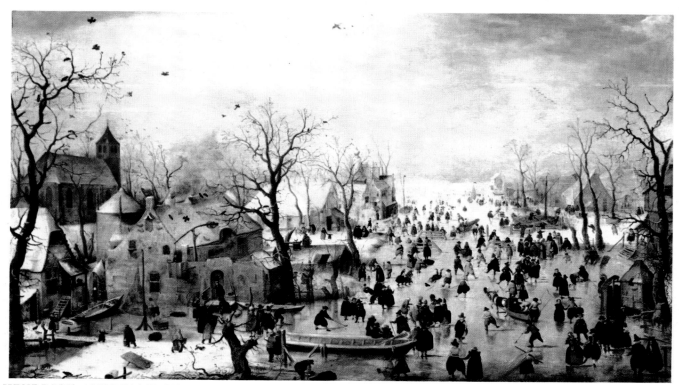

HENDRICK AVERCAMP Winter Landscape *oil on panel 30½ × 52 in.*
Amsterdam, Rijksmuseum

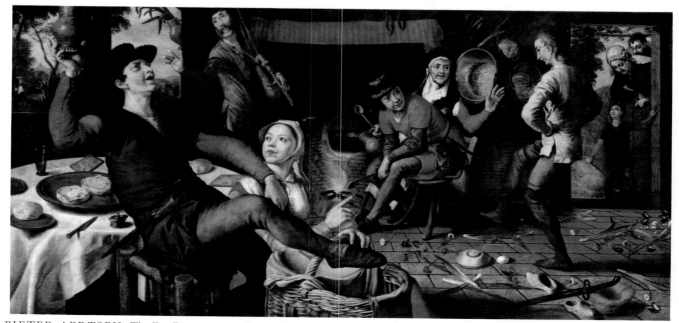

PIETER AERTSEN The Egg Dance, 1557 *oil on panel 33 × 50 in.*
Amsterdam, Rijksmuseum

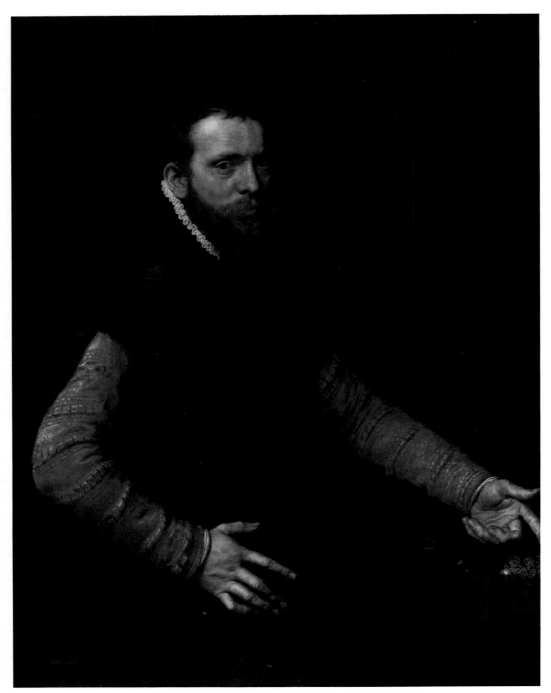

SIR ANTHONIS MOR Portrait of a Goldsmith, 1564 *oil on panel* $46\frac{1}{2} \times 33\frac{3}{8}$ *in.*
The Hague, Mauritshuis

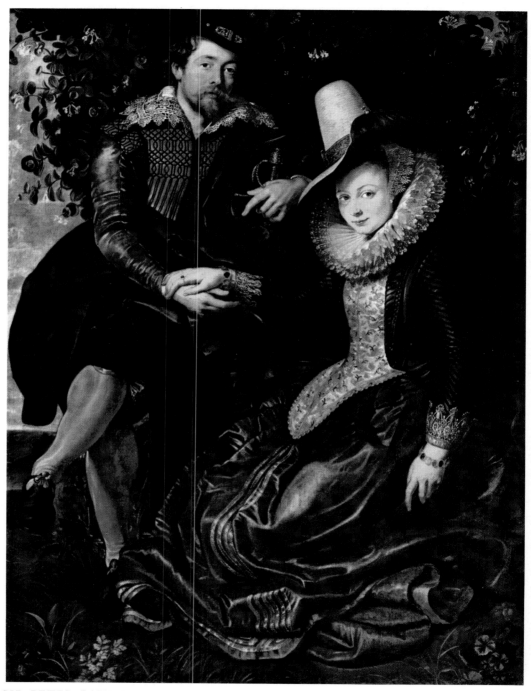

SIR PETER PAUL RUBENS The Artist and his First Wife, Isabella Brandt, in the Honeysuckle
Bower, 1609 *oil on canvas 70 × 53 in.*
Munich, Alte Pinakothek

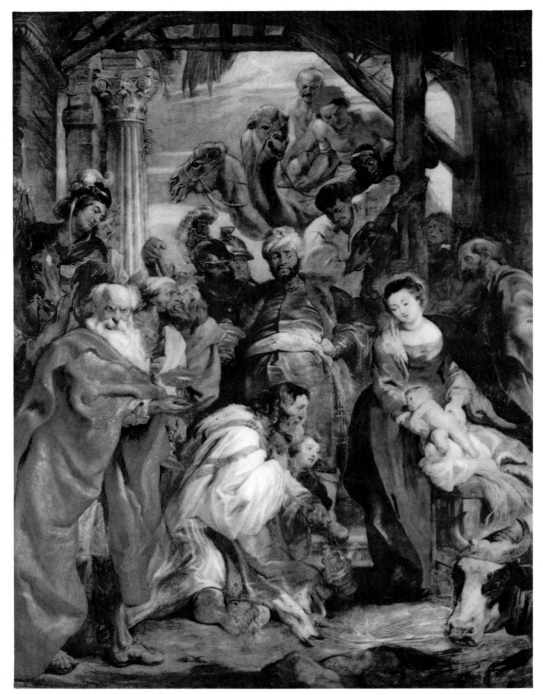

SIR PETER PAUL RUBENS The Adoration of the Magi, 1624 *oil on canvas* *176×72½ in.*
Antwerp, Musée Royal des Beaux-Arts

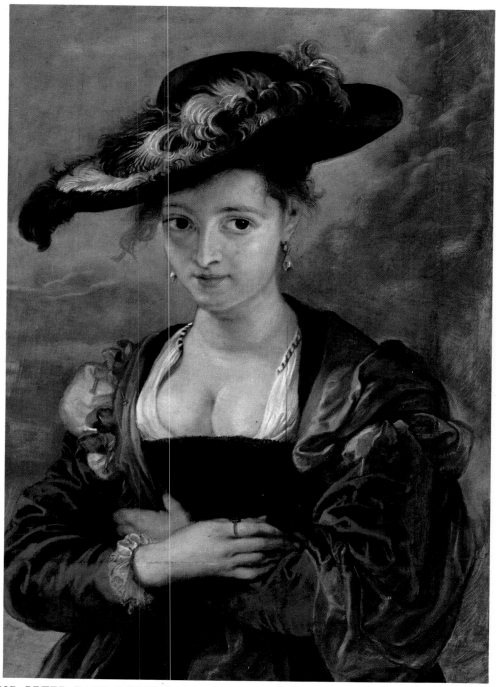

SIR PETER PAUL RUBENS The Straw Hat, about 1626 *oil on canvas 31 × 21½ in.*
London, National Gallery

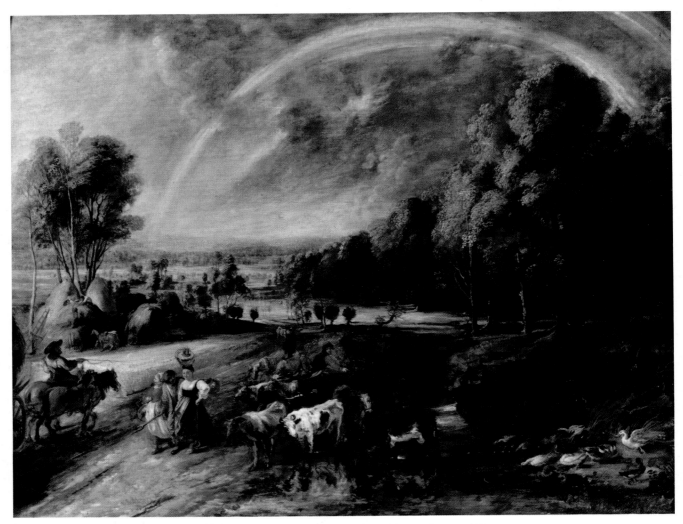

SIR PETER PAUL RUBENS Landscape with Rainbow, about 1640 *oil on panel* $37 \times 48\frac{3}{8}$ *in.*
Munich, Alte Pinakothek

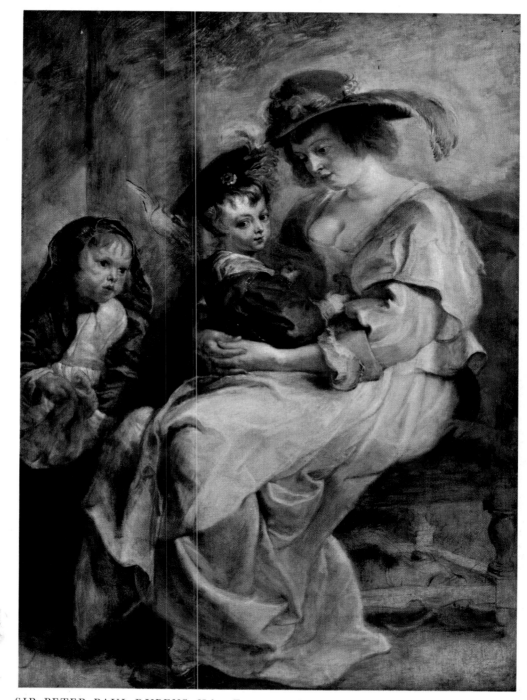

SIR PETER PAUL RUBENS Helena Fourment and her Children, about 1635
oil on canvas 44½ × 72½ in.
Paris, Louvre

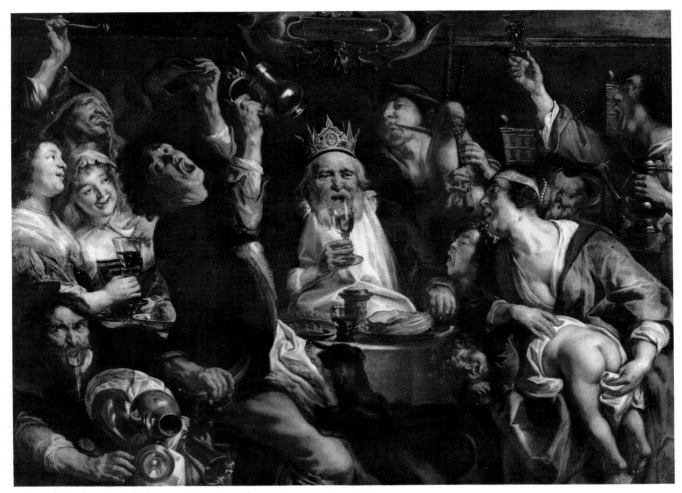

JACOB JORDAENS The King Drinks, 1638 *oil on canvas* $61\frac{3}{8} \times 82\frac{5}{8}$ *in.*
Brussels, Musées Royaux des Beaux-Arts

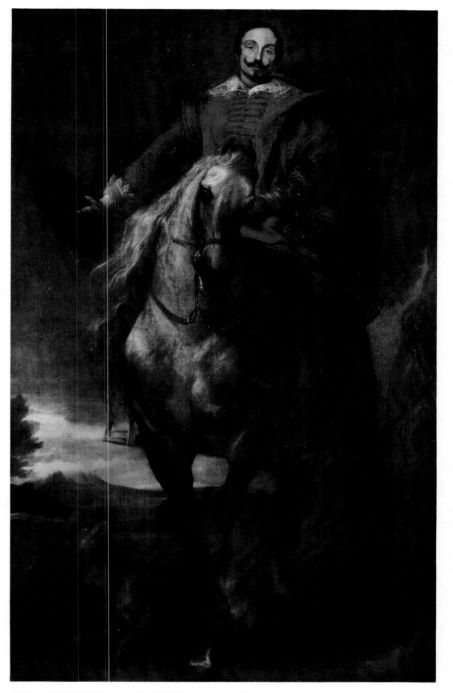

SIR ANTHONY VAN DYCK Portrait of the Painter Cornelis de Wael, about 1627
oil on canvas $103\frac{1}{2} \times 64\frac{5}{8}$ in.
Antwerp, Musée Royal des Beaux-Arts

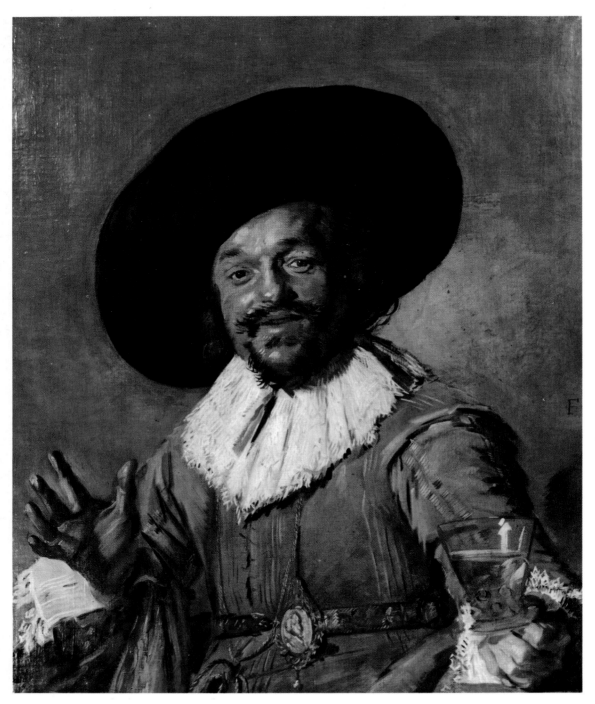

FRANS HALS The Merry Drinker, 1627 *oil on canvas 32 × 26 in.*
Amsterdam, Rijksmuseum

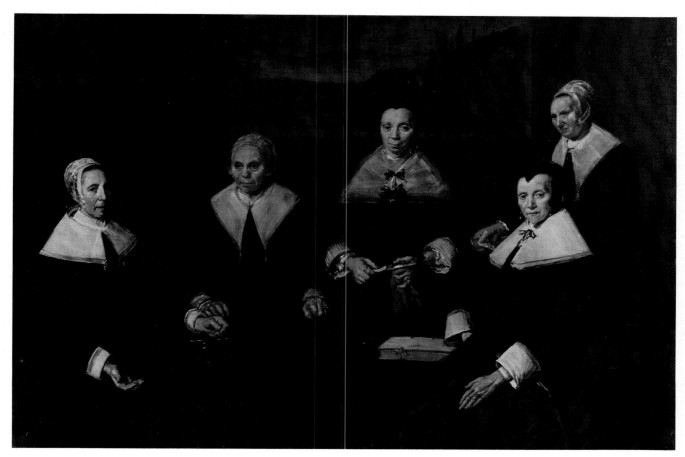

FRANS HALS The Lady Governors of the Old Men's Home at Haarlem, 1664 *oil on canvas 66⅞ × 98 in.*
Haarlem, Frans Hals Museum

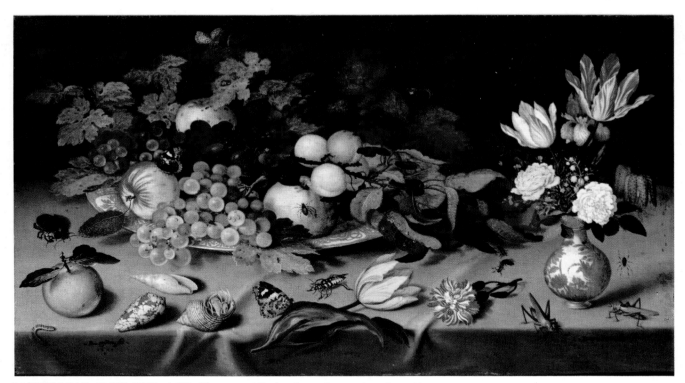

BALTHASAR VAN DER AST Flowers and Fruit, 1620 *oil on panel* $19\frac{1}{4} \times 27\frac{5}{8}$ *in.*
Amsterdam, Rijksmuseum

HENDRICK TERBRUGGHEN Jacob Reproaching Laban, 1627 *oil on canvas* $38\frac{1}{2} \times 45$ *in.*
London, National Gallery

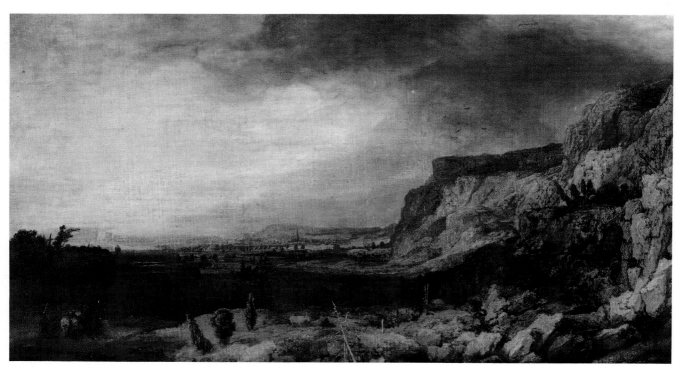

HERCULES SEGHERS Landscape *oil on canvas* $21\frac{3}{8} \times 39\frac{3}{8}$ *in.*
Florence, Uffizi

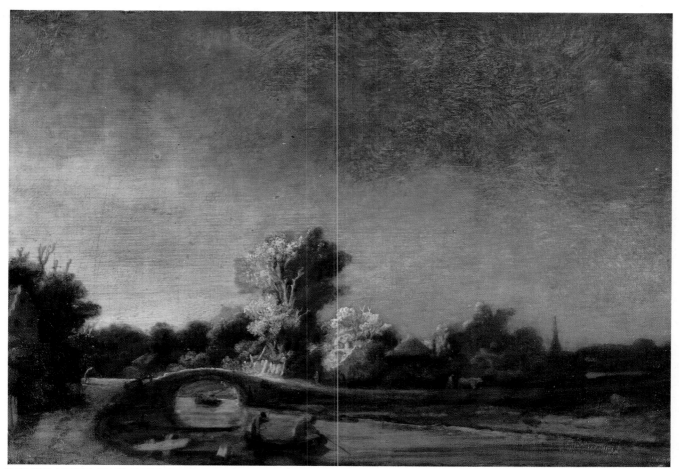

REMBRANDT VAN RYN Landscape with a Stone Bridge, about 1638 *oil on panel* $11\frac{1}{4} \times 17\frac{1}{4}$ *in.*
Amsterdam, Rijksmuseum

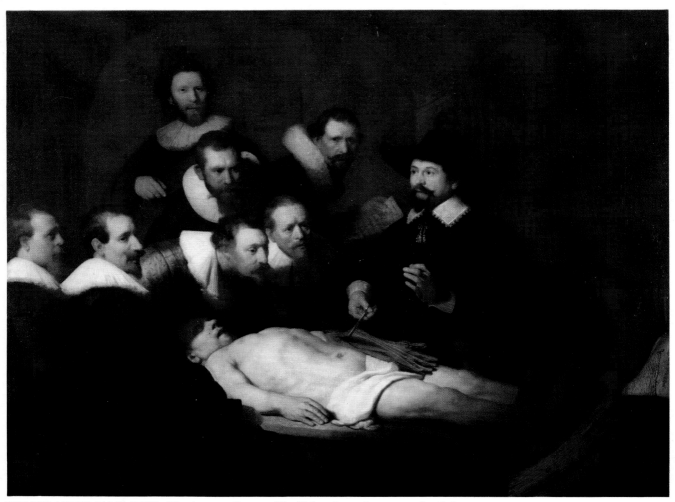

REMBRANDT VAN RYN The Anatomy Lesson of Dr. Tulp, 1632 *oil on canvas 64×85 in.*
The Hague, Mauritshuis

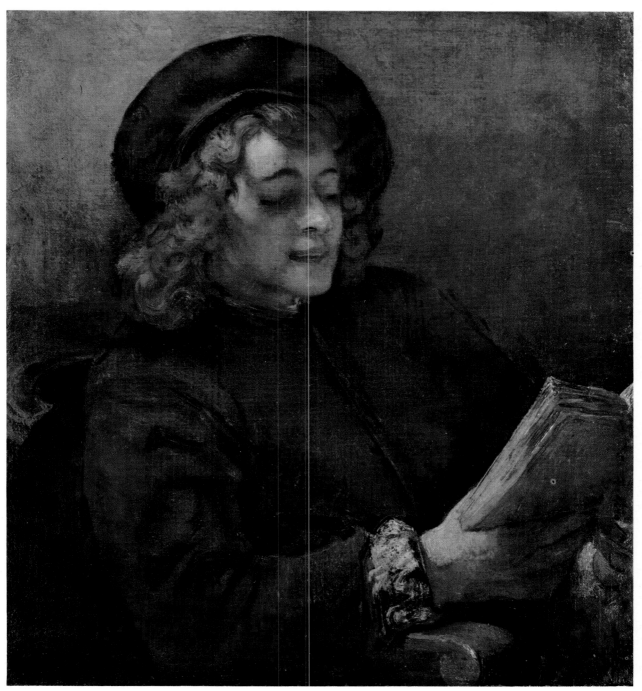

REMBRANDT VAN RYN Portrait of Titus, about 1656 *oil on canvas* *52⅝ × 40⅞ in.*
Vienna, Kunsthistorisches Museum

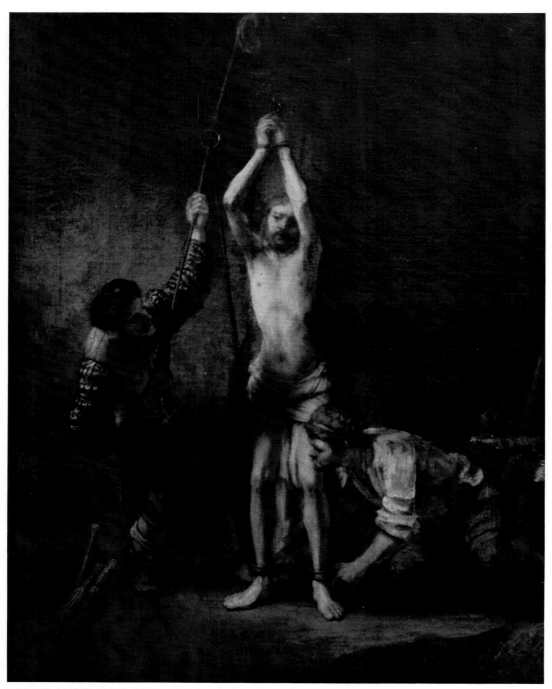

REMBRANDT VAN RYN The Flagellation, 1658 *oil on canvas* $36\frac{5}{8} \times 28\frac{3}{4}$ *in.*
Darmstadt, Hessisches Landesmuseums

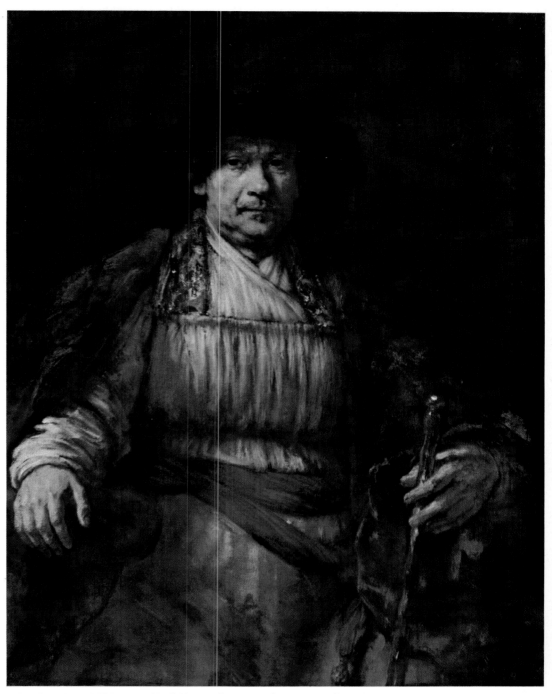

REMBRANDT VAN RYN Self-portrait, 1658 *oil on canvas* $52\frac{5}{8} \times 40\frac{7}{8}$ *in.*
New York, Frick Collection

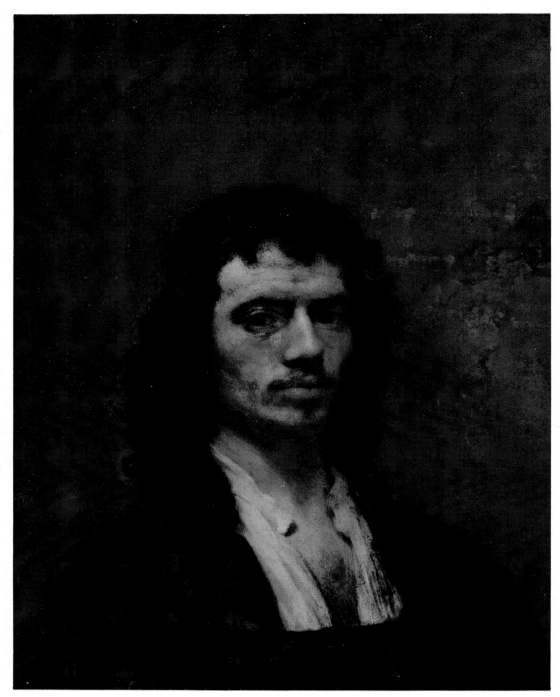

CAREL FABRITIUS Self-portrait, 1646 *oil on panel 25½ × 19 in.*
Rotterdam, Museum Boymans-van Beuningen

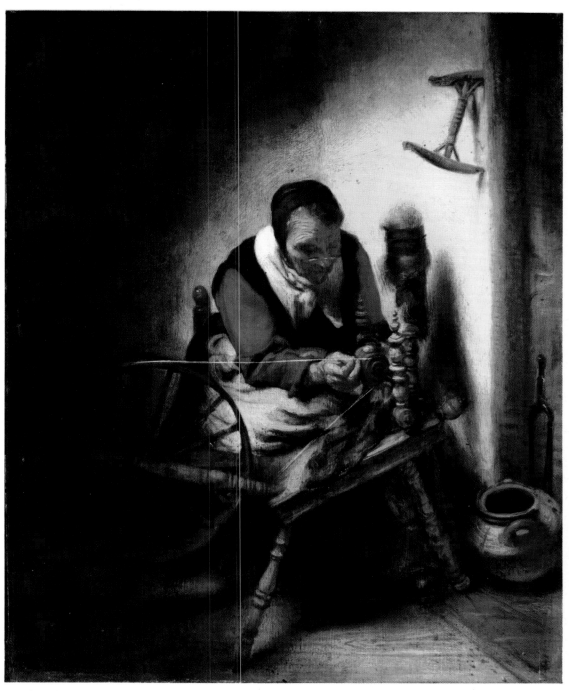

NICOLAS MAES Woman Spinning, 1655 *oil on panel* *16¼ × 13 in.*
Amsterdam, Rijksmuseum

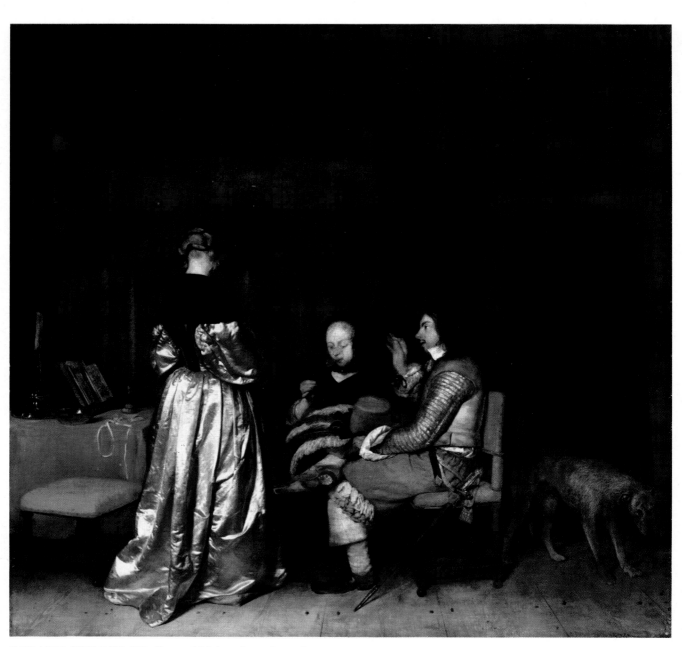

GERARD TERBORCH Paternal Advice, about 1655 *oil on canvas 28 × 28¾ in.*
Amsterdam, Rijksmuseum

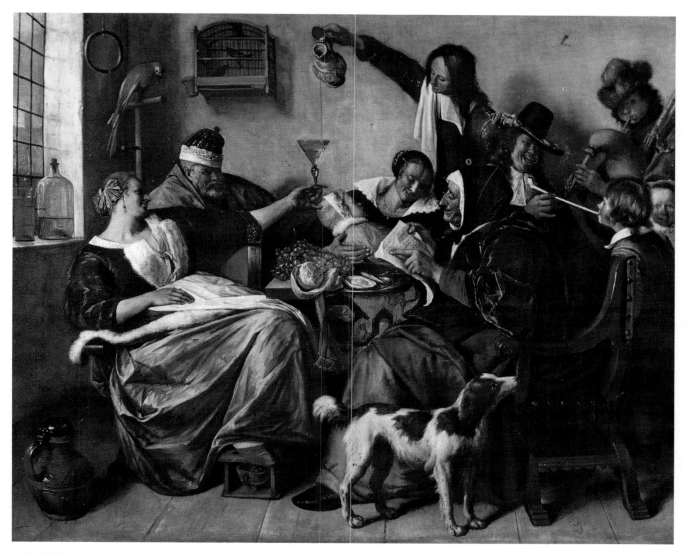

JAN STEEN The Artist's Family *oil on canvas* $53\frac{7}{8} \times 64\frac{1}{4}$ *in.*
The Hague, Mauritshuis

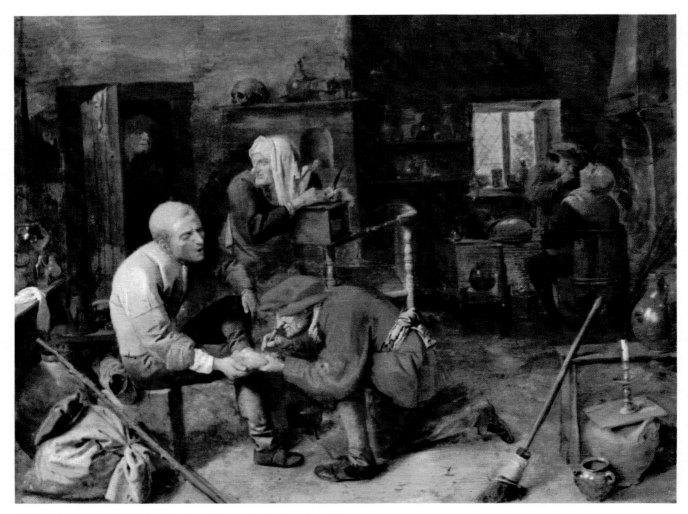

ADRIAEN BROUWER The Operation *oil on panel 12¼ × 15¾ in.*
Munich, Alte Pinakothek

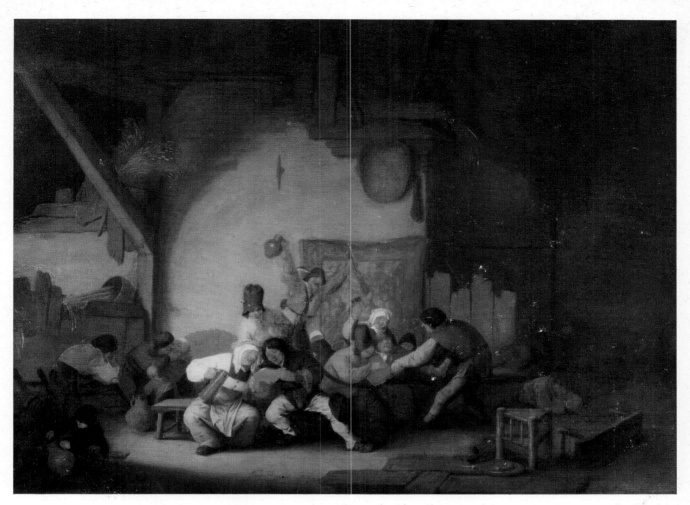

ADRIAEN VAN OSTADE The Peasants' Party, about 1659 *oil on panel 18½ × 25 in.*
The Hague, Mauritshuis

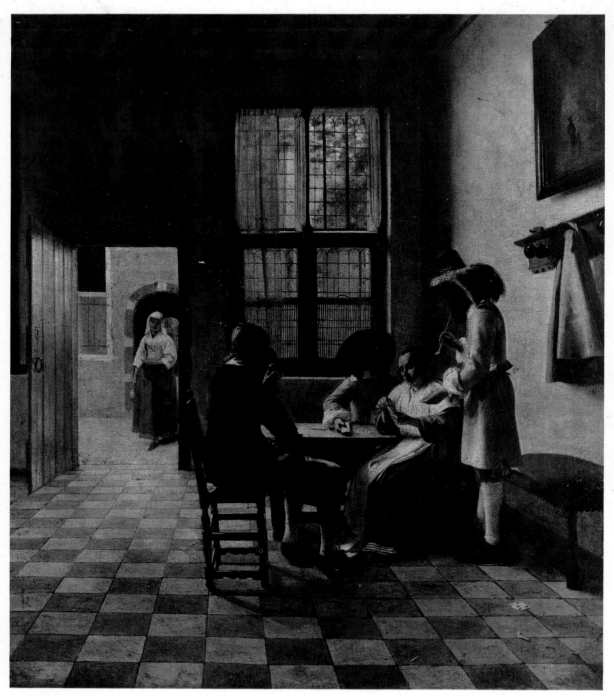

PIETER DE HOOCH Interior of a Tavern, 1658 *oil on canvas 30 × 26 in.*
London, Royal Collection

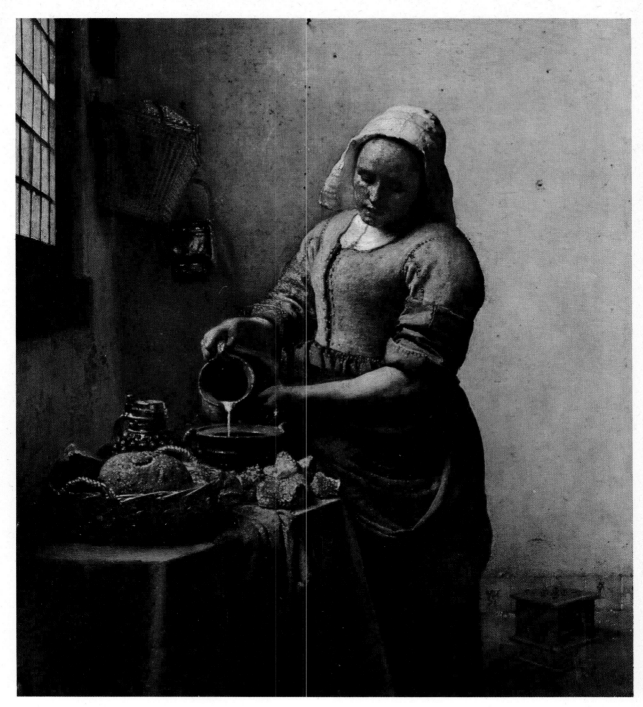

JAN VERMEER Maid Pouring Milk, 1658 *oil on canvas* $17\frac{3}{4} \times 16\frac{1}{8}$ *in.*
Amsterdam, Rijksmuseum

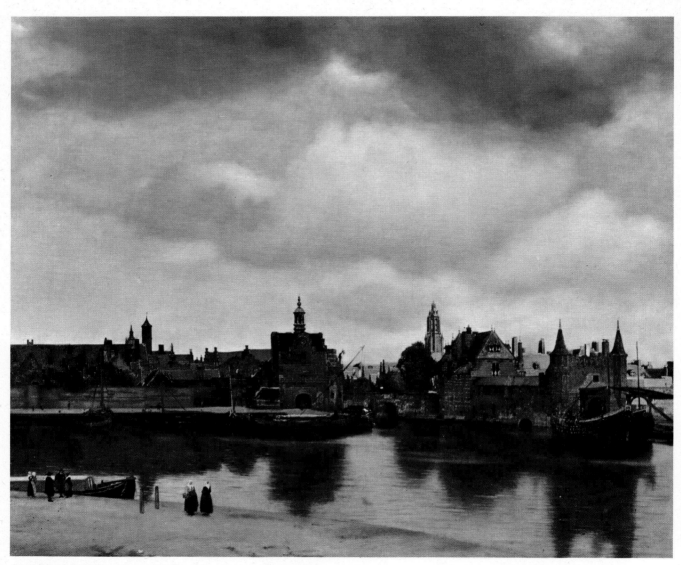

JAN VERMEER View of Delft, 1658 *oil on canvas* *39 × 46⅛ in.*
The Hague, Mauritshuis

64

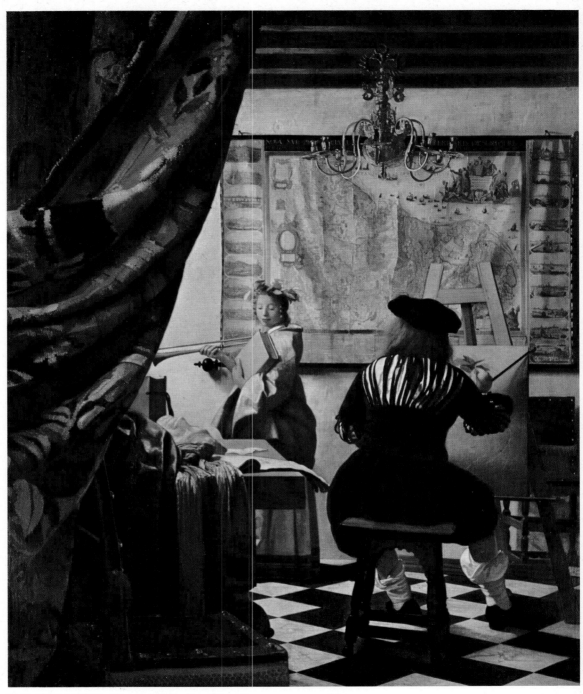

JAN VERMEER The Artist's Studio, 1665 *oil on canvas* $47 \times 39\frac{1}{4}$ *in.*
Vienna, Kunsthistorisches Museum

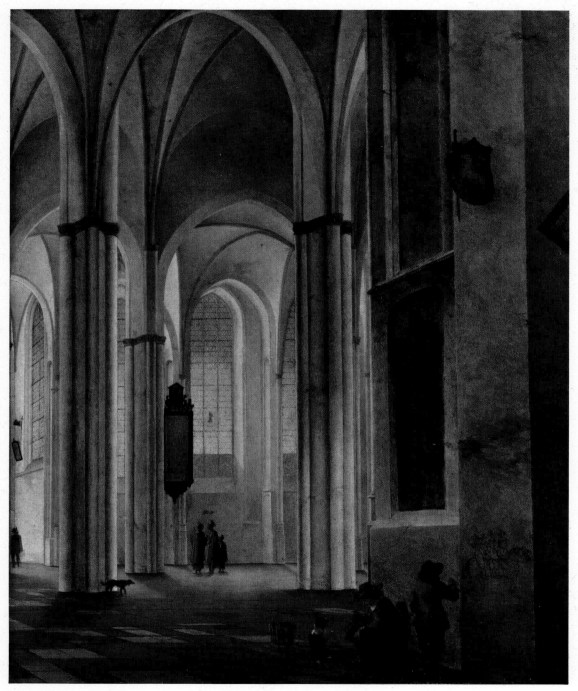

PIETER SAENREDAM Interior of the Buurkerk at Utrecht, 1644 *oil on panel* *23½ × 20 in.*
London, National Gallery

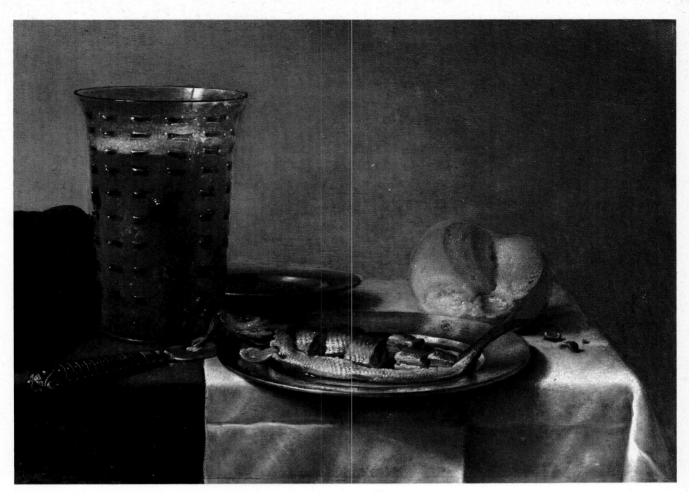

PIETER CLAESZ Still-life with Wine Glass, 1642 *oil on panel 27⅛ × 20⅞ in.*
Rotterdam, Museum Boymans-van Beuningen

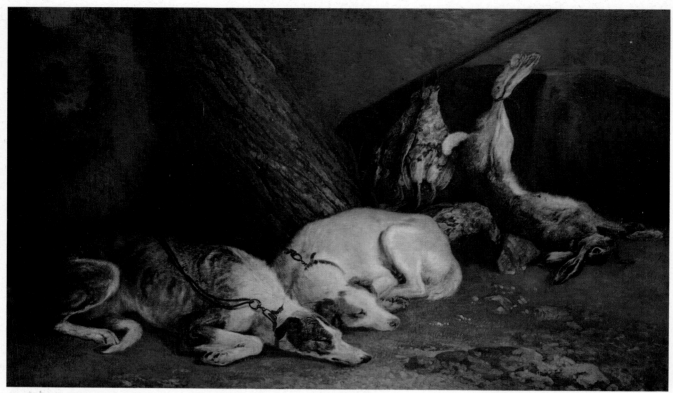

JAN FYT Hounds Resting *oil on panel* $41\frac{3}{8} \times 69\frac{1}{4}$ *in.*
Antwerp, Musée Royal des Beaux-Arts

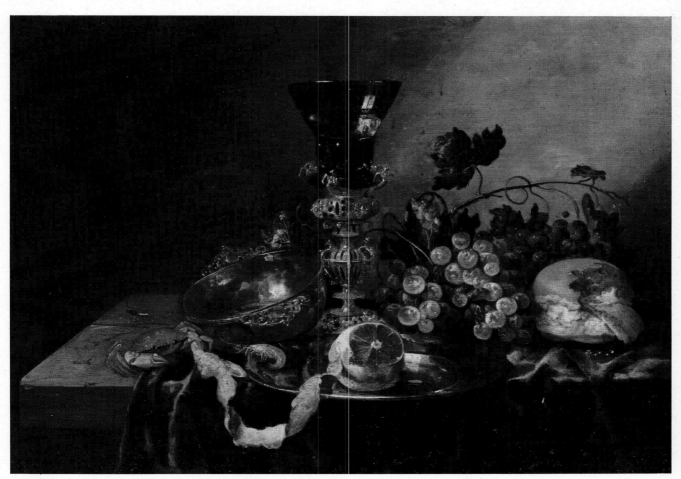

ABRAHAM HENDRICKZ VAN BEYEREN Still-life with Fruit *oil on panel 17¾ × 24¾ in.*
Munich, Alte Pinakothek

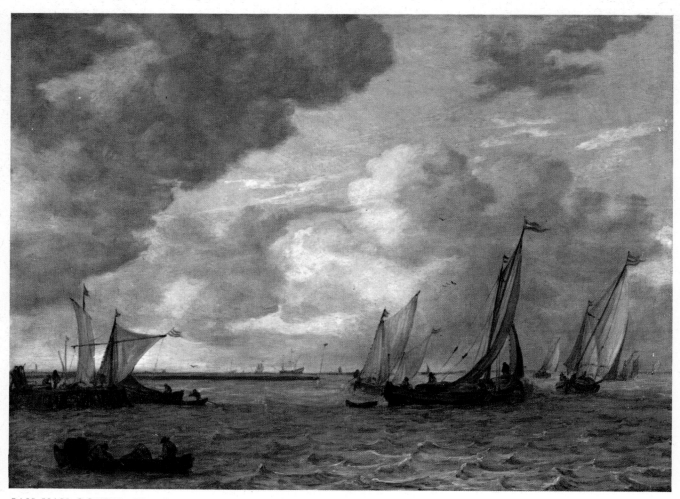

JAN VAN GOYEN River Scene, 1655 *oil on panel* 16¼ × 22 *in.*
The Hague, Mauritshuis

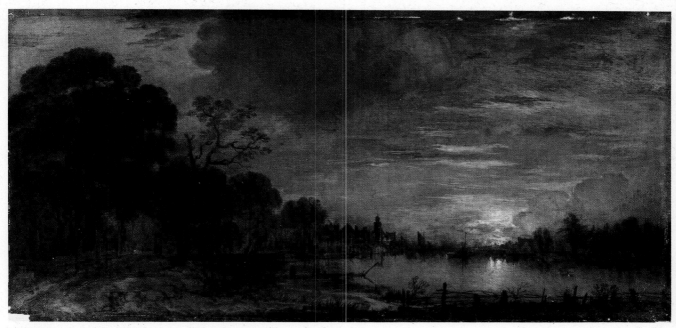

AERT VAN DER NEER Moonlit Landscape *oil on panel* $6\frac{7}{8} \times 15$ *in.*
West Berlin, Staatliche Museen

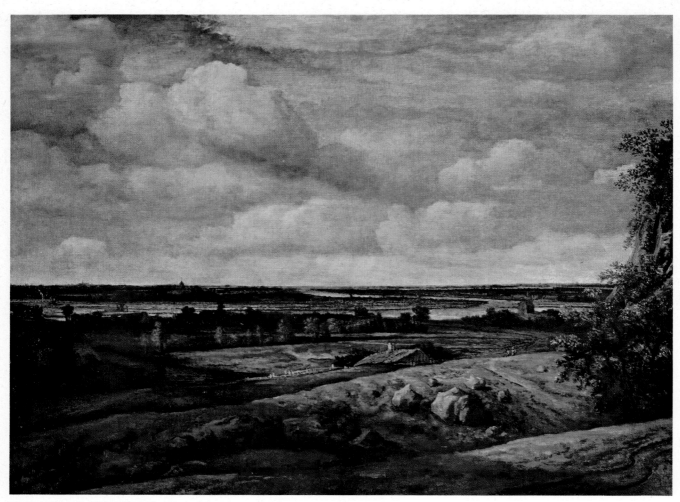

PHILIPS DE KONINCK View of the River Waal, 1654 *oil on canvas* $59 \times 79\frac{7}{8}$ *in.*
Copenhagen, Statens Museum for Kunst

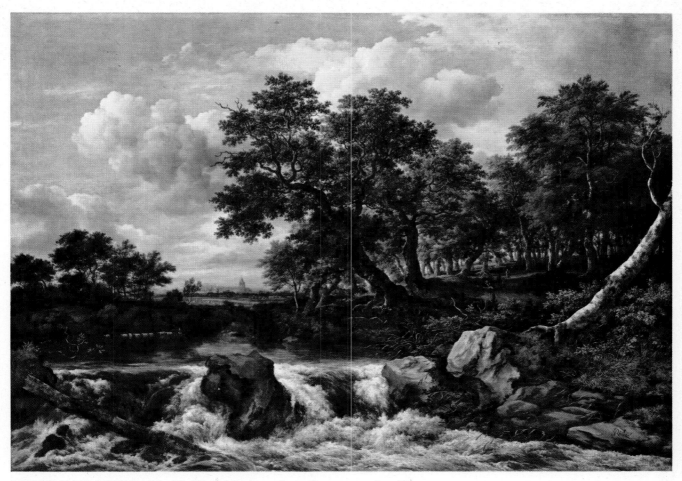

JAKOB VAN RUISDAEL The Waterfall, about 1670 *oil on canvas* $55\frac{7}{8} \times 76\frac{3}{4}$ *in.*
Amsterdam, Rijksmuseum

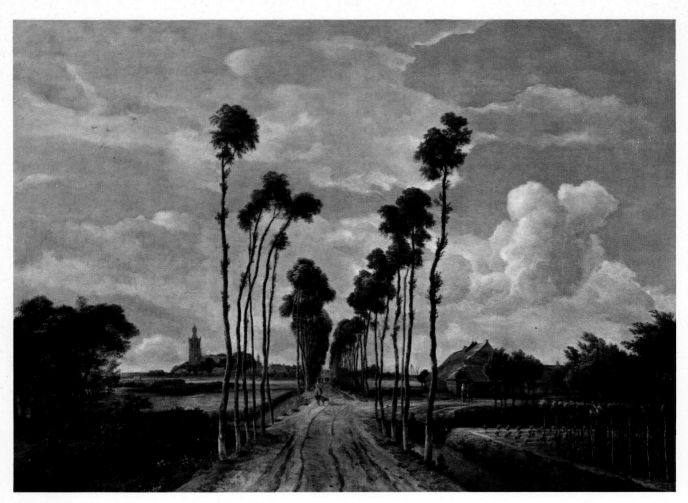

MEINDERT HOBBEMA The Avenue at Middelharnis, 1689 *oil on canvas* $40\frac{3}{4} \times 55\frac{1}{2}$ *in.*
London, National Gallery

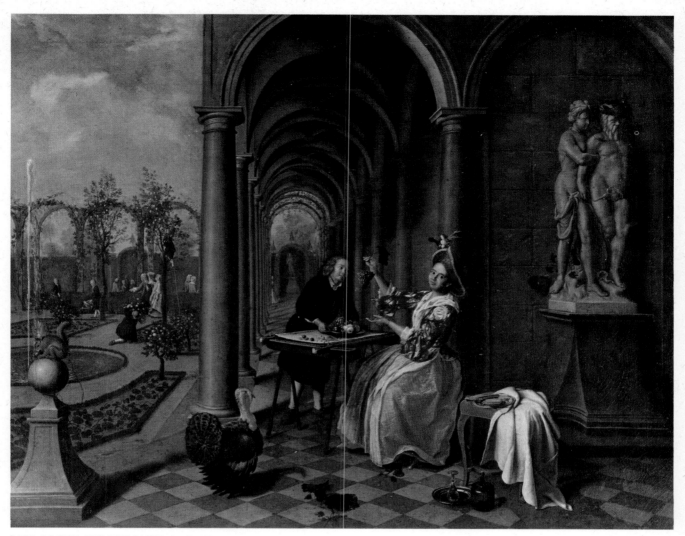

JAN JOSEF HOREMANS the ELDER Garden with Figures on a Terrace, 1735 *oil on canvas* $25\frac{3}{4} \times 31\frac{1}{2}$ *in.*
London, collection Rex A. L. Cohen

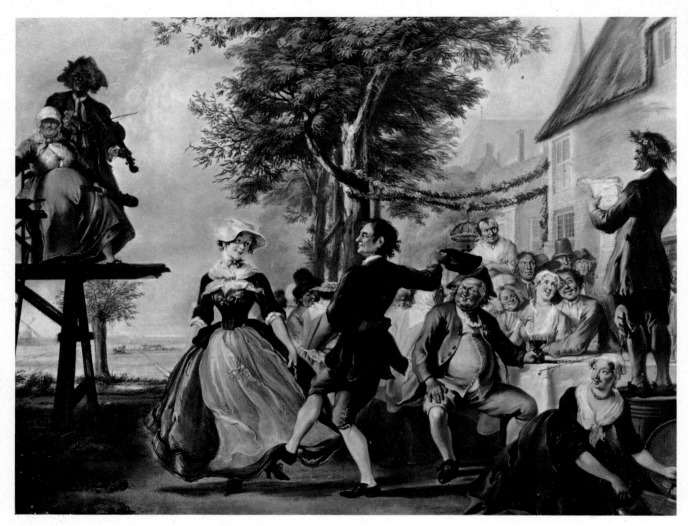

CORNELIS TROOST The Wedding of Kloris and Roosje, about 1739 *pastel on paper* 25¼ × 32⅝ *in.*
The Hague, Mauritshuis

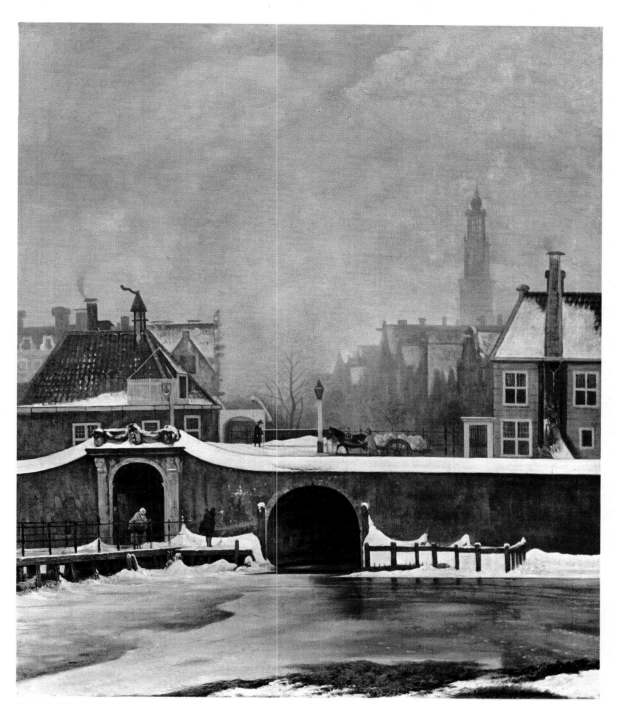

WOUTER JOHANNES VAN TROOSTWIJK The Raampoortje Gate at Amsterdam, 1809
oil on canvas $22\frac{1}{4} \times 18\frac{7}{8}$ in.
Amsterdam, Rijksmuseum

FRANÇOIS JOSEPH NAVEZ Self-portrait, 1826 *oil on canvas*
Brussels, Musées Royaux des Beaux-Arts

HENDRIK LEYS The Bird Catcher, 1866 *oil on panel* *24×36¼ in.*
Antwerp, Musée Royal des Beaux-Arts

ALFRED STEVENS The Desperate Woman *oil on panel* *40⅛ × 28 in.*
Antwerp, Musée Royal des Beaux-Arts

HENRI DE BRAEKELEER Man in a Chair, 1875 *oil on canvas* $31\frac{1}{8} \times 24\frac{3}{4}$ *in.*
Antwerp, Musée Royal des Beaux-Arts

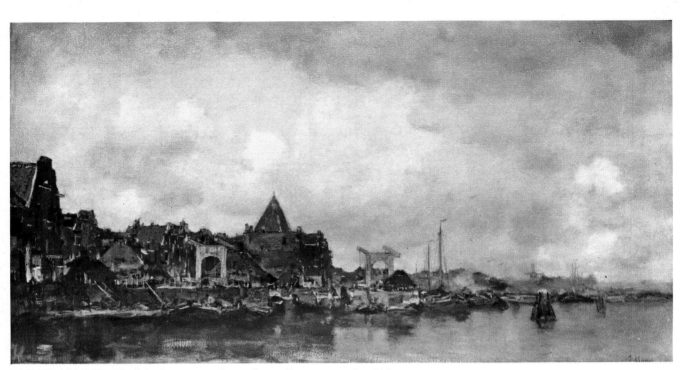

JAKOB MARIS The Schreijerstoren at Amsterdam *oil on canvas 27½ × 58¼ in.*
The Hague, Gemeentemuseum, acquired with the support of the "Vereeniging Rembrandt."

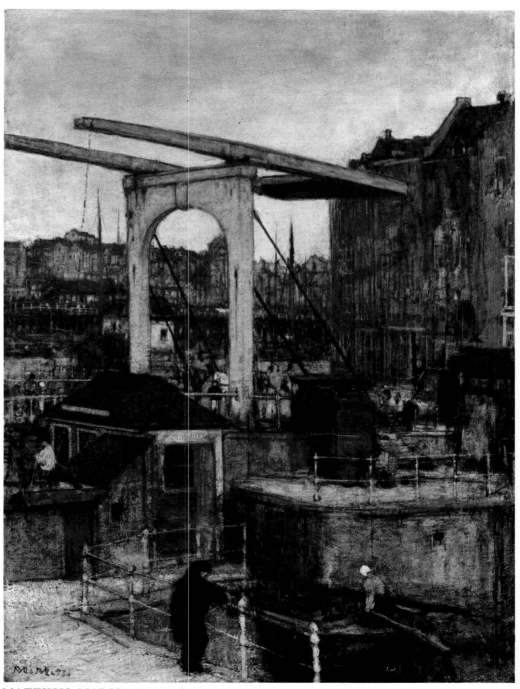

MATTHIJS MARIS Memory of Amsterdam, 1871 *oil on canvas* $18\frac{1}{4} \times 11\frac{3}{4}$ *in.*
Amsterdam, Rijksmuseum

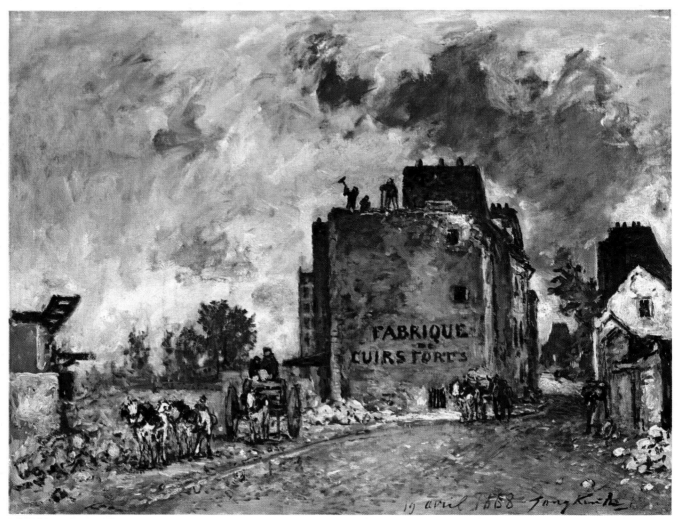

JOHAN BARTHOLD JONGKIND Demolition of the Rue des Francs, 1868 *oil on canvas* 13⅜ × 16¼ *in.*
The Hague, Gemeentemuseum

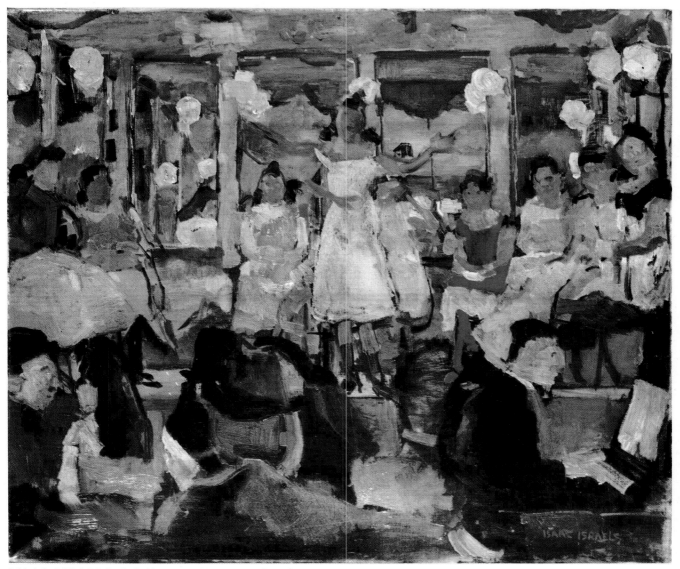

ISAAC ISRAELS Café Chantant, about 1895 *oil on canvas* $35\frac{1}{2} \times 41\frac{1}{4}$ *in.*
Otterlo, Holland, Rijksmuseum Kröller-Müller

FÉLICIEN ROPS Death at the Ball, 1893 *oil on canvas* $59\frac{1}{2} \times 33\frac{1}{2}$ *in.*
Otterlo, Holland, Rijksmuseum Kröller-Müller

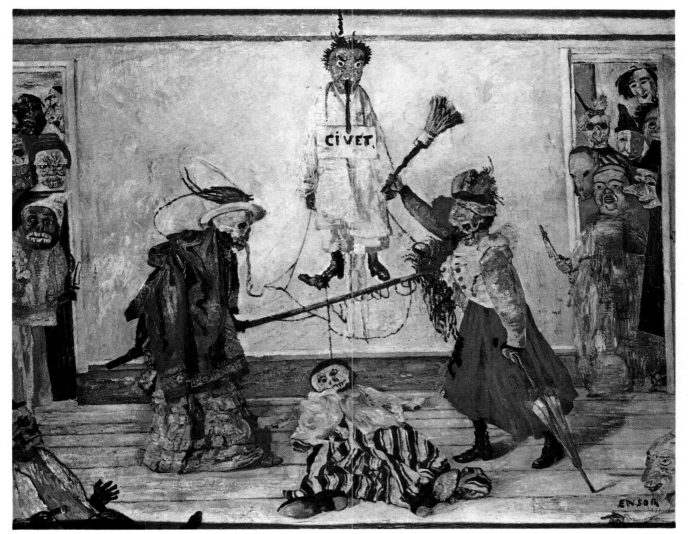

JAMES ENSOR People in Masks Fighting over a Hanged Man, 1891 *oil on canvas 23¼ × 29⅛ in.*
Antwerp, Musée Royal des Beaux-Arts

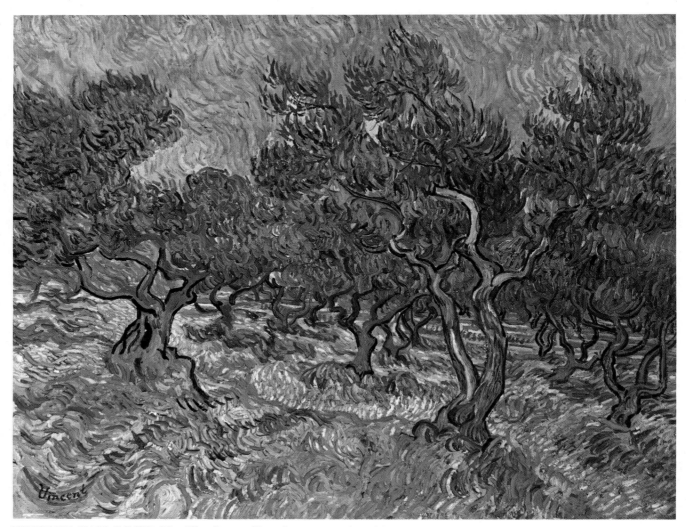

VINCENT VAN GOGH The Olive Grove, 1889 *oil on canvas* $27\frac{3}{4} \times 35\frac{1}{2}$ *in.*
Otterlo, Holland, Rijksmuseum Kröller-Müller

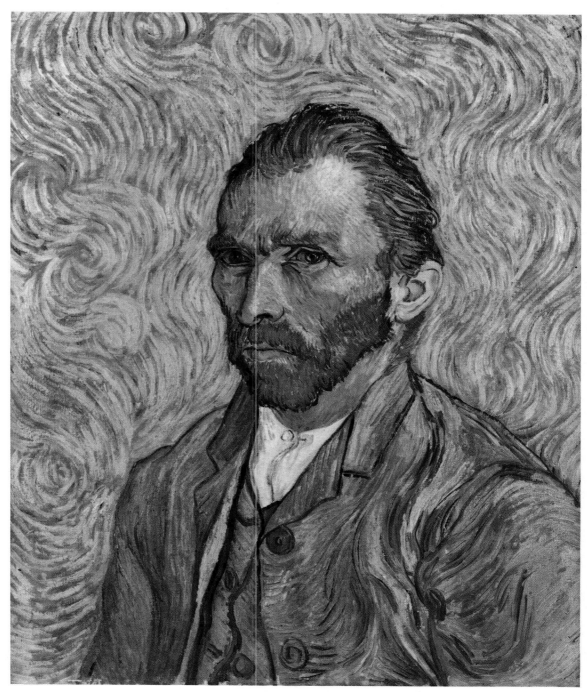

VINCENT VAN GOGH Self-portrait, Saint-Rémy, 1890 *oil on canvas* $25\frac{5}{8} \times 21\frac{1}{4}$ *in.*
Paris, Musée de l'Impressionnisme, gift of Paul and Marguerite Gachet

FLORIS VERSTER Still-life with Bottles, 1892 *oil on canvas* $37\frac{3}{8} \times 26\frac{3}{8}$ *in.*
Otterlo, Holland, Rijksmuseum Kröller-Müller

GEORGE HENDRIK BREITNER Amsterdam; The Dam at Night, 1893 *oil on canvas 57⅞ × 87¾ in.*
Amsterdam, Stedelijk Museum

JACOB SMITS Evening Landscape, between 1901-14 *oil on canvas* *37 × 39⅜ in.*
Antwerp, Musée Royal des Beaux-Arts

GERMAN ART TO 1900

As in all western European countries, painting in Germany had its origin in the spread of Christianity. During the 8th century, Anglo-Saxon missionaries carried the Gospel east of the Rhine, bringing manuscripts from as far away as Byzantium that served as models in the *scriptoria* of the monasteries established by Charlemagne. The first artistic productions of the Frankish monasteries are little more than imitations of these Mediterranean monastic arts, but by the 11th century a style had developed that owed little to classical models. While the influence of Byzantine art is evident in the *Annunciation to the Shepherds* (p. 97), the intense emotion evidenced in the forward thrust and outstretched hand of the angel is typically Teutonic. The elongation of the angel's body and the disproportion of the long fingers of all the figures accentuate the force of the gestures. In the illustration of St. Pantaleon from a 12th-century Cologne manuscript (p. 98), facial expressiveness is intensified by the size of the head relative to the body, a distortion for emotional effect often encountered in German medieval art.

A number of altarpieces, mostly in the form of paintings on wood panels, have survived from the 13th and 14th centuries. These panels were painted in tempera—an emulsion of dry pigment, egg yolk, and water, which forms a smooth, opaque layer of color when dry. The borders of these paintings were often carved in the same piece of wood on which the picture was painted (pp. 99, 100, 101). Often, small niches (used for relics or small statues of saints) were incorporated into the frame, as at the top of the Cologne *Crucifixion* (p. 100).

In the middle of the 14th century a Bohemian ruler became Holy Roman emperor and established his residence in Prague. As a result, a considerable amount of Bohemian painting showed an Italianate influence (p. 102), whereas the native Bohemian art was of a more robust character. It is found in Hamburg, particularly in the work of Master Bertram (p. 101).

In Westphalia and the Rhineland a softer, more delicate style resulted from the close links between these regions and the courts of Burgundy and Paris (pp. 104, 105, 106). Konrad von Soest, a Westphalian, is one of the earliest painters in Germany to whom a number of works can be attributed with any certainty. His *Crucifixion* (p. 103) shows a familiarity with Franco-Burgundian art, but is more characteristic of the Soft Style which dominated German painting in the first half of the 15th century. The painting of the Master of St. Veronica (p. 104) and Master Francke (p. 105) has the warm color and firm, rhythmical line characteristic of this style, as does *The Garden of Paradise* (p. 106).

The final distillation of the Soft Style is found in the work of Stefan Lochner. Here there is no drama, no intensity of emotion or psychological insight. The colors are pleasant, and the atmosphere is almost that of a fairy tale (p. 107). With Lochner the Soft Style disappeared from German painting, displaced by a northern realism inspired in part by the artistic activity in Flanders.

Italian influences

The massive panels of Konrad Witz, such as *Joachim and Anna at the Golden Gate* (p. 108), are painted with an attention to realistic detail unknown heretofore. Witz shares the Flemish love of materials and fondness for portraiture. His painting is less painstaking in fine detail

than that of the early Italian Renaissance, but it has much the same monumental feeling.

The work of Michael Pacher also embodies many Italian innovations. The receding perspective lines of the buildings and windows in his altarpiece panel on p. 109, which define and emphasize space, the attention to details of costume, and the sumptuous color are all characteristically Italian.

The Crucifixion by the Master of the St. Bartholomew Altarpiece (p. 110) is a work in which both Italian and Flemish characteristics are combined with the Gothic tradition. The colors are brilliant, and careful attention is paid to contour and decorative details. Particularly characteristic of this painter are the long, spidery fingers, reminiscent of the Italian painter Carlo Crivelli.

Lucas Cranach was a court painter to the Elector of Saxony, Frederick the Wise, and an artist of great versatility. He painted portraits and altarpieces and other religious works and made woodcut illustrations for books. He pioneered in providing charming landscape settings for his religious pictures (p. 111). Mythology furnished subjects for paintings of the female nude, which he developed into a peculiarly characteristic type of his own.

Albrecht Dürer, 1471-1528

Nuremberg produced in Albrecht Dürer the first northern painter of both artistic and intellectual genius, and the first artist outside Italy who managed to absorb more than the superficial aspects of the Renaissance. His drawings and engravings, as well as paintings, reveal the strength that resulted from the fusion of German force and ruggedness with Italian dignity and nobility.

Of the many pictures Dürer painted of himself, the *Self-Portrait in a Fur Coat* (p. 112), done when he was 28, is the most renowned. It is an idealized, not a factual, portrait. In actuality Dürer's eyes were not so large, nor his face so perfectly symmetrical. He altered his features in order to create an image that conformed to the northern European conception of Christ's appearance, and further intensified the allusion by the grave expression of the face and the position of the right hand. By this deliberate representation of himself as Christ, Dürer expressed his belief that his creative power as an artist came from God, and that through it he shared in God's universality.

The Four Apostles (p. 113) was painted at a time when Nuremberg was being torn by religious strife as radical Lutheran sentiment increased. An inscription at the bottom of each panel from the writings of the saints portrayed admonished the more radical followers of Luther that the only truth lies in the teachings of the Scriptures.

The picture has symbolic implications as well. The figures are larger than life-size, and each is the personification of one of the four temperaments—the physical ages and psychological states into which all men can be divided. This was an ancient theory that had been given currency in a Christian context by contemporary philosophers. Youthful John the Evangelist on the left represents the sanguine temperament; aged Peter, the phlegmatic; and in the second panel the adult Mark personifies the choleric, and Paul the melancholic.

Hans Burgkmair was a contemporary of Dürer, and collaborated with him on the designs for a number of woodcuts. He was influenced by contemporary early Italian Renaissance art, and combined his influence with a late Gothic manner. His paintings lack the feeling for depth and volume that mark Dürer's work, and never achieve more than a rather empty pathos (p. 114).

Grünewald, c. 1470-1528

Unlike Dürer, who was very much a part of his own age and whose work contributed directly to the mainstream of northern European art, Mathis Gothardt, called Grünewald, was virtually unknown in his own time. It is only relatively recently that he has come to be recognized as an artist of major importance.

The Crucifixion (p. 115) is at once a final statement of medieval religious emotion and a summing up of the German spirit. In the history of painting there is no more agonizing portrayal of the Crucifixion, unless it is Grünewald's other, and very similar, Crucifixion at Isenheim. In both paintings the torture and cruelty to which the crucified body has been subjected are depicted with a savage and horrifying intensity that manages at the same time to convey a monumental and profound compassion. Such fiercely outspoken realism was not new in German art, but it has never been used with more powerful effect in the expression of a universal theme.

Albrecht Altdorfer was the first German landscape painter in the modern sense, painting scenery for its own beauty and not as a background for religious or mythological scenes (p. 116). When figures appear in his paintings, they act as a complement to the landscape.

Hans Baldung, called Grien, worked mainly in Strassburg. Outside of religious paintings, one of his favorite subjects—as it was one of Cranach's—was the female nude (p. 117), which he often treated in a gruesome

allegorical style, contrasted with the figure of Death.

Hans Holbein was another 16th-century artist of great versatility, although he is known primarily as a portrait painter. His portrait of the Hanseatic merchant Georg Gisze (p. 118) is one of a long succession of portraits commissioned by German merchants. While Holbein's portraits do not show an especially deep psychological penetration, they have a directness of expression that commands attention.

The reputation of Georg Pencz depends to a large extent on portraiture, although he also painted large illusionistic decorations. His portraits are indebted to Dürer, Giorgione and Titian, and finally to the restrained Mannerism of Bronzino. The *Portrait of Jörg Herz* (p. 119) belongs to his Mannerist period.

As a result of continuous religious and political strife, a period of indifferent German work began in the middle of the 16th century. Aesthetic ideals were overwhelmed by an enthusiasm for the Italian style, and many German painters mastered the foreign idiom so completely that often, as in Von Aachen's *The Victory of Truth* (p. 120), it is difficult to distinguish their work from that of their Italian contemporaries. Only in the northern regions did still-life, landscape, and genre painting retain their integrity. In still-life, which had begun to develop in the Netherlands about 1600 as a specialized branch of painting, the German painter Georg Flegel (p. 121) attained prominence. The landscapes of Adam Elsheimer of Frankfurt were highly regarded, even in Italy, for their range of light, color, and atmosphere (p. 122). Johann Liss' large-scale genre paintings (p. 123) are also representative of painting in this era. Portrait painting languished, rarely breaking away from French and Flemish models (p. 124).

With the end of the Thirty Years' War the political situation stabilized, and during the 18th century painting again flourished. In the Catholic south the Baroque style was adopted with enthusiasm, and many new altarpieces and wall and ceiling decorations were painted in this style (pp. 125, 126, 127). A soberer atmosphere prevailed in the Protestant courts and among the middle classes of the north and east. In the last two decades of the 18th century a renewed interest in Classicism (p. 128) pervaded these areas.

The end of the 18th century marked the end of a taste in European painting that had endured for 300 years. The role of the Catholic Church was greatly altered after the French Revolution, and there was almost no demand for religious painting.

In German art the most important achievements of the 19th century were landscapes and portraits, commissioned by a prosperous, well-read, growing middle class. Representative of Classical Revival landscapes, the paintings of Joseph Koch presented the grandeur of mountains, waterfalls, and gorges in a monumental way (p. 131). In accordance with the tenets of Classicism, his landscapes have small human figures, often with historical or mythological connotations.

The Romantic painters

The reaction to Classicism was Romanticism, and its greatest German exponent was the landscapist Caspar David Friedrich. In his paintings the immensity of nature, its moods, its loneliness and incomprehensibility, and above all its silence are expressed for the first time in terms of human experience. Man, contemplating nature in this way, is made aware of his own transitory existence, and these paintings are pervaded by a mood of melancholy and sadness (p. 129).

Philipp Runge is considered the foremost Romantic landscape painter. The portrait group of his parents and his two children (p. 130) is a moving presentation of the contrast between the heavy apathy of old age and the preoccupation of the very young with their own limited world.

The Nazarenes were a group of Romantic painters whose aim was to rejuvenate German art by reviving religious painting in a spirit compounded of that of late medieval Germany and that of 15th-century Italy. The Romantic concept of the inseparability of landscape and figures is apparent in the painting by Julius Schnorr von Carolsfeld (p. 132), but the attempt to re-create the religious attitudes of the Middle Ages in the 19th century was doomed to failure. A more genuine and contemporary religious feeling is conveyed by Wilhelm Leibl's *Three Women in a Church* (p. 136).

Classicism persisted throughout the 19th century (p. 135), but along with the Classic and the Romantic there developed a "naturalistic" view of reality. This view refused to be tied to any kind of idealization, but recognized the unpretentious as susceptible of artistic greatness (pp. 133, 134). These tendencies, more nearly than any others of the restless, transitional 19th century, anticipate the beginnings of "modern" art.

List of Color Plates

MANUSCRIPT: REICHENAU (Lake Constance)
The Annunciation to the Shepherds: page of The Pericope Book of Henry II.
about 1007-12 *vellum* $11 \times 8\frac{1}{4}$ *in.*
Munich, Bayerische Staatsbibliothek

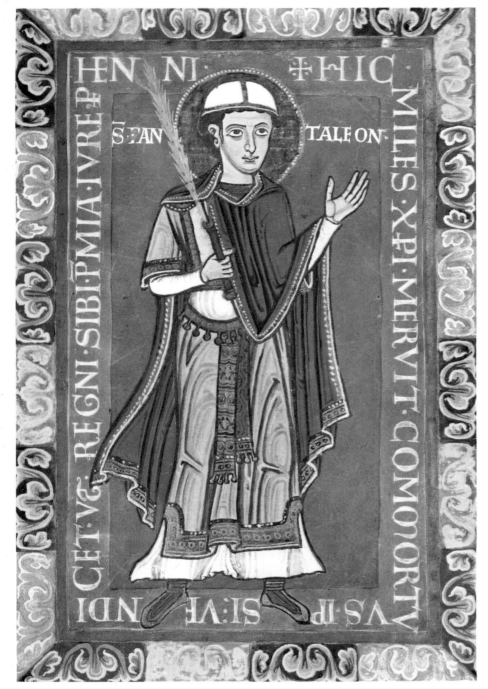

MANUSCRIPT: COLOGNE St. Pantaleon: page of a Book of Gospels (detail)
about 1170 *vellum approximately actual size*
Cologne, Stadtarchiv

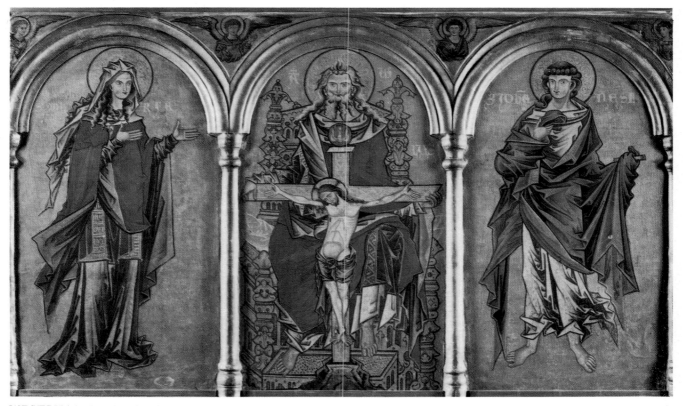

WESTPHALIA Altarpiece from Soest, about 1250-70
tempera on panel 25 × 47 in.
West Berlin, Staatliche Museen

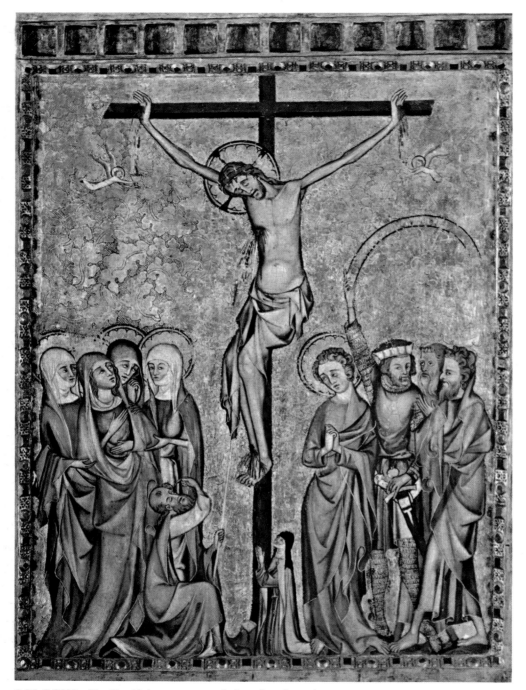

COLOGNE The Crucifixion: center panel of an altarpiece, about 1320
tempera on panel 21¼ × 16¼ in.
Cologne, Wallraf-Richartz-Museum

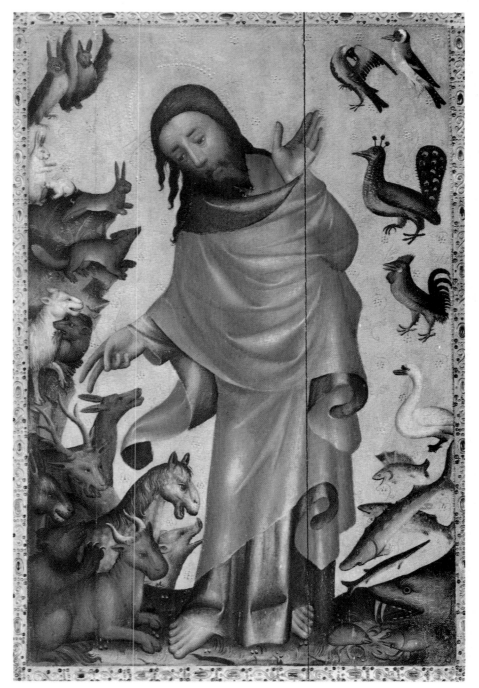

MASTER BERTRAM God Creating the Animals: panel from the Grabow Altar, 1379
tempera on panel $33\frac{7}{8} \times 22\frac{1}{2}$ *in.*
Hamburg, Kunsthalle

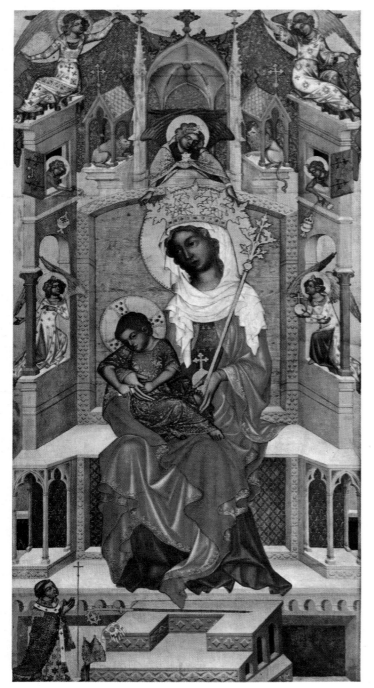

BOHEMIA The Madonna and Child from Glatz, about 1350
tempera on panel 73¼ × 37⅜ in.
West Berlin, Staatliche Museen

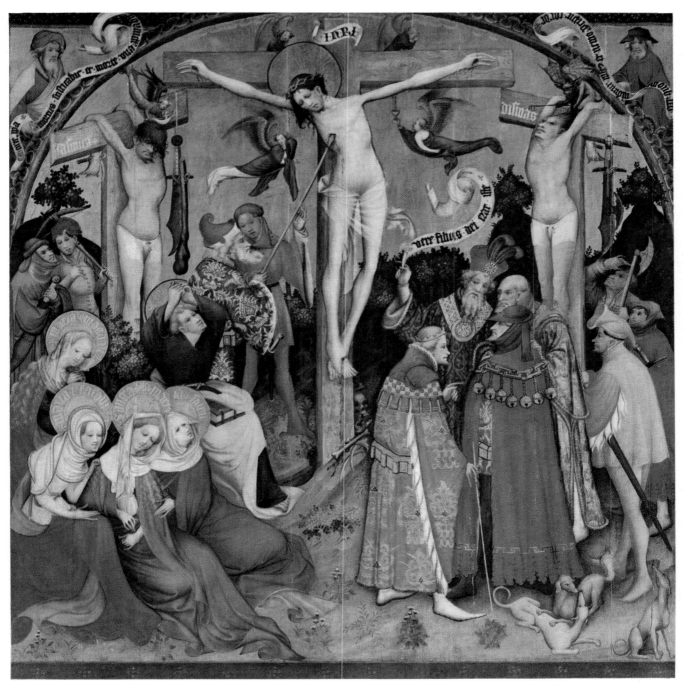

KONRAD VON SOEST The Crucifixion: center panel of an altarpiece, 1403
tempera on panel 62⅝ × 62⅝ in.
Bad Wildungen, Parish Church

MASTER OF ST. VERONICA The Madonna and Child with a Pea Blossom, about 1400
tempera on panel 21¼ × 14⅛ in.
Nuremberg, Germanisches Nationalmuseum

MASTER FRANCKE The Mocking of St. Thomas of Canterbury: altarpiece panel, after 1424
tempera on panel 39 × 35⅜ in.
Hamburg, Kunsthalle

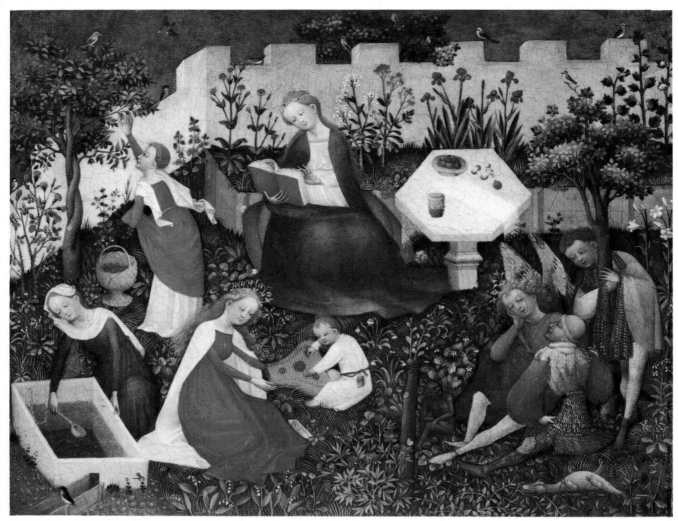

MASTER OF THE UPPER RHINE The Garden of Paradise, about 1410 *tempera on panel* $10\frac{3}{4} \times 13\frac{1}{4}$ *in.*
Frankfurt-am-Main, Historisches Museum

STEFAN LOCHNER The Presentation in the Temple, 1447 *tempera on panel* $54\frac{3}{4} \times 49\frac{5}{8}$ *in.*
Darmstadt, Hessisches Landesmuseum

KONRAD WITZ Joachim and Anna at the Golden Gate: altarpiece panel, about 1440
tempera on panel 61¾ × 47⅝ in.
Basel, Kunstmuseum

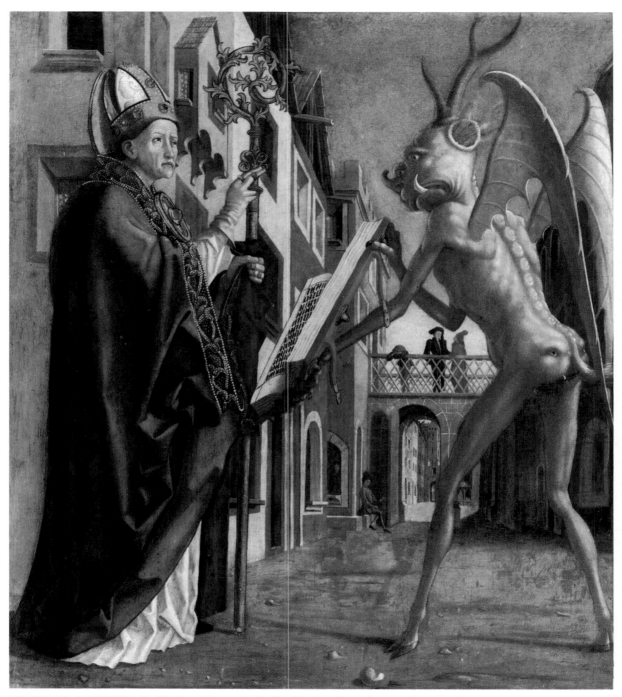

MICHAEL PACHER St. Wolfgang Forces the Devil to Hold the Prayerbook for him: altarpiece panel, about 1483
oil on panel $40\frac{1}{2} \times 35\frac{7}{8}$ in.
Munich, Alte Pinakothek

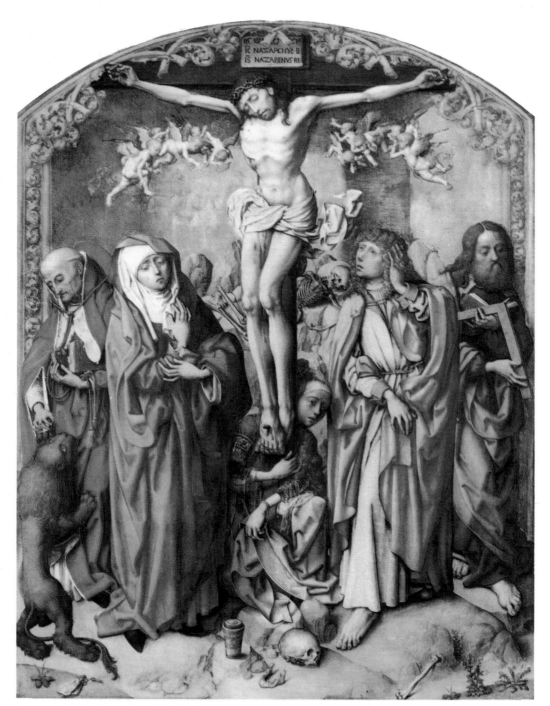

MASTER OF THE ST. BARTHOLOMEW ALTARPIECE The Crucifixion: center panel
of an altarpiece, about 1500 *tempera on panel* $42\frac{1}{8} \times 31\frac{1}{4}$ *in.*
Cologne, Wallraf-Richartz-Museum

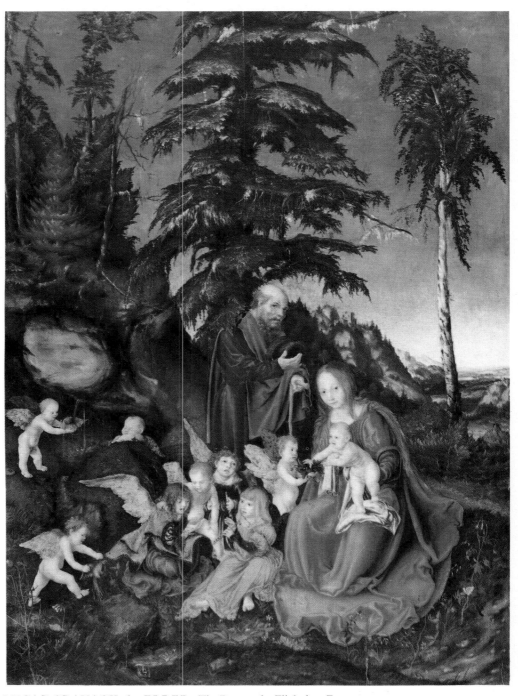

LUCAS CRANACH the ELDER The Rest on the Flight into Egypt, 1504
oil on panel 27⅛ × 20⅜ in.
West Berlin, Staatliche Museen

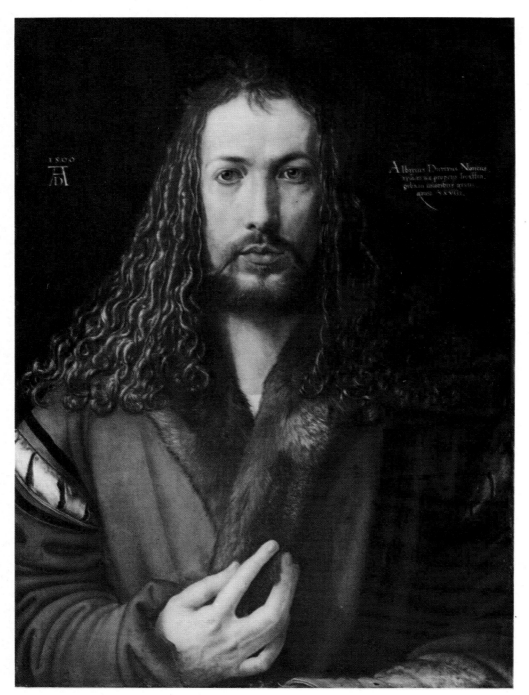

ALBRECHT DÜRER Self-portrait in a Fur Coat, 1500 *oil on panel 26⅛ × 19¼ in.*
Munich, Alte Pinakothek

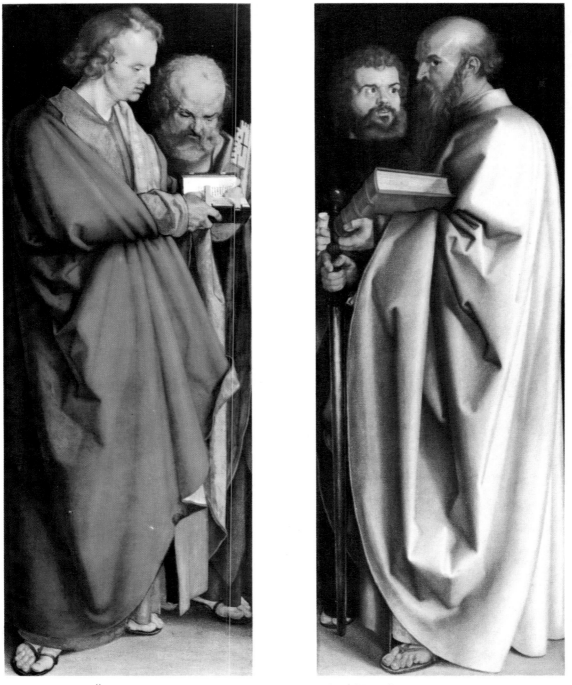

ALBRECHT DÜRER The Four Apostles 1526 *oil on panel* $84\frac{3}{4} \times 29\frac{7}{8}$ *in. each*
Munich, Alte Pinakothek

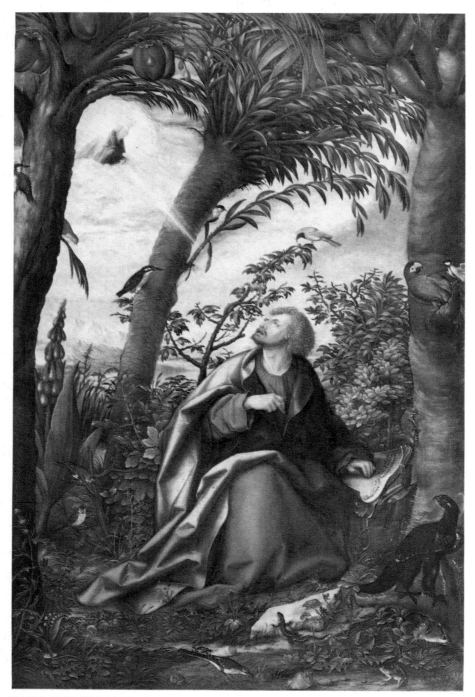

HANS BURGKMAIR St. John on Patmos: center panel of an altarpiece, 1518
oil on panel $60\frac{1}{4} \times 49\frac{1}{8}$ in.
Munich, Alte Pinakothek

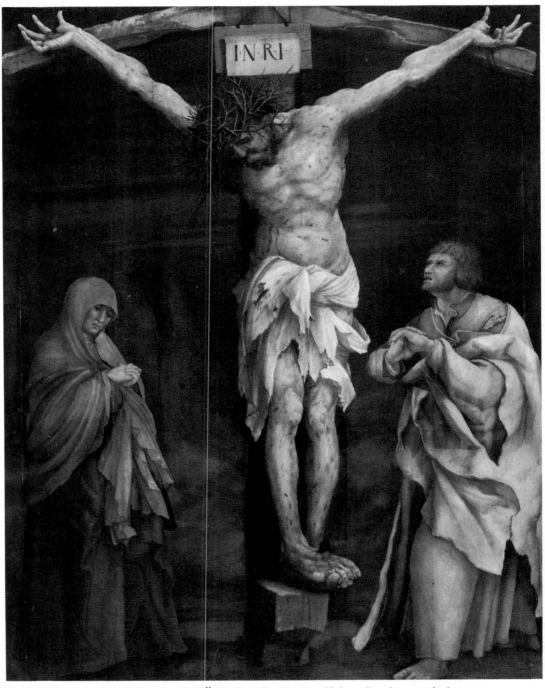

MATHIS GOTHARDT, called GRÜNEWALD The Crucifixion: altarpiece panel, about 1524
oil on panel 77⅛ × 59⅞ in.
Karlsruhe, Kunsthalle

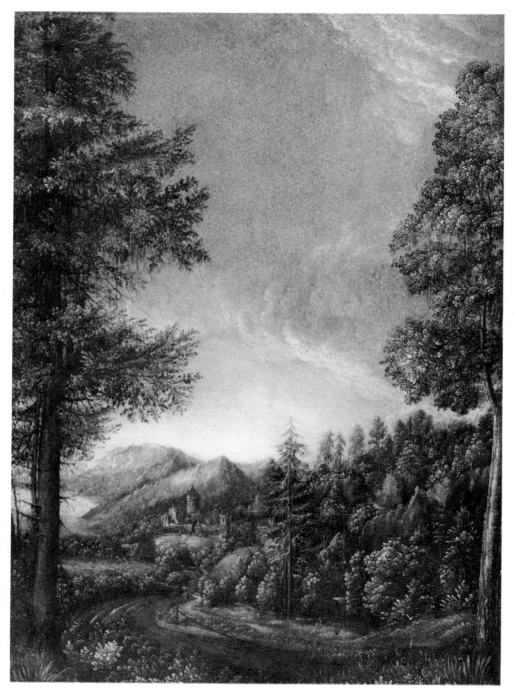

ALBRECHT ALTDORFER Worth Castle and the Scheuchenberg, about 1527
parchment on panel $11\frac{7}{8} \times 8\frac{5}{8}$ *in.*
Munich, Alte Pinakothek

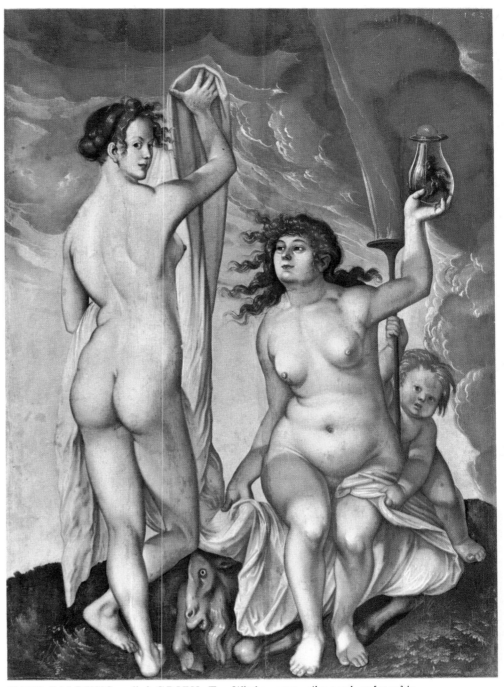

HANS BALDUNG, called GRIEN Two Witches, 1523 *oil on panel 25⅝ × 17¾ in.*
Frankfurt-am-Main, Städelsches Kunstinstitut

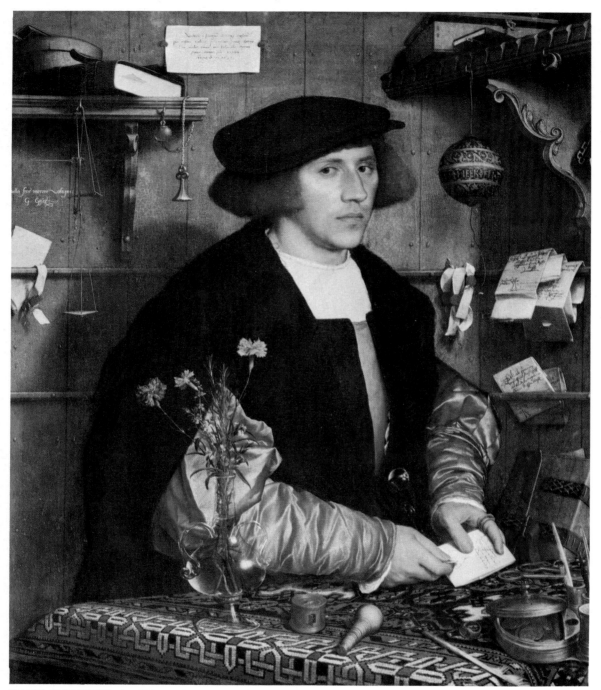

HANS HOLBEIN the YOUNGER Portrait of Georg Gisze, 1532 *oil on panel* $37\frac{3}{4} \times 33\frac{1}{8}$ *in.*
West Berlin, Staatliche Museen

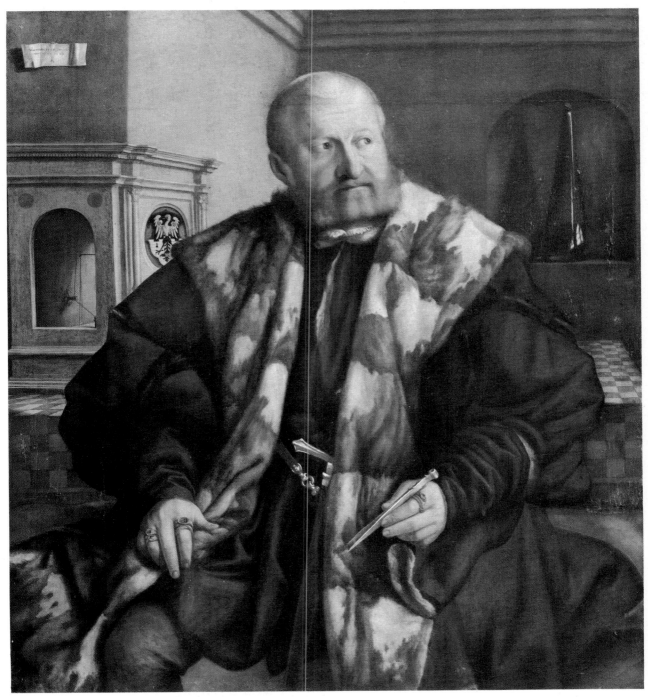

GEORG PENCZ Portrait of Jörg Herz, 1545 *oil on canvas* $42\frac{7}{8} \times 38\frac{5}{8}$ *in.*
Karlsruhe, Kunsthalle

HANS VON AACHEN The Victory of Truth, 1598 *oil on copper* *22 × 18½ in.*
Munich, Alte Pinakothek

GEORG FLEGEL Larder Lit by a Candle, about 1630-35 *oil on canvas 28½ × 23⅝ in.*
Karlsruhe, Kunsthalle

ADAM ELSHEIMER Morning in the Mountains, before 1610 *oil on panel* $6\frac{3}{4} \times 8\frac{5}{8}$ *in.*
Brunswick, Herzog Anton Ulrich-Museum

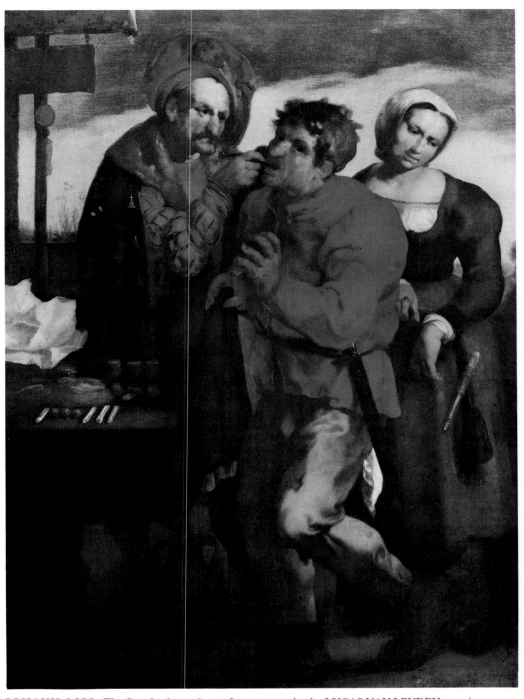

JOHANN LISS The Quack, about 1617 (after an engraving by LUCAS VAN LEYDEN, 1523)
oil on canvas 50¾ × 38¼ in.
Bremen, Kunsthalle

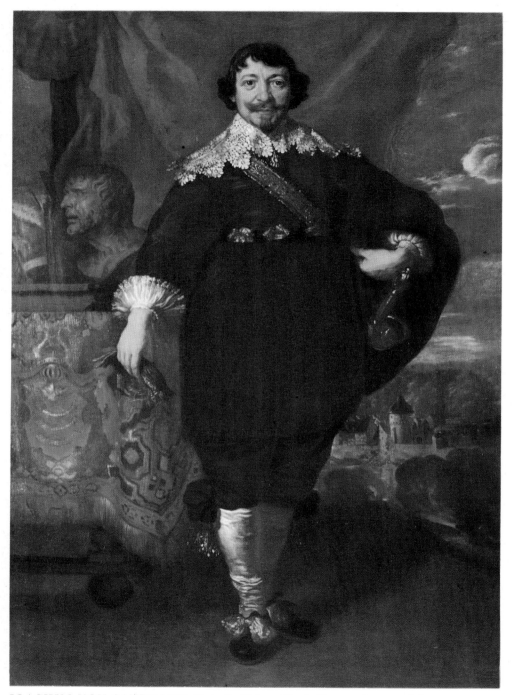

JOACHIM VON SANDRART Portrait of Johann Maximilian zum Jungen, 1636
oil on canvas 74⅜×53⅜ in.
Frankfurt-am-Main, Historisches Museum

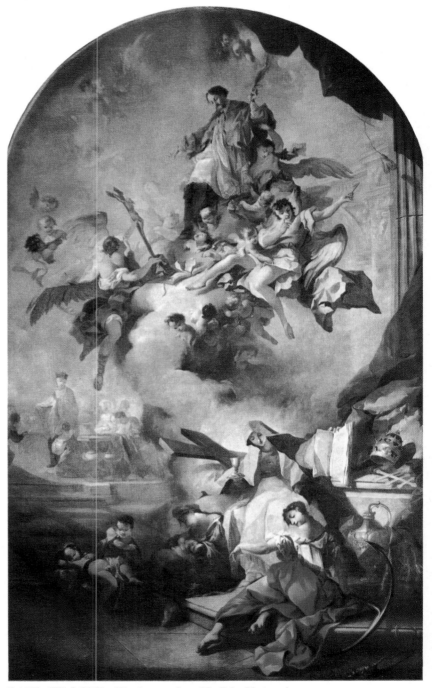

PAUL TROGER The Assumption of St. John Nepomuk, 1750
oil on canvas 212¼ × 137⅞ in.
Vienna, Österreichische Galerie, on loan from the Schottenstift

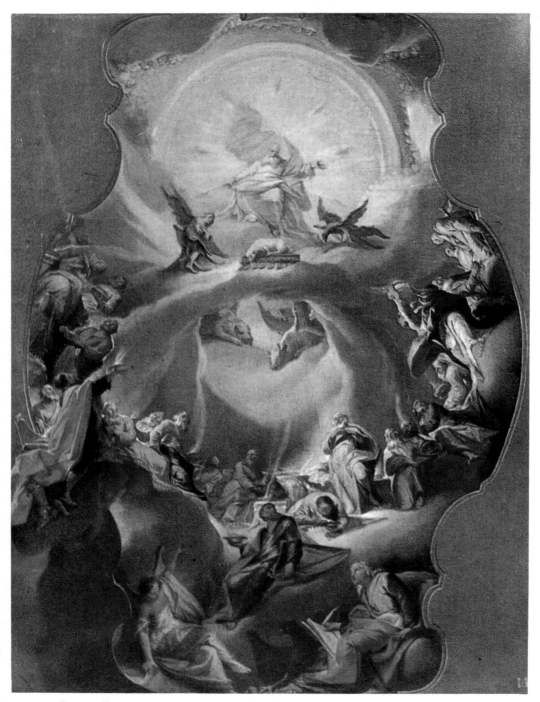

MATTHÄUS GÜNTHER The Adoration of the Lamb (sketch for a ceiling painting) about 1750-60
oil on canvas 34¼ × 25 in.
Augsburg, Städtische Galerie

126

FRANZ ANTON MAULBERTSCH The Victory of St. James over the Saracens (sketch for·a ceiling painting) 1765
oil on cardboard 12¼ × 18⅞ in.
Vienna, Österreichische Galerie

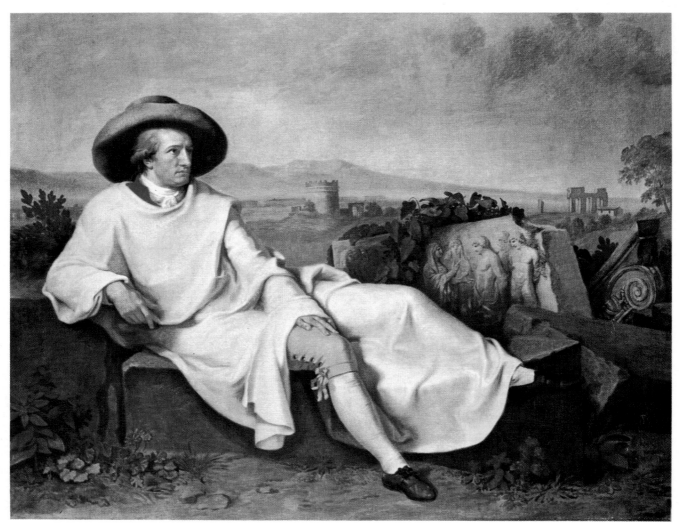

J. H. W. TISCHBEIN Portrait of Goethe in the Campagna, 1787 *oil on canvas $64\frac{5}{8} \times 81\frac{1}{8}$ in.*
Frankfurt-am-Main, Städelsches Kunstinstitut

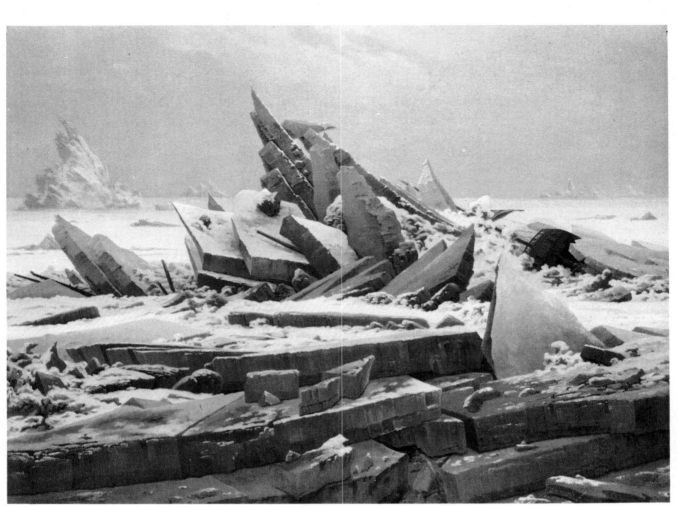

CASPAR DAVID FRIEDRICH Polar Picture with W. E. Parry's "Griper", 1819 (generally known as The Wreck of the Hoffnung) 1824
oil on canvas $38\frac{5}{8} \times 50\frac{3}{8}$ in.
Hamburg, Kunsthalle

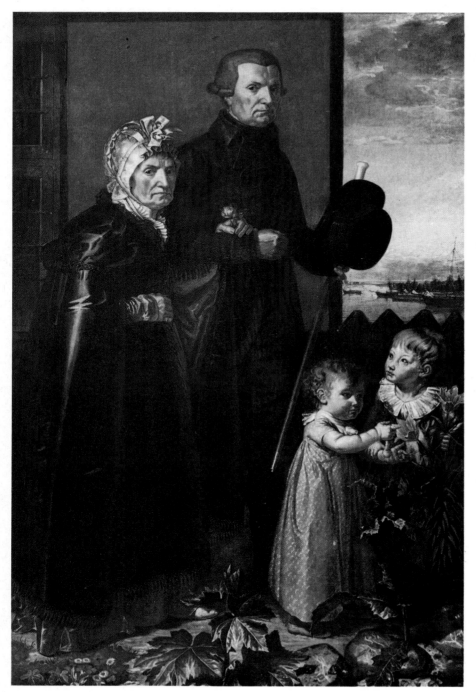

PHILIPP OTTO RUNGE The Parents of the Artist, 1806 *oil on canvas* $76\frac{3}{8} \times 51\frac{1}{2}$ *in.*
Hamburg, Kunsthalle

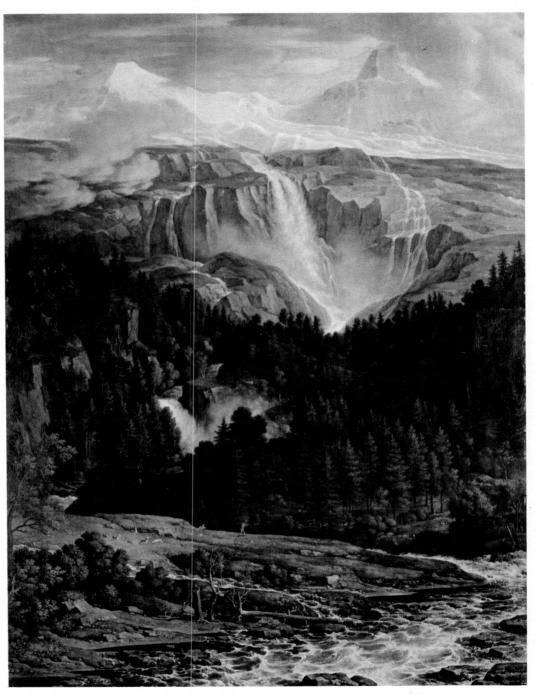

JOSEPH ANTON KOCH The Schmadribach Fall, 1811 *oil on canvas* *48 × 36¾ in.*
Leipzig, Museum of Fine Arts

JULIUS SCHNORR VON CAROLSFELD The Visit of the Family of St. John to the Family of Christ, 1818
oil on canvas 48×40½ in.
Dresden, Gemäldegalerie

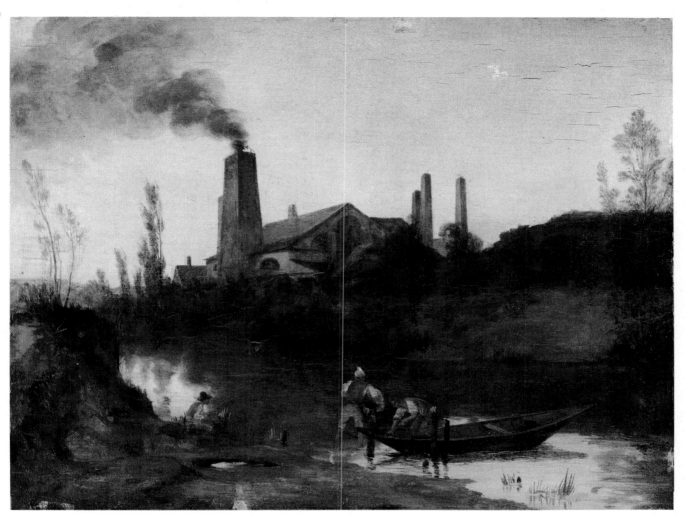

KARL BLECHEN The Ironworks at Eberswalde, about 1834 *oil on panel* $9\frac{1}{8} \times 12\frac{1}{2}$ *in.*
West Berlin, Staatliche Museen

ADOLF VON MENZEL The Room with the Balcony, 1845 *oil on cardboard $22\frac{7}{8} \times 18\frac{1}{4}$ in.*
West Berlin, Staatliche Museen

134

ANSELM FEUERBACH Iphigenia, 1871 *oil on canvas* $75\frac{5}{8} \times 49\frac{1}{2}$ *in.*
Stuttgart, Staatsgalerie

WILHELM LEIBL Three Women in Church, 1881 *oil on panel* $51\frac{3}{8} \times 30\frac{3}{8}$ *in.*
Hamburg, Kunsthalle

SPANISH ART TO 1900

The development of painting in Spain closely paralleled that in the rest of Europe. Whereas Spanish architecture and decorative arts cannot be understood without considering the Moorish influences stemming from the North African invasion of the Iberian Peninsula in 711, these influences had little effect on painting. During the centuries-long Moorish occupation of Spain there was a prohibition on representing the human figure. It was the gradual reconquest of the peninsula by the Christian kingdoms of the north that brought about the expansion of Christian painting, and then its forms were exclusively European.

Early in the 14th century, books illuminated with miniatures by Italian painters were circulating in Spain, and the work of contemporary Sienese and Florentine artists became well known. *The Madonna Enthroned* (p. 145) is pure Sienese in the formal rows of angels with their narrow slanting eyes, but Bassa has simplified and humanized the style. His forms have solidity, and there is movement in their attitudes and emotion in their facial expressions. The result is quite unlike the meticulous, detailed gracefulness of Siena.

Luis Borrassá was influenced by the International Gothic style as it was practiced in Siena, but gave it a very personal interpretation. To the Italian delicacy and attention to detail he added a characteristically Spanish

power of observation, from which lighting, modeling, and even foreshortening came as natural results. This feeling for the observable and natural in an attitude, a facial expression, a fold of drapery, persists through all Spanish painting. In *The Resurrection* (p. 146) he introduces contemporary dress into a biblical scene, a trend which continued throughout the 15th century.

Luis Dalmáu was so impressed by the Flemish painter Jan van Eyck that he persuaded the King of Aragón to send him to Flanders, where he worked for about five years as an apprentice to Van Eyck. The composition of *The Madonna of the Councilors* (p. 147) derives directly from Van Eyck's Ghent Altarpiece, and the facial types, too, are more Flemish than Spanish.

Despite a number of trips to Italy, Jaime Baçó, called Jacomart, was surprisingly untouched by the style of contemporary Italian art. Rather, he adhered to the traditional style of the region of Valencia, where he spent most of his life. *S. Ildefonso and Alfonso de Borja* (p. 148) is typical both of the style and the painter. His figures—of which there is usually only one, or at most two—are arranged on gold backgrounds in stiff, restrained poses. Glittering jewels and lavish brocades are reproduced in painstaking detail. Jacomart was mostly concerned with the smaller compartments of altars. In these compartmental paintings Jacomart's decorative talents evoke a spirit of gentleness and intimacy.

Jaime Huguet was an extremely successful painter in Barcelona, engaged primarily in the painting of altarpieces. *The Adoration of the Magi* (p. 149) was painted for Pedro, the Portuguese pretender to the throne of Aragón, in 1465. The figures are strongly drawn, their movements effectively realistic within the limits imposed by his conventional patrons. The faces appear somewhat insubstantial, overwhelmed by the decorative details of costume and the large amount of glittering gold.

Fernando Gallego was a Castilian painter, active in the provinces of Salamanca and Zamora, who was primarily a creator of altarpieces. Most Castilian painting of the period was influenced by Martin Schongauer, a German whose engravings were widely sold at Castilian fairs. *The Madonna of the Rose* (p. 150) shows a familiarity with Flemish painting as well. These influences, however, were no more than a basis for Gallego's style, which was strong, unstereotyped, and highly realistic. Simplified textures and smooth surfaces, particularly in the intricate patterns of brocade and other decorative detail, are indicative of a preoccupation with forms themselves.

Italian influences

Another Castilian, Pedro Berruguete, is thought to have been a pupil of Gallego's. At any rate he was proficient in the Spanish-Flemish style that Gallego made popular, and learned the technique of oil painting as well as that of tempera. In 1472, Berruguete went to Italy, where he remained for ten years at the court of the Duke of Urbino. Here he gained confidence, and his style acquired a sophisticated Italian overlay. His faces assumed more character and expression, and his figures a greater vitality.

After his return to Spain, the Spanish, Flemish, and Italian elements of Berruguete's work fused with each other into a new, consistent style. In the painting *St. Peter Martyr and the Crucifix* (p. 151) his mastery of architectural perspective, derived from the Flemish, and of facial expressiveness, learned in Italy, gives meaning to his own Spanish realism and love of decorative detail.

Rodrigo de Osona was subject to much the same influences as Berruguete. His masterly drawing and expert handling of the oil medium must have been perfected in Flanders, while the architectural details and strong individualization of the figures are Italianate. *The Madonna with the Montesa Knight* (p. 152) is representative of Osona's mature style, in which the cosmopolitan elements of his training blend with his native background. More delicate and refined than Berruguete's, Osona's sophisticated, narrow figures are almost too elegant. They are very Spanish, however, as are their undertones of sadness and somewhat melancholy reflection.

16th-century painting

An entirely different Italian influence is evident in the work of Hernando Yáñez de la Almedina, in which it overshadows the mixed Flemish style then current in Spain. As a young painter Yáñez went to Florence, where he worked with Leonardo da Vinci and became familiar with contemporary Venetian painting. In *The Adoration of the Shepherds* (p. 153), the inspiration of Leonardo is evident in the modeling of the figures, in the blending of light and shade, and in the faces, particularly that of Mary. The outdoor setting and the touches of everyday country life represent the Spanish side of Yáñez that presents sacred themes in new and different contexts.

Luca Signorelli and Antonio Correggio were the two Italians who made the deepest impression on Pedro

Machuca. *The Deposition* (p. 154) gives evidence of both: from Correggio, the use of deep shadows and the technique of softening and blending the edges of forms; and from Signorelli, the dramatic effect of figures in motion, particularly apparent in the seminude figure in the bottom right corner. The powerful diagonal from upper right to lower left, and the contrast of brilliant colors and stark whites with dark shadow, create a strong sense of drama and movement not usually associated with this subject.

One of the few 16th-century Spanish painters who never went to Italy was Juan de Juanes. However, his father and teacher, Juan Vicente Masip, had once traveled in Italy, and the influence of Raphael and the great Venetian painters is reflected in both the father's and the son's work.

Juanes inherited his father's skill with movement and volumes, as is evident in *The Last Supper* (p. 155). The devotion with which he executed his sacred subjects became proverbial in Valencia, but his piety tended to produce some weakness. The exaggerated gestures, the sometimes unnatural poses, and an air of sentimentality in some of the figures weaken his interpretation of the last supper.

Luis de Morales was born and lived all his life in the region of Estramadura, where he evolved an emotional style quite separate from the mainstream of Spanish art. He evidently found his early inspiration in Flemish painting. His output was huge but restricted to a handful of traditional subjects that he repeated over and over in the hope each time of intensifying their significance. The expressions, gestures, and details began to be overdone and to convey only a facile melancholy sentiment. A picture such as *The Madonna and Child* (p. 156), one of many versions of this subject, was immensely popular with ordinary people, and much imitated, to the detriment of his reputation.

El Greco, c. 1541–1614

It was a Greek, not a Spaniard, who gave the most powerful expression to the Spanish temperament and the spirit of the Counter-Reformation. El Greco was born Domenikos Theotokopoulos in Crete, at that time a Venetian possession. His first painting lessons were with the Cretan monks, who taught him to make icons in the flat, mystical manner they had inherited from Byzantium. This mysticism became the basis of his style, reaching its fullest expression in his painting in Spain.

When El Greco left Crete at about 19 for Venice, he was already an accomplished painter, but he apprenticed himself to the greatest painters of the day, first in the studio of Jacopo Bassano, then to Tintoretto and Titian. After Venice he went to Rome, where the posthumous influence of Michelangelo was still at its height. By the time he left Italy for Spain in 1572, he had studied and absorbed the most significant traditions of the Italian High Renaissance. From this background he developed his highly Manneristic, totally personal style.

One of the first commissions El Greco received after he had settled in Toledo was for an altarpiece for the church attached to the convent of San Domingo El Antiguo. *The Holy Trinity* (p. 157), now in the Prado in Madrid, is based on an engraving by Dürer, very freely adapted. The movement and color in this painting are still close to the Venetian school, as is the realistic figure of Christ.

The Martyrdom of St. Maurice and the Theban Legion was painted on commission as part of the decorations of Philip II's Escorial. The massacre of a legion of Egyptian Christians by the Romans forms part of the background of the picture. The quiet discussion between St. Maurice and the Roman captains, shown in the detail on p. 158, is the focal point of the painting—a discussion that is carried on with restrained and sober gestures. It is far from being an orthodox treatment of the theme of martyrdom, and whether it was for this or for some other reason, Philip II disliked the painting. It was finally hung in an obscure corner of the Escorial rather than over the altar for which it was intended.

The story portrayed in *The Burial of Count Orgaz* (p. 159) is a miracle that occurred two and a half centuries earlier. At the burial of the Count, a very devout man, St. Stephen and St. Augustine were reputed to have descended from heaven and themselves lowered the body into its tomb in the presence of the assembled nobles. The nobles are portraits of El Greco's contemporaries, and their black dress with white ruffs was the fashion in Spain in the 16th and 17th centuries. The only note of color in the earthly scene is in the raiment of the two saints. In the heavenly scene above, these colors are echoed and transformed into a lighter, more luminous harmony. In like manner the quiet, sober atmosphere of the burial is contrasted with the great swirling movements above as the angel at Mary's feet bears the soul, newborn to the afterlife, upward toward Christ the Judge in the far background.

The character of Don Fernando Niño de Guevara, as revealed in El Greco's portrait of him (p. 160), has been interpreted in several ways. Knowing it to be a portrait of the Grand Inquisitor of Spain, the man responsible for the horrors of the Inquisition, we find it easy to read into this face an inhuman cruelty and a total absence of personal feeling. But it can be argued that the contrast between the right and the left half of the figure, its unstable position on the edge of the chair, and its placement at the point where wall and door meet are all indicative of inner conflict and insecurity. The right hand is relaxed, the left grips the arm of the chair, and even the folds of the robe fall less quietly on the left than the right. Whatever one chooses to read into the portrait, it is inescapably that of a formidable man, of energy held under iron control.

The Laocoön (p. 161) is based on the story in the *Aeneid* in which the Trojan priest Laocoön and his two sons are destroyed by serpents, sent by the gods, for having warned the Trojans about the wooden horse. In El Greco's interpretation of this mythological theme the two punishing gods, Apollo and Artemis, stand at the side while each of the three figures struggles to resolve his own spiritual conflicts without regard for the others. The small flat heads and extremely attenuated bodies are typical of El Greco's later painting, where they are particularly found in the figures of angels in religious subjects. The style had its roots in Italian Mannerism, but in El Greco's hands it lost its artificial elegance and became a very personal expression of his mystical visions.

The political domination of the Italian peninsula by the Spanish had begun in the Middle Ages and long continued, especially in the south, where for centuries the Kingdom of Naples remained closely linked with Spain. So it is difficult to decide whether a painter like José de Ribera, who left Spain as a very young man and spent most of the rest of his life in Naples, should be regarded as a Spaniard working in Italy or a Spanish-born Italian whose works are almost indistinguishable from those of his Spanish contemporaries.

The predominant Italian influence on Ribera's painting was that of Caravaggio and his followers—an influence that was particularly strong around Naples, where it lasted much longer than elsewhere in Italy. Ribera's paintings, like Caravaggio's, are made up of contrasts of intense light and deep shadow (pp. 162, 163, 164).

Ribera's Spanish heritage is revealed in such paintings as *The Holy Trinity* (p. 163), in the detailed intensity with which the tangible world is depicted, and in the equally tangible and naturalistic representation of the supernatural world. Unlike Caravaggio's colors, which are revealed in intensely lighted areas, Ribera's palette is somber, consisting of the earth colors—dull yellow, browns, olive greens, brownish reds, and black. These were the colors customarily used by most Spanish artists during the 16th and 17th centuries.

Diego Velázquez, 1599–1660

Like so many of his contemporaries, Diego Velázquez was impressed by Italian paintings, particularly those of Caravaggio, which were beginning to reach Seville when Velázquez was a student. The *Old Woman Frying Eggs* (p. 165), painted when he was 19, is evidence of the strong impression Caravaggio made on the young artist. This painting is a genre study of a type known as *bodegón*, very popular in Spain; it portrays kitchen subjects involving food and cooking utensils.

In 1623, Velázquez became both court painter to and a lifelong friend of Philip IV. In this position he made a number of expeditions to purchase paintings for the royal collection, and had various other responsibilities that had nothing to do with his profession as a painter.

As an artist he was called upon for portraits, historical pictures, and paintings of the elegant and sophisticated Spanish court life. These paintings were carried out with an impersonal, factual realism that was the complete antithesis of the mystical idealism of El Greco. Velázquez regarded his subjects with imperturbable objectivity, and any personal reactions he may have had to them are never allowed to surface. Velázquez has been called a "painters' painter" because of his unerring choice of the exact equivalents in paint of the colors and textures of the physical objects he was portraying.

That Velázquez's painting goes far beyond mere photography is evident in the group portrait called *The Maids of Honor* (p. 167). The illusion of actuality is achieved by re-creating the scene from the observer's point of view. The figures in the foreground are sharply defined, the two figures in the middle ground on the right are a little blurred, and the rear wall with the figure in the doorway is still less defined. Least distinct of all are the figures of the entering king and queen, who are shown only as reflections in the mirror on the back wall.

Again in *The Surrender of Breda* (p. 166), as the eye focuses on the central figures, those behind are less distinct. Color, too, is changed by distance and atmosphere. The

strongest colors and contrasts are in the foreground, while those further back gradually merge into the neutral color of the far distance.

As a translation of physical reality onto a flat painted surface, the portrait of *Pope Innocent X* (p. 168) is without peer. The man is a living, breathing, physical presence. The resemblance to El Greco's *Don Fernando de Guevara* (p. 160) is unmistakable evidence of Velázquez's admiration for the older painter. The similarity is not confined to color and pose alone, for Pope Innocent betrays a character that belies his name.

The female nude occurs very rarely as a subject in Spanish art. This was only partly on account of religious objections; more important was the absence of a prosperous middle-class market for such pictures. The Spanish artist relied almost completely on the patronage of the Church and the court.

It was Velázquez's study of the Venetians, in particular of Titian, that led to the painting of *The Toilet of Venus* (p. 169). Evidence of his study of Titian's work is seen in the softened outlines of the figure, the generalized lighting, and a lighter palette. This is probably the most famous of Velázquez's paintings, perhaps because the slim, svelte figure conforms so closely to present-day standards of feminine beauty. But compared with Titian's nudes, this Venus is curiously matter-of-fact and unexciting.

Other 17th-century painters

When Velázquez visited Italy in 1630 and again in 1649 he took back with him a number of both Caravaggio's and Ribera's paintings for the royal collections of Philip IV. Although Francisco de Zurbarán never went to Italy, he came to know the paintings that had been brought to Spain, and their influence on his style was profound and enduring.

Zurbarán's early paintings were almost all single figures or small groups of figures in solemn and natural attitudes. Their features were often those of peasants, and his female saints were portraits of young ladies of Seville. *The Death of St. Bonaventura* (p. 170) is reminiscent of Caravaggio in its lighting and deep, impenetrable shadows, and Spanish in its detailed realism and subdued coloring.

The lighting of *The Immaculate Conception* (p. 171) and *The Annunciation* (p. 172) is warmer and the figures are more idealized, but the simplicity of composition and clarity of outline remain consistent throughout Zurba-

rán's painting. The last two pictures became part of a collection of his works formed by King Louis Philippe of France, and became well known thoughout Europe.

Of other 17th-century Spanish painters only a few are worth mention. Alonso Cano was a contemporary of Zurbarán and Velázquez, and was known as a sculptor and an architect as well as a painter. It was perhaps because of this diffusion of energy that Cano failed to mature along the lines of his early promise. *The Immaculate Conception* (p. 173) is typical of Cano's later style, straightforward and understandable. The coloring is more Venetian than Spanish, probably owing to his study of Titian and the great Venetian colorists.

Bartolomé Esteban Murillo was a Sevillian painter, born about the time Velázquez and Zurbarán were finishing their apprenticeships. The gentle, temperate nature of the man is revealed in his paintings, the best of them having considerable charm. From Ribera's pictures he learned to give his subjects body by means of light and shadow, but his forms have none of the starkness of Zurbarán or Ribera. Murillo painted the urchins, peddlers, and young girls of Seville with great realism (p. 174). His coloring, inspired by the Flemish and Venetian colorists, is delicate and subtle.

Murillo and his workshop produced a tremendous number of devotional pictures that found a ready foreign market, especially in 18th-century England. The facile sentimentality of many of these mass-produced paintings has unjustifiably tarnished Murillo's reputation. At their best, as in *The Dream of the Patrician* (p. 175), his work shows a harmony of composition and draftsmanship, a subtlety of color, and a devout serenity that place him in the front rank of Spanish artists.

Juan de Valdés Leal, another Andalusian painter, was active in Seville in the second half of the 17th century. He was a man of extraordinary energy and erratic character with a taste for the dramatic, the violent, and the macabre. The results of his study of Flemish paintings, especially those of Rubens and Van Dyck, are apparent in his *Temptation of St. Jerome* (p. 176). The color, light, and movement produce a realism that reflects not only the influence of Flemish painting but his own excitable personality as well. Upon the death of Murillo in 1682, Valdés became the most esteemed painter in Seville.

Claudio Coello was born in Madrid, and a great deal of his painting was done there. He was known as a fresco painter, and some of his earlier works were executed in this medium. Later, as court painter to Charles II, he

painted in oil for the Escorial. Coello's was a talent at ease only in huge, complicated compositions such as *The Madonna and Child and the Theological Virtues* (p. 177). Here his sense of balance, space, and movement show to the best advantage.

During the 18th century, Madrid became the center of a brilliant school of painters among whom was Luis Egidio Meléndez. A prolific painter, he produced some effective portraits, but most of his paintings were still-lifes of fruit, vegetables, and all the paraphernalia of the kitchen. Like the *Still-life* on page 178, these paintings are executed with extreme precision and a naturalism so flawless that they escape coldness only by virtue of the warm colors and swelling volumes of the objects. It is not surprising that Meléndez was also a miniaturist and made paintings in choir books for the Royal Chapel for Ferdinand VI.

Francisco Goya, 1746–1828

By far the most outstanding painter of the late 18th and early 19th centuries was Francisco de Goya y Lucientes, the third of Spain's greatest painters. His two predecessors, El Greco and Velázquez, had shown to the world the spiritual and material sides of the Spanish temperament. It was Goya who revealed its dark and rebellious pessimism.

Goya's early years were spent in Saragossa, where his family lived, except for two trips to Madrid and a working trip to Italy. When he was 29, he settled in Madrid and was offered a position as tapestry designer in the royal workshop. In this capacity he produced 60 paintings of various aspects of Madrid life in the light, uncomplicated style of *The Parasol* (p. 179).

This period, which lasted until he was 46, was also a time of intensive study of the palace collections of Italian, Flemish, and Spanish paintings. In addition, during this period two Italian painters, Giovanni Battista Tiepolo and Luca Giordano, were at work on the palace frescoes, and they made a deep impression on Goya.

At the accession of Charles IV to the throne, Goya was appointed court painter and began a long series of portraits whose subjects ranged from the aristocrats of the court to his own close friends, one of whom was Don Juan Bautista de Muguiro (p. 183). As a portraitist, he was in great demand by Madrid society. He painted numbers of full-length portraits of fashionable ladies like the *Countess del Carpio* (p. 180), in which he gave rather more attention to the details of their costume than to the interpretation of their characters.

Neither Goya's tapestry designs nor his society portraits reveal the stubborn independence and rebellious nature that he kept under control. In fact, Goya was unhappy with his situation despite its financial returns, and when he was instructed to paint Charles IV with his family he did so with passionate and unrestrained realism (p. 181). The splendor of their dress and the glitter of jewels and decorations are faithfully recorded, while their faces betray a vacuity and lack of character so appalling that it led the French novelist Théophile Gautier to observe that they looked like the "corner baker and his wife after they won the lottery." That this unsparing portrait was accepted by the royal family without demur is indicative of the depth of their fatuity.

In works resulting from the Napoleonic occupation of Spain, and the subsequent popular war of independence, Goya provided a devastating indictment of the brutalities and atrocities men are led to commit in warfare. *The Second of May 1808* (p. 182) is a picture of the chaos and bloodshed of the day the war of independence started.

One of Goya's last drawings before his death in 1828 was called *I Am Still Learning*. Even at the age of 82 his creative energy and zest for living were undulled.

The only Spanish painter worth mentioning in the rest of the 19th century is Eduardo Rosales. Rather surprisingly, the power of observation and concern for everyday surroundings that characterizes Spanish art did not extend to landscape. Most painters dealt with it in a cursory manner and Rosales is one of the few who painted landscape for its own sake. Most of his pictures, however, were huge canvases on subjects such as that of *The Death of Lucretia* (p. 184), suitable for the adornment of public buildings.

Except for Rosales, Spanish painting in the 19th century was at a low ebb. But the 20th century has seen a generation of Spanish artists making valuable contributions to a new kind of art.

List of Color Plates

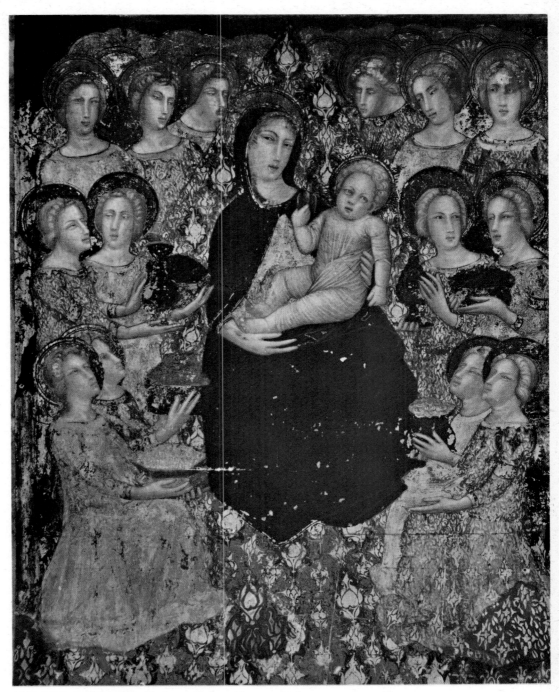

FERRER BASSA The Madonna Enthroned, 1345-46 *fresco secco* 50 × 39¾ *in.*
Pedralbes, Spain, Convent of the Nuns of the Order of St. Clare, St. Michael's Chapel

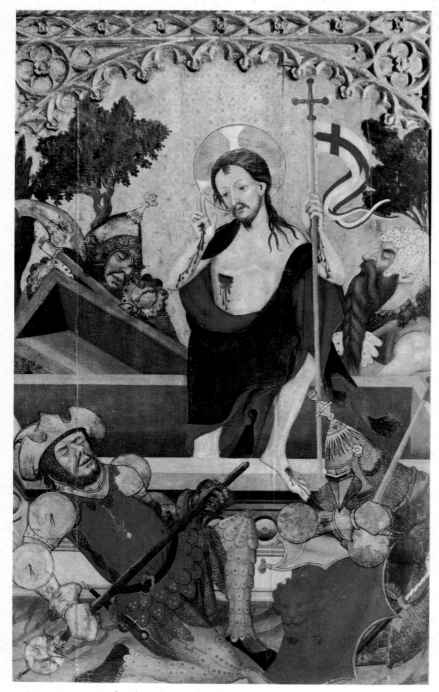

LUIS BORRASSÁ The Resurrection (detail): from the Altar of St. Creus, before 1414
tempera on panel
Barcelona, Museum of Catalan Art

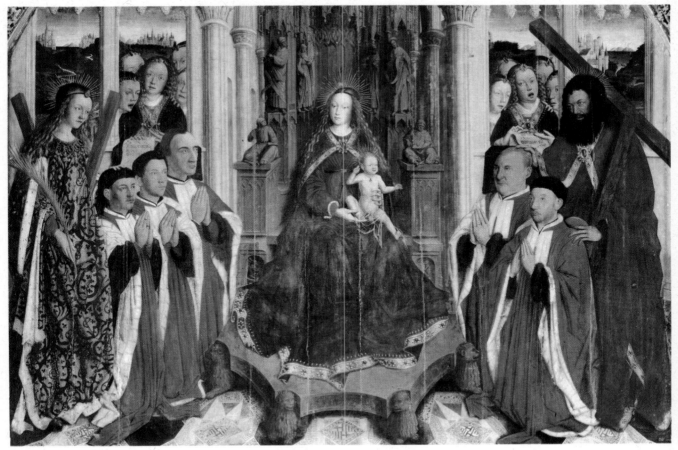

LUIS DALMÁU The Madonna of the Councilors, 1443-45 *tempera and oil on panel*
Barcelona, Museum of Catalan Art

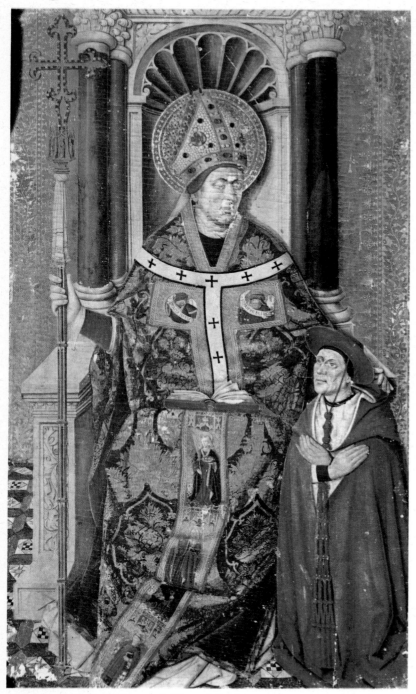

JACOMART S. Ildefonso and Alfonso de Borja, 1451-55 *tempera on panel*
Valencia, College of Játiva

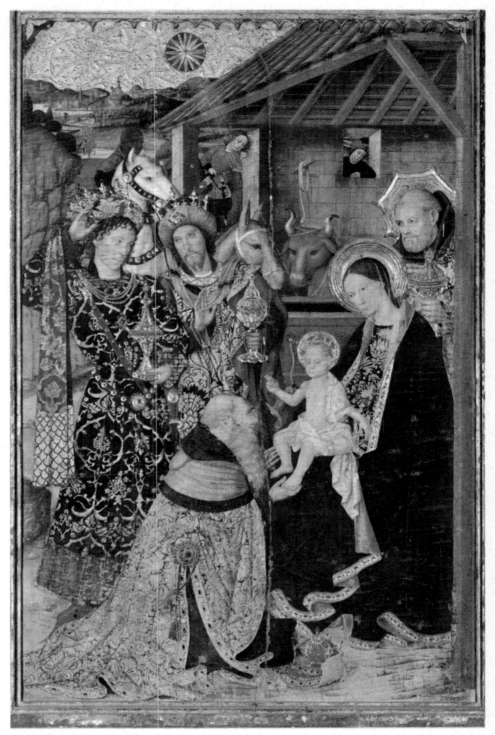

JAIME HUGUET The Adoration of the Magi: from the Altar of the Condestable of Portugal
about 1465 *tempera on panel* $61\frac{3}{4} \times 39\frac{3}{8}$ *in.*
Barcelona, S. Agueda

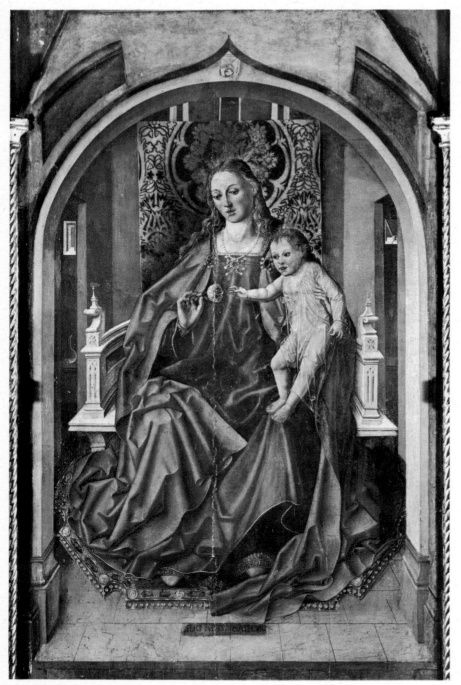

FERNANDO GALLEGO The Madonna of the Rose, about 1475 *oil on panel 46⅛ × 27 in.*
Salamanca, Museo Diocesano

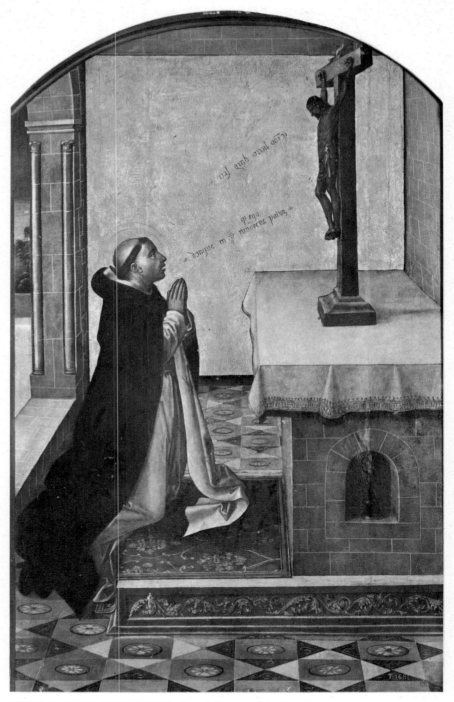

PEDRO BERRUGUETE St. Peter Martyr and the Crucifix, about 1500
oil on panel 51⅜ × 33⅞ *in.*
Madrid, Prado

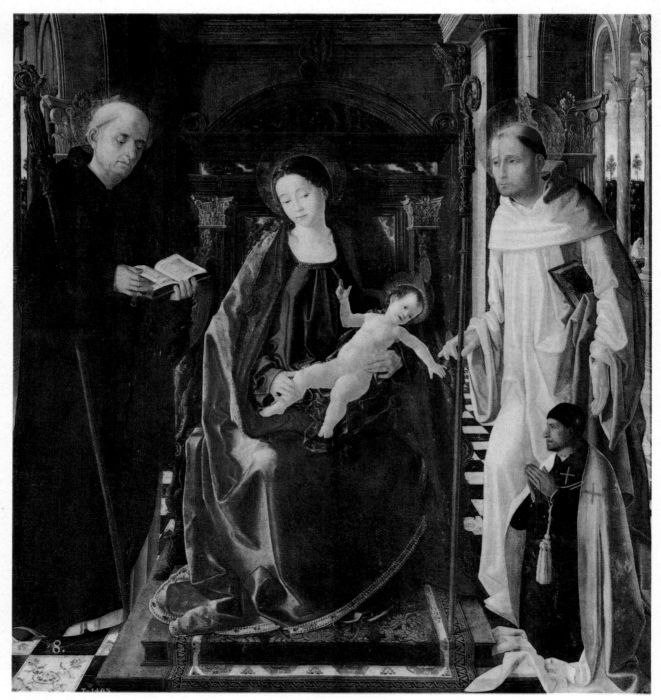

RODRIGO DE OSONA The Madonna with the Montesa Knight, 1476-84 *oil on panel* $40\frac{1}{8} \times 37\frac{3}{4}$ *in.*
Madrid, Prado

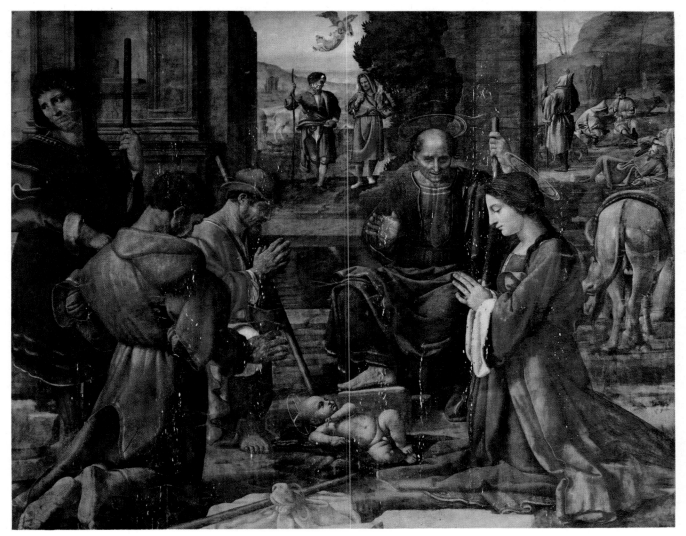

HERNANDO YAÑEZ DE LA ALMEDINA The Adoration of the Shepherds, 1507 *oil on panel* *76⅜ × 89⅜ in.*
Valencia, Cathedral

PEDRO MACHUCA The Deposition, after 1520 *oil on panel* $55\frac{1}{2} \times 50\frac{3}{8}$ *in.*
Madrid, Prado

154

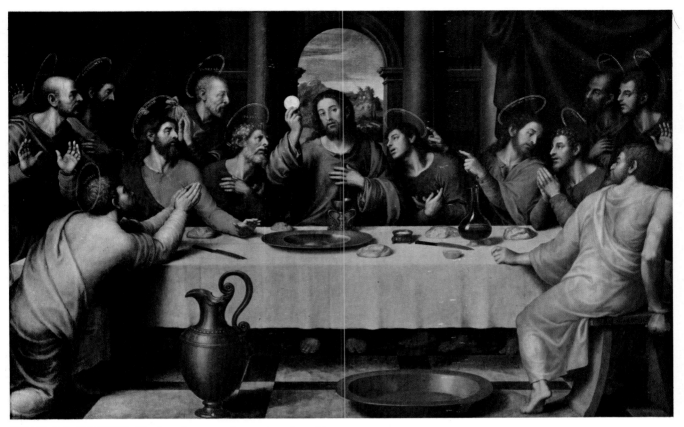

JUAN DE JUANES The Last Supper *oil on panel* $45\frac{5}{8} \times 75\frac{1}{4}$ *in.*
Madrid, Prado

LUIS DE MORALES The Madonna and Child *oil on panel* *33⅜ × 25¼ in.*
Madrid, Prado

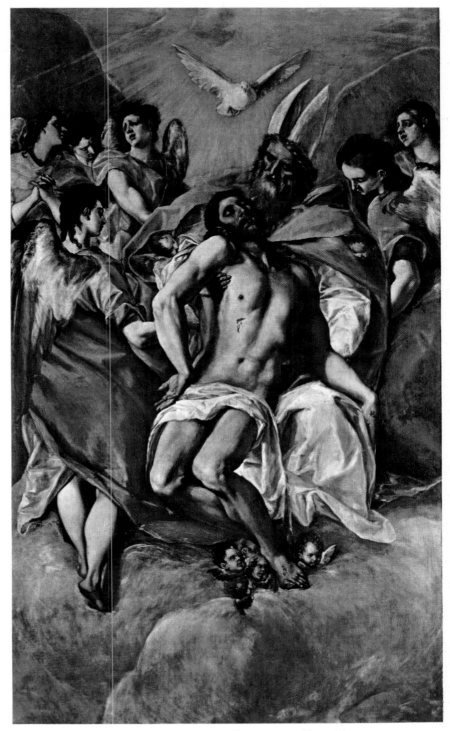

EL GRECO The Holy Trinity, 1577-79 *oil on canvas* *118⅛ × 70½ in.*
Madrid, Prado

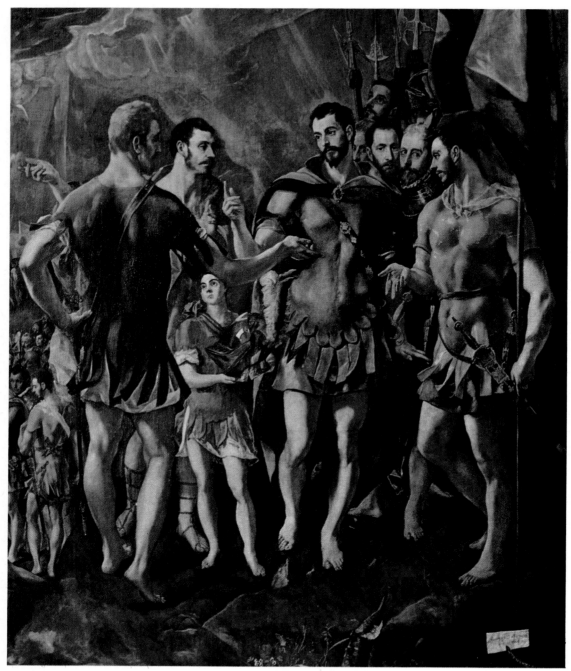

EL GRECO The Martyrdom of St. Maurice and the Theban Legion (detail), 1580-82 *oil on canvas 176⅜ × 118¼ in.*
near Madrid, The Escorial

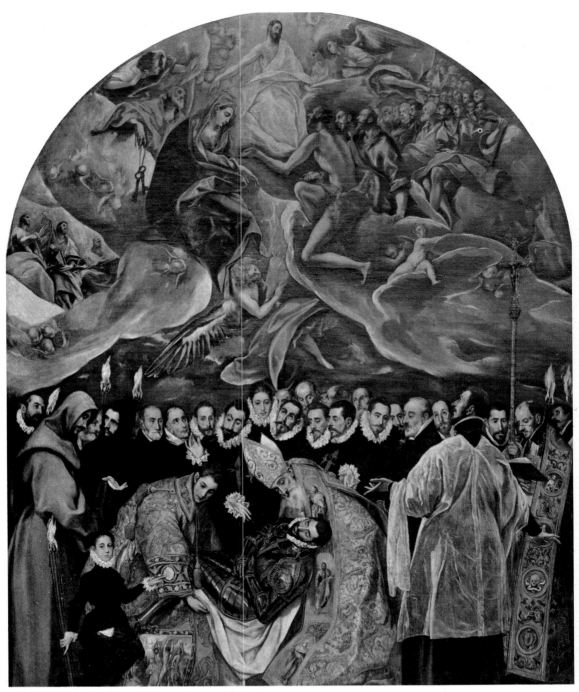

EL GRECO The Burial of Count Orgaz, 1586-88 *oil on canvas* $191\frac{7}{8} \times 141\frac{3}{4}$ *in.*
Toledo, S. Tomé

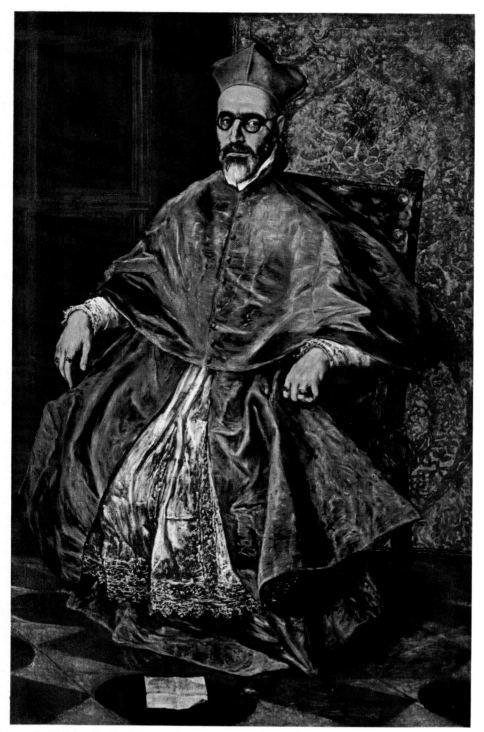

EL GRECO Cardinal Don Fernando Nino de Guevara, about 1600 *oil on canvas* $67\frac{1}{4} \times 42\frac{1}{2}$ *in.*
New York, Metropolitan Museum of Art

160

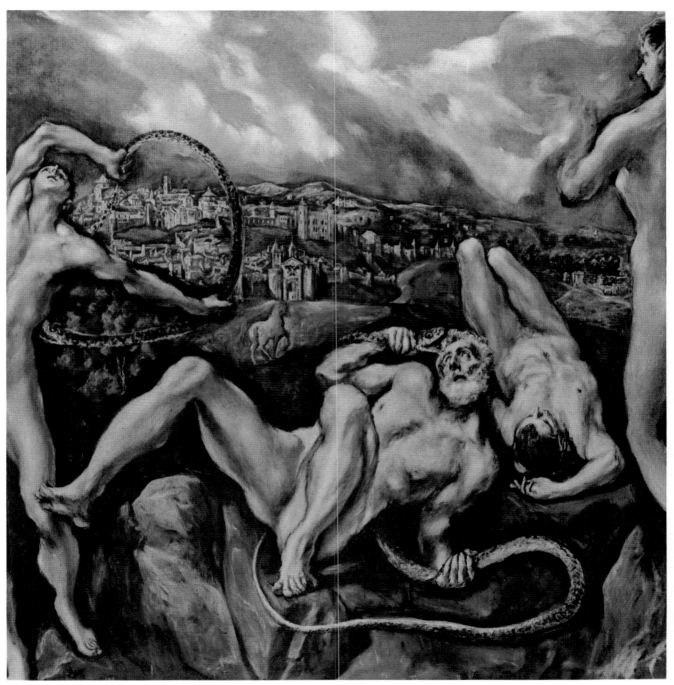

EL GRECO Laocoön (detail), about 1610-1614 *oil on canvas* $55\frac{7}{8} \times 76$ *in.*
Washington, D. C., National Gallery of Art, Kress Collection

JOSÉ DE RIBERA The Martyrdom of St. Bartholomew, 1630 (?) *oil on canvas* $92\frac{1}{8} \times 92\frac{1}{8}$ *in.*
Madrid, Prado

JOSÉ DE RIBERA The Holy Trinity, 1636 *oil on canvas* *89 × 71¼ in.*
Madrid, Prado

JOSÉ DE RIBERA St. Agnes in Prison, 1641 *oil on canvas* *79½ × 59⅞ in.*
Dresden, Gemäldegalerie

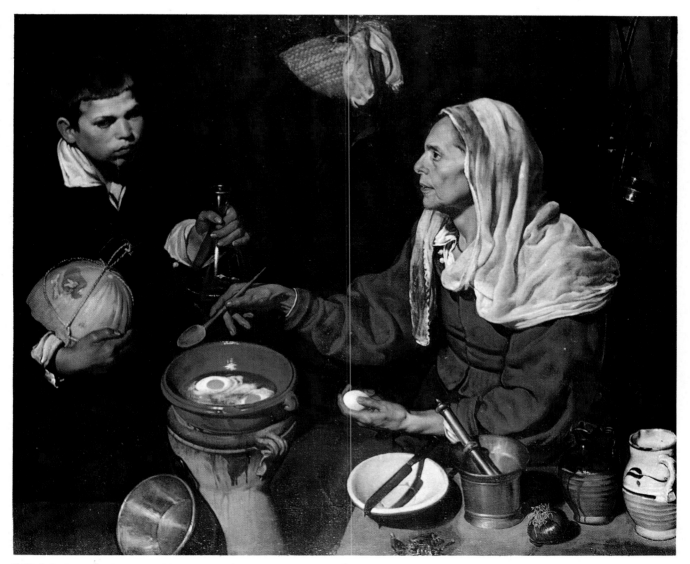

DIEGO VELÁZQUEZ Old Woman Frying Eggs, about 1618 *oil on canvas 39 × 46 in.*
Edinburgh, National Gallery of Scotland

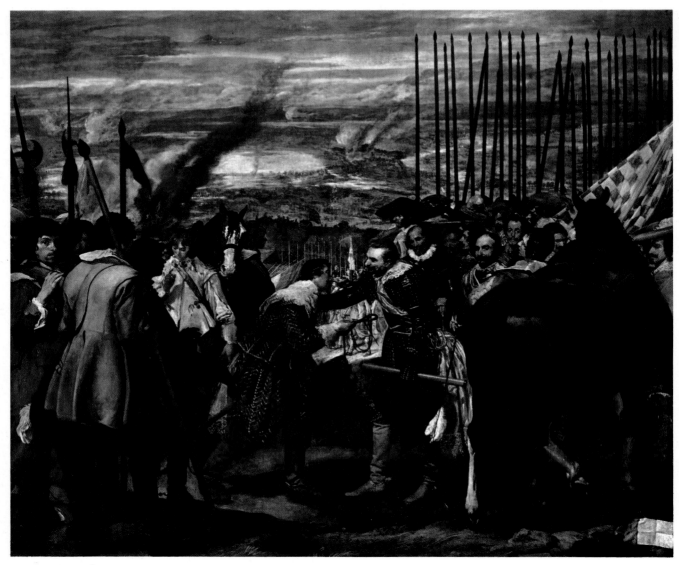

DIEGO VELÁZQUEZ The Surrender of Breda, 1635 *oil on canvas* *121⅛ × 144¾ in.*
Madrid, Prado

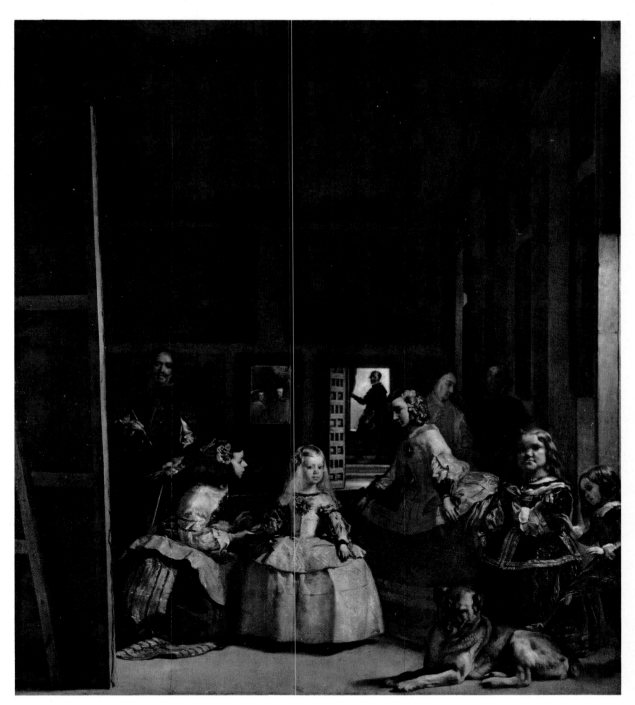

DIEGO VELÁZQUEZ The Maids of Honor, about 1656 *oil on canvas 125¼ × 108⅞ in.*
Madrid, Prado

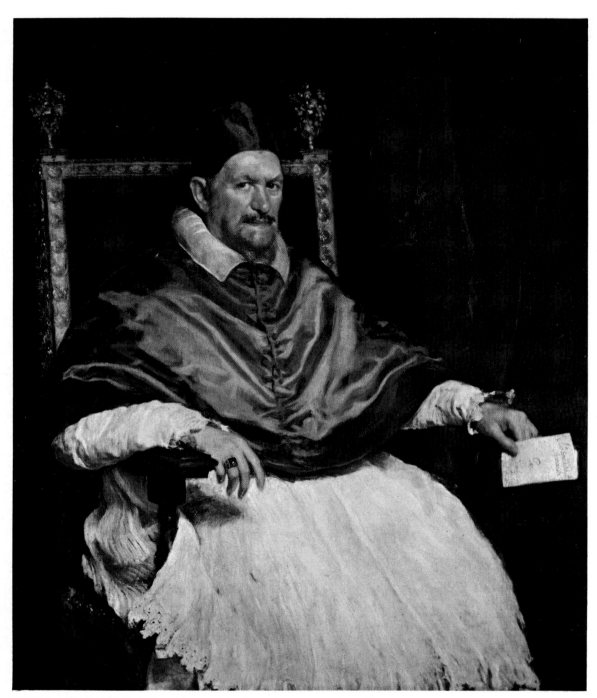

DIEGO VELÁZQUEZ Pope Innocent X, 1650 *oil on canvas* 55⅛ × 47¼ *in.*
Rome, Doria Pamphili Palace

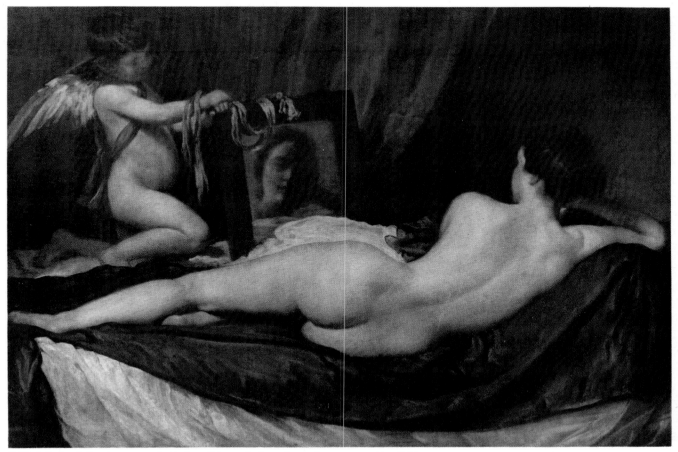

DIEGO VELÁZQUEZ The Toilet of Venus, before 1651 *oil on canvas* *48¼ × 68⅜ in.*
London, National Gallery

169

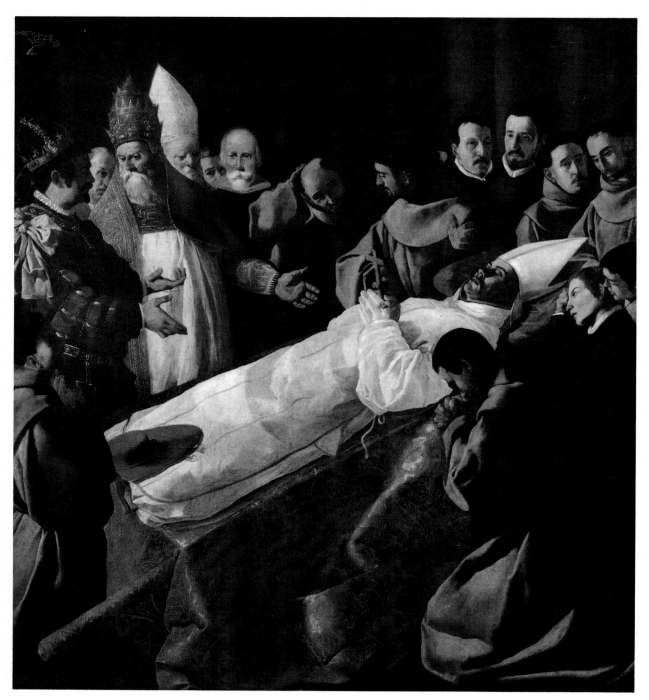

FRANCISCO DE ZURBARÁN The Death of S. Bonaventura, about 1629 *oil on canvas* $98\frac{3}{8} \times 88\frac{5}{8}$ *in.*
Paris, Louvre

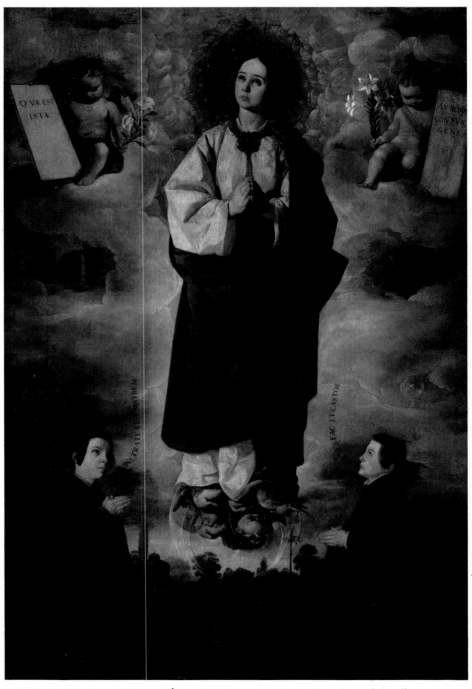

FRANCISCO DE ZURBARÁN The Immaculate Conception, about 1632 *oil on canvas*
Barcelona, Museum of Catalan Art

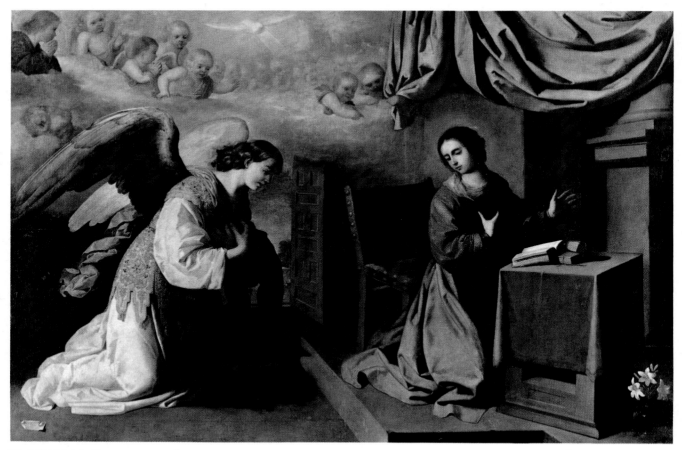

FRANCISCO DE ZURBARÁN The Annunciation, about 1658 *oil on canvas* $83\frac{3}{4} \times 123\frac{1}{2}$ *in.*
Philadelphia, Pa., Museum of Art, Wilstach Collection

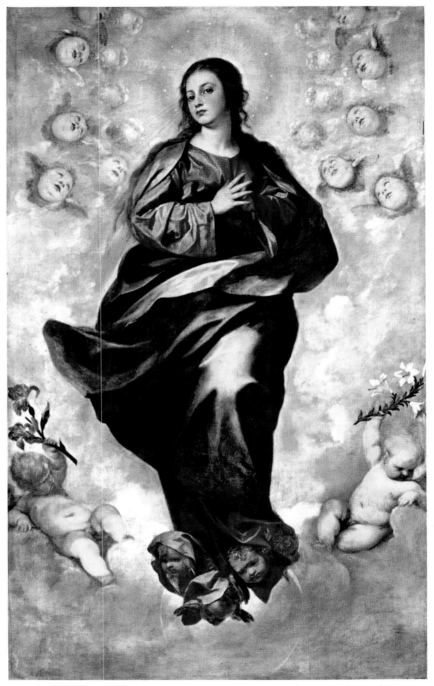

ALONSO CANO The Immaculate Conception, 1650 *oil on canvas* *72 × 44¼ in.*
Vitoria, Spain, Museo Provincial de Bellas Artes

173

BARTOLOMÉ ESTEBAN MURILLO A Girl and her Duenna, about 1665-75 *oil on canvas* *49⅝ × 41¾ in.*
Washington, D. C., National Gallery of Art, Widener Collection

BARTOLOMÉ ESTEBAN MURILLO The Dream of the Patrician: from The Foundation of S. Maria Maggiore, about 1665
oil on canvas 91⅜ × 205¼ in.
Madrid, Prado

JUAN DE VALDÉS LEAL The Temptation of St. Jerome, 1657 *oil on canvas* $87\frac{3}{8} \times 97\frac{1}{4}$ *in.*
Seville, Museo Provincial de Bellas Artes

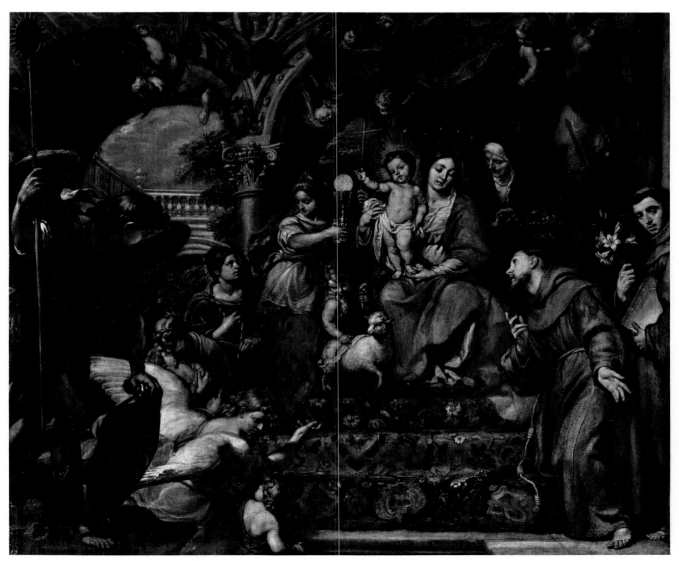

CLAUDIO COELLO The Madonna and Child and the Theological Virtues, 1669 *oil on canvas $91\frac{3}{8} \times 107\frac{7}{8}$ in.*
Madrid, Prado

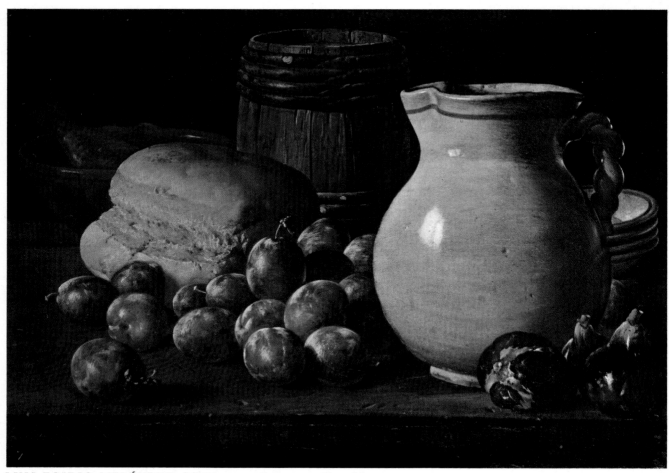

LUIS EGIDIO MELÉNDEZ Still-life, 1772 *oil on canvas* *$16\frac{1}{2} \times 24\frac{3}{8}$ in.*
Madrid, Prado

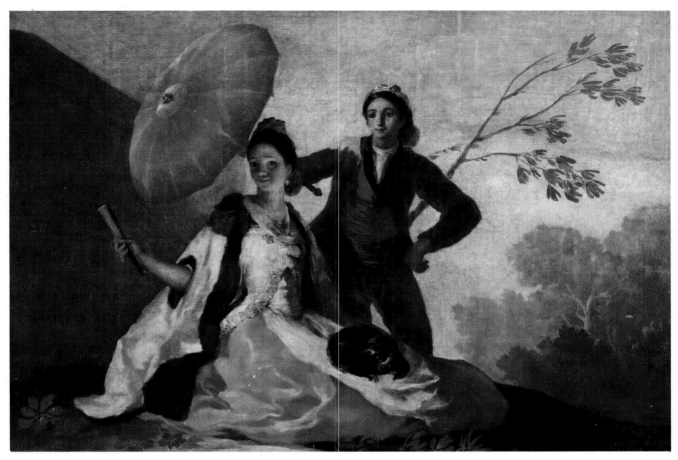

FRANCISCO GOYA The Parasol, 1777 *oil on canvas 41 × 60 in.*
Madrid, Prado

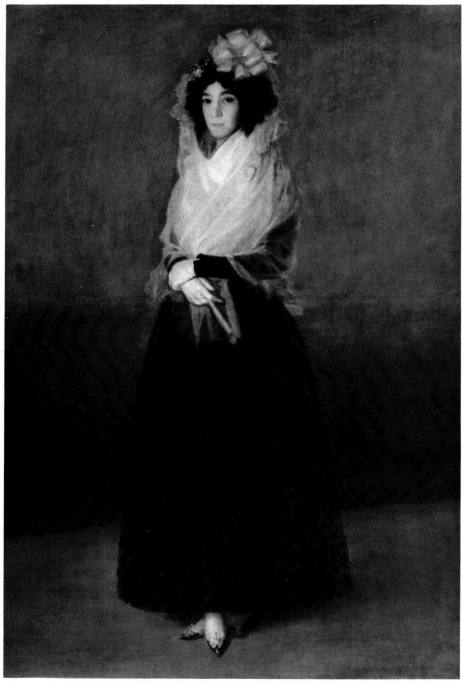

FRANCISCO GOYA The Countess del Carpio, Marchioness of Solana, 1791-95
oil on canvas *72 × 48¾ in.*
Paris, Louvre, De Besteigui Collection

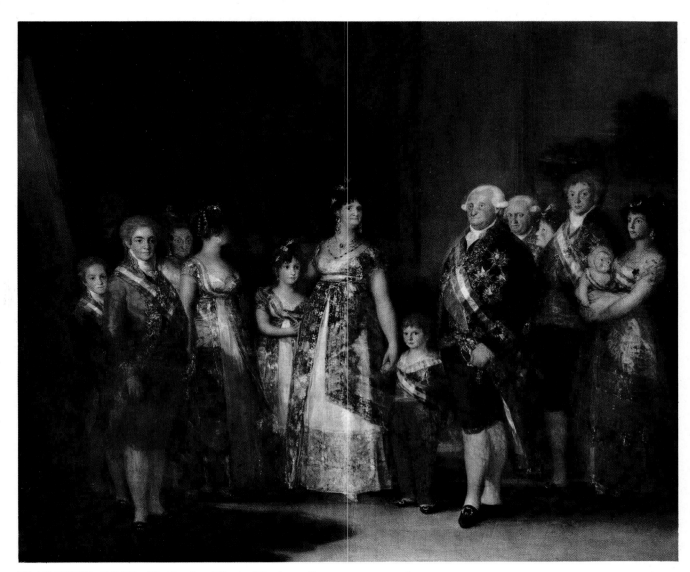

FRANCISCO GOYA The Family of Charles IV, 1800 *oil on canvas 110 × 132 in.*
Madrid, Prado

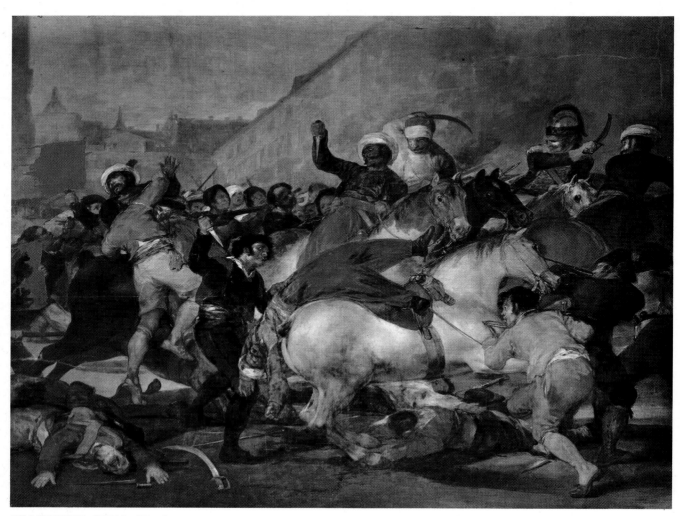

FRANCISCO GOYA The Second of May, 1808 painted 1814 *oil on canvas 105 × 136 in.*
Madrid, Prado

FRANCISCO GOYA Don Juan Bautista de Muguiro, 1827 *oil on canvas* $40\frac{1}{2} \times 33\frac{1}{8}$ *in.*
Madrid, Prado

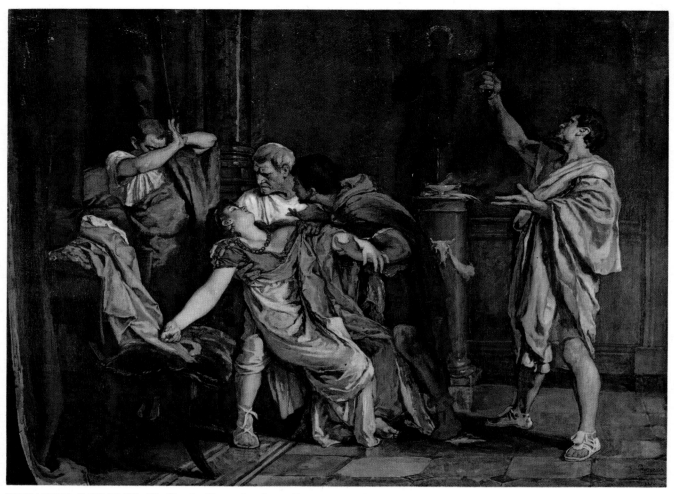

EDUARDO ROSALES The Death of Lucretia, 1871 *oil on canvas* *$100\frac{3}{8} \times 134\frac{5}{8}$ in.*
Madrid, Museo Nacional de Arte Moderno

184

FRENCH ART
FROM 1350 TO 1850

After the mural paintings of the Romanesque period and the stained-glass windows of the Gothic cathedrals, the first notable expression of French pictorial art appeared in the paintings of the manuscript illuminators of the 13th and 14th centuries. In the mid-14th century a number of Flemish artists came to work in France, and their naturalistic tendencies combined fruitfully with French Gothic traditions. The International Gothic style, with its mixture of fantasy and everyday reality, predominated in the first half of the 15th century. The style attained great elegance in the work of the miniaturists, particularly of the Limbourg brothers, illuminators of the *Très Riches Heures du Duc de Berri* (p. 197).

Henri Bellechose was a Flemish painter, and another of the many miniaturists attached to the courts of the dukes of Burgundy. He was also known as a painter of large altarpieces. One of his few existing works, *The Communion and Martyrdom of St. Denis* (p. 200), successfully combines the elegance of the International Gothic with Flemish realism and detail.

During the first half of the 15th century while their activities were confined by the Hundred Years' War with England, French painters continued to exploit the formulas of International Gothic uninfluenced by the rapid advances taking place in Italian and Flemish art.

The artistic revival of the second half of the 15th cen-

tury first showed itself in Provence, in what has come to be known as the School of Avignon. Here a group of artists from all parts of France and Flanders exchanged ideas, many of them enriched by contact with the artistic centers of Italy.

The School of Avignon

One of the first paintings of the Avignon School was *The Aix Annunciation* (p. 203), which shows a strong Flemish influence in its realism and detail.

Enguerrand Quarton's *Coronation of the Virgin* (p. 198) combines an imaginative and decorative design with a high degree of realism in the rendering of details.

The Avignon *Pietà* (p. 199) is the most important single painting of the Provençal school. The restrained intensity of grief expressed by the three mourning figures, and the monumental effect created by the formal design, have an emotional power that is the equal of an Italian painting of the same period. The Avignon *Pietà* is one of the last expressions of the idealism of the Middle Ages. In the declining years of the medieval period the concerns of everyday life and the individual assumed greater importance and religious painting lost much of its spiritual vitality.

Other 15th-century painters

The paintings of Jean Fouquet of Tours reflect the changing attitude of the times. He is known to have been in Rome shortly before 1450 and to have become familiar with contemporary Italian painting. On his return he worked in the court of King Charles VII, and Étienne Chevalier, the royal treasurer, became his chief patron. In *The Madonna and Child with Angels* (p. 201) details have been subordinated to the large effect and simplification has been carried to the point of stylization. The madonna is a portrait of the King's mistress; her costume and stylish plucked hairline are in the current fashion.

Fouquet's gifts as a portrait painter are evident in *Étienne Chevalier and St. Stephen* (p. 202). Flemish realism and Italian simplicity have combined to produce a painting of great dignity and expressiveness.

The Life of St. Bertin (p. 204), by the Franco-Flemish painter Simon Marmion, is one of an original series of 12 panel paintings representing episodes in the life of the saint. Marmion had painted illuminated manuscripts, and the delicacy of design and color of the miniaturist is evident, as are both Gothic and Flemish influences.

Nicholas Froment was a French court painter known

to have traveled in Italy. The Italian influence is particularly apparent in the two foreground figures in *The Virgin in the Burning Bush* (p. 205), an imaginative treatment of this theme.

The identity of the Master of Moulins remains a mystery, although a number of works have been attributed to his hand. *The Madonna and Child with Angels* (p. 206) is part of a triptych, a panel painting in three parts. The center panel is often twice the width of the wings, which can be folded over it and are usually painted on both sides. In both color and composition it is reminiscent of the Flemish painter Hugo van der Goes.

The School of Fontainebleau

In the 16th century there was no demand for religious painting, and French artists turned to portraits and subjects drawn from classical mythology. The so-called School of Fontainebleau was established, which drew artists from all over France to learn from the Italian painters that Francis I had imported to embellish his château and other residences. The Renaissance had already passed its peak, and the Italians who came to France were the Mannerists and eclectics of the following period. The result of this encounter between the French tradition of realism and the new and foreign taste of the Renaissance led to the uneasy style of French 16th-century painting.

François Clouet's picture *Pierre Quthe* (p. 207), in which Flemish and north Italian influences are combined, is typical of the almost uniform style of 16th-century French portraiture. Usually smaller than life size, almost full face and half length against a neutral background, these portraits have a sameness that is only relieved by slight stylistic differences.

The elongated forms and artificially elegant poses of Diana and her companions (p. 208) derive directly from aspects of Mannerism, while the heads and faces are typically French in their realism; they are in fact so specific as to be identifiable with actual people.

17th-century Italianate painters

In the early years of the 17th century a number of young French painters went to Italy to take a closer look at the Renaissance. Among them were Simon Vouet (p. 209), Jacques Blanchard (p. 219), and Sébastien Bourdon (p. 223). Eustache Le Sueur (p. 224) never went to Rome, but he assimilated the style of his teacher Vouet so well that he belongs with this group. Those

who went to Italy returned with a thick Baroque veneer and proceeded to decorate the palaces of Paris with highly colored mythological scenes and its churches with elaborate classical altarpieces. They were all versatile and highly skilled in their craft, and their work was joyfully received by a public not distinguished for its discrimination. As a meaningful contribution to French or European art, these painters had little to offer.

Of all the French artists who followed Caravaggio, Le Valentin did so the most closely. *The Four Ages of Man* (p. 210) has shed all French characteristics and might well have been painted by an Italian. Le Valentin arrived in Italy when he was about 20, and though many of his pictures were sent to France, he lived and worked in Rome for the rest of his life.

The Le Nain brothers, Louis, Mathieu, and Antoine, were all painters, Louis being the most talented of the three. His paintings are generally subdued in color, while their classical composition makes it seem possible that he visited Rome. The illumination of *The Peasants' Meal* (p. 211) has the quality of Caravaggio, but the observant sympathy with which the scene is recorded—neither satirized nor idealized—is more reminiscent of Dutch genre painting. There is no suggestion of Caravaggio in *Landscape with Figures* (p. 212), nor any of the boisterousness of some of the Dutch painters. There is a seriousness in the quiet reserve and dignity of the scene that is both classical and human.

Louis' brother Mathieu was quite different. He was a lieutenant in the city militia and was made a chevalier. Most of his paintings deal with this side of Parisian life. *The Backgammon Players* (p. 213), in its subject, lighting, and full vigorous style, reflects the strong influence of Caravaggio. A third Le Nain brother, Antoine, was known for small portraits painted on copper.

For many years the identity of Georges de La Tour was unknown. Until his rediscovery in the 20th century his works had been attributed to, among others, Vermeer and Velázquez. His paintings seem to have a particular appeal to the taste of today, perhaps because of their calm impersonal simplicity.

By the time he was 27, La Tour was successfully established as a painter in Lunéville, one of the chief towns of the Duchy of Lorraine. He painted scenes of everyday life for his wealthy bourgeois patrons, illuminated by daylight and with no strong contrasts of tone or color.

Ten years later he was painting nocturnal scenes, mostly with religious connotations, illuminated by a single torch or candle shielded by a hand. The parallel between these paintings and those of Caravaggio is unavoidable at first sight. But La Tour's use of light as a structural and unifying element of pictorial design is even more comprehensive. Both of the paintings shown on pages 214 and 215 have the quality of simplicity. All the details that might interfere with the clear tones, the linear rhythms, and the formal dignity of the composition have been eliminated. The result is almost an abstraction, which at the same time is startlingly real and highly expressive.

Only three paintings are definitely attributable to Baugin, and almost nothing is known of his life. He appears to have been one of a group of still-life painters active in Paris at the beginning of the 17th century. *The Five Senses* (p. 225), like the other two, is restrained in composition and austere in color, and has the descriptive quality of Dutch still-life painting.

Poussin and Claude

For two French painters, Nicolas Poussin and Claude Gellée Lorrain, usually known simply as Claude, the lure of classical Rome was so insistent that, except for an occasional short visit, neither one returned to France.

Logic and order were the two qualities that Poussin sought in his study of classical antiquity and in the classically minded painters of the Renaissance, especially in the most orderly of them all—Raphael. But Poussin was not living in a time that gave feeling and spontaneity to classical images, and his careful ingenious designs are the products of intellect, not of instinct. The figures in *The Inspiration of the Poet* (p. 216) are as precisely drawn and solidly modeled as any of Michelangelo's Sistine ceiling figures, their formal relationships as carefully structured as in any Raphael painting, and their colors as rich as Titian's. This is not to say that Poussin was an eclectic like so many of his contemporaries, for it was not the style or mannerisms of classical art but its formal qualities of coherence and clarity that interested him.

In the last fifteen years of his life Poussin painted a number of landscapes to which the term "heroic" has been applied. These were constructed on the same precise geometrical bases as his figure paintings and almost invariably included figures, usually on a small scale, as those in *Diogenes* (p. 217). The masses of rocks and trees and patterns of light lead the eye back to the middle and far distances of the landscape. There is a complete absence of any sense of living nature or of its changing

moods. It is not conceived as a separate entity but only in its relation to man, and subject, like man, to the same intellectual, rational control.

In Poussin's last picture, *Apollo and Daphne* (p. 218), the figures assume an equal importance with the landscape. The formal organization is as carefully worked out as in any of his earlier work, but there is a more relaxed, serene quality in this picture despite the number and variety of its pictorial elements.

Claude's landscapes have a very different quality from Poussin's. Claude, too, places small figures in the foreground that furnish the titles for many of his pictures, but they contribute little to the composition or understanding of the picture; it is probable that he was simply following a convention. In his earlier paintings, such as *The Embarkation of the Queen of Sheba* (p. 220), large buildings in the architectural style of the Renaissance help to create pictorial depth by their sharp perspective. In his later works the buildings are confined to a single accent or dispensed with altogether.

The formal designs of Claude's landscapes are built up to the same architectural perfection as Poussin's, by the patterns of light and linear rhythms. It is the pervasive light and color that distinguish Claude's paintings and give them life and color and mood. Poussin's calm, even light comes from some indefinable source, and in it every form is delineated with crystal clarity. For Claude light was a constantly changing element that altered the appearance of every object it touched. The golden light of the setting sun, as in *The Embarkation,* permeates many of his pictures. Others such as *Europa* (p. 221) have an aura of mystery, the forms only partially revealed in the half light. It is not clarity and order alone that make great painting; it is, rather, the added elements of feeling and emotion in Claude's views of nature that give them an expressiveness as freely appreciated today as when they were painted.

Philippe de Champaigne's early paintings were influenced by the portrait style of Van Dyck, and later of Rubens, but in 1643 he came in contact with the severe doctrine of the Jansenists, a movement directed at strengthening the church through theological and moral reform. Both of his daughters joined a convent, and Champaigne painted several pictures of the nuns of Port Royal. *Two Nuns of Port Royal* (p. 222) is a votive picture painted in gratitude for his daughter's cure. She had been stricken with paralysis, and was cured presumably through the prayers of the prioress. It is a simple and geometrically severe composition with no hint of his earlier Baroque style, a rejection that conditioned the restrained poses and coloring of his later portraits.

Charles Lebrun and the French Academy

The French Academy of Painting and Sculpture, which had been founded in 1648 as a division of the government, was reorganized in 1663, and its rules and regulations became the basis of French academic art. No artist could expect official approval who deviated in the slightest degree from the established principles. Acceptable procedures were based on the sanctity of classical antiquity, which was to be imitated without changes. Only noble subjects were to be painted, culled from ancient history and the poetry of the past. Nature could be observed, but must be altered to agree with classic forms. Color was to be subordinated to line and drawing, and not to be used for expressive purposes.

It was Charles Lebrun who shaped these policies and controlled the great decorative projects in the Louvre and the palace at Versailles that were completed in the reign of Louis XIV. He was motivated by a deep admiration for Poussin, in whose work Lebrun saw a complete expression of his own aesthetic ideals. But the attempt to reduce Poussin's logic and order to a formula shows how little Lebrun understood the careful deliberation, the judgment and discretion that made Poussin's art an expression of the classic spirit, not a factual imitation.

Lebrun's own paintings, such as *Chancellor Séguier* (p. 226), are executed in strict accordance with his own dictates. He was made a director of the Gobelins tapestry factory, which he used as an aid in his attempt to standardize the art of France.

Fortunately there had been some strong opposition to the dictatorial attitudes of the Academy from the beginning, especially in the matter of color. The group that set itself against the academic views on color were admirers of Rubens and were called "Rubenistes," while the opposing side were known as "Poussinistes." Among the "Rubenistes" were two portrait painters, Nicolas de Largillierre and Hyacinthe Rigaud.

Largillierre received his early training in Antwerp, where he was influenced by the portraiture of Van Dyck, and later worked as an assistant to the English portraitist Sir Peter Lely. By 1862 he was successfully established in Paris and became a member of the Academy. His diploma painting was a portrait of Charles Lebrun surrounded by tools symbolic of his art and achievement as

dictated by academic protocol. The strictures of the Academy were least inhibiting in the field of portraiture partly because likeness is a requirement, and most features do not conform to classical ideals, and partly because Poussin had painted no portraits to serve as models. In his informal groups, such as *The Artist and his Family* (p. 227), Largillierre takes full advantage of these loopholes, and his portraits, if not profound, have a liveliness and color not found in the strict academic style.

There are two distinct styles to be found in the numerous portraits of Largillierre's contemporary Hyacinthe Rigaud. For royalty, visiting princes, diplomats, and generals he developed an elegant, rather pompous manner suited to his clientele and reminiscent of Van Dyck's official portraits. When he married, an inventory of his possessions included seven of Rembrandt's paintings and two copies. Whether or not there is any directly traceable influence of Rembrandt's work in *The Artist's Mother* (p. 228), the painting has a sensitiveness to character and a quiet naturalism that is in strong contrast to his official portrait style.

By the end of the 17th century the glamour of the Grand Manner had begun to pall even for Louis XIV, and a new movement in French art was inaugurated that marked the final defeat of the "Poussinistes" by the "Rubenistes." It was centered on the court life of Versailles in small-scale pictures, appropriate complements to the Rococo style of the interiors. If they reflect an empty and artificial way of life, at least these paintings have color and a youthful spirit, and at their best a poetic delicacy that is totally French.

Antoine Watteau

Antoine Watteau was the connecting link between the 17th and 18th centuries, stylistically descended from Rubens but molded by the temper of his own time. His paintings reflect the languid elegance of court life where the pursuit of love and amusement is the chief occupation. The *fête galante* was the favored genre—pictures of courtiers and ladies listening to music, or disporting themselves in idyllic garden or rural surroundings. *The Embarkation for Cythera* (p. 230) is a *fête galante* with an allegorical theme. Cythera was an island, the supposed home of Aphrodite, the goddess of love, where lovers could expect to find their paradise. In the picture the game of love is enacted from the first refusal to final capitulation and embarkation on a ship guided by a band of cupids.

As in many of Watteau's paintings, there is a strong feeling of nostalgia, of the fallibility of human happiness, and of the inevitable passage of time from which each fleeting moment must be snatched before it fades. These feelings are given pictorial expression through the winding line of figures, the shadowed evening light where the brightest spot contains the fabled but invisible island, and the muted secondary colors.

Watteau never sought commissions and was more at home with art dealers than with noble patrons. *The Signboard for the Shop of the Art Dealer Gersaint* (p. 231) was painted as a tribute to his long friendship with Gersaint. It is a demonstration of all of Watteau's most impressive technical achievements derived from his study of Rubens. The draftsmanship is flawless, and the rich oil paint is confidently applied. The curled-up dog is a motif adopted from Rubens that he often used. The delicate and subtle coloring is Watteau at his most distinctive.

The search for amusement and entertainment led to an increased interest in the theatre, particularly in the traditional Italian *commedia dell'arte*, which provided themes for a number of painters including Watteau. These were lively comedies in which the dialogue, instead of being memorized, was largely improvised by the actors. *Gilles* (p. 232) is thought to be a portrait of the comedian Belloni, one of the great contemporary Italian interpreters of the classic wistful and melancholy role of Pierrot, who was the object of ridicule and laughter and one of the stock characters in these plays.

Other 18th-century court painters

The *fêtes galantes* initiated by Watteau continued their popularity and had many imitators—among them Nicolas Lancret, and Watteau's only pupil, Jean Baptiste Pater.

Lancret's *Italian Comedians by a Fountain* (p. 234) is light-hearted, cheerful, and decorative. It has none of Watteau's expressive undertones and the faces have little individuality, but the color is rich and the drawing more than competent. The *fête galante* by its nature restricts the artist to an artificial elegance that is primarily decorative and Lancret's best work, like Watteau's, is found in paintings with a more realistic view of the world.

Pater's paintings show rather less originality than Lancret's. He borrowed heavily from his teacher, and his only personal characteristic is in the misty atmosphere and powdery colors of such pictures as *The Dance* (p. 235).

189

Not all painting was concerned with imaginative rustic idylls. Jean François de Troy painted the manners and modes of upper-class Parisian society. *Le Déjeuner d'Huitres* (p. 229) is a factual record, neither idealized nor satirized, and interesting mainly as a picture of one side of 18th-century life.

Jean Baptiste Oudry began his artistic career as a portrait painter and designer of historical scenes. Later he specialized in landscapes and hunting scenes, one of which so pleased Louis XV that he was appointed official painter of the king's hunt and favorite dogs. *The Dead Wolf* (p. 233), one of his occasional still-life paintings, is effective as a design, but as a painting the landscape is perfunctory, the dogs are so much decoration, and the perfect fruit attractively arranged but lacking in solidity. Oudry was appointed director of the Beauvais tapestry works and also supervised much of the work at the Gobelins factory. In the manufacture of tapestry he insisted on faithful reproduction of all the subtle shades and details of the design, many of which he provided.

The style of Watteau provided a point of departure for several generations of fashionable painters from François Boucher to Jean Honoré Fragonard.

Boucher's paintings leave nothing to be desired as decorative boudoir art. They are light and frivolous, but never in bad taste. *The Toilet of Venus* (p. 239) is a display of pretty women, its light eroticism thinly clothed in mythology. Men almost never appear in his pictures. Boucher became a friend of Madame de Pompadour, Louis XV's mistress, and painted her a number of times. In most of these portraits (p. 240) she is shown in repose, unoccupied, and holding a book or piece of music in a negligent hand. The rich texture and color of her elaborate costumes are recorded in minute detail, a quality that brings him closer to the Flemish school than to Italy where he had spent several years.

18th-century portraiture

The most famous and fashionable portraitist of the middle of the century was Maurice Quentin de Latour. His use of pastel in preference to oils contributed a unique quality to his work, and one that quickly led to imitation. The vivacious expression of his *Self-portrait* (p. 241) is one with which he endowed most of his sitters—a mobility of features that must have been a flattering exaggeration for some.

Jean Marc Nattier is usually associated with the highly decorative, unreal style of portraiture demanded by Rococo taste. Although he occasionally painted portraits of men, most of them are of women, often portrayed as goddesses or as the spirits of the seasons, that gained for him a large court following. The relative simplicity of *Marie Lecsinska* of the Russian nobility (p. 242) is due in part to his sitter's request to be painted in "ordinary" dress. Even with his usual attention to dress, setting, and the symbols of her rank, Nattier achieved a portrait that is more direct and truthful and not so consciously charming as his elaborate mythological creations.

The virtuosity of Latour's work overshadowed that of his contemporary Jean Baptiste Perronneau, but of the two Perronneau produced a more sensitive and penetrating likeness. He was less given to flattery, and *Madame de Sorquainville* (p. 243) emerges as not only an attractive but a vital personality.

Joseph Duplessis' painting of *Gluck at the Clavichord* (p. 244) is his best-known work and one of his most natural likenesses. In many of his portraits his emphasis on details of dress tended to overshadow the faces. Even in this there is a certain quality of lifelessness in the face and an over-attention to the shiny fabric of the costume.

In the mid-18th century increasing disapproval of the frivolity of aristocratic society gave rise to a middle-class morality thickly coated with sentiment. In literature it took the form of novels in which the heroine emerges triumphant, her virtue unsullied. In painting, the pictures of Jean Baptiste Greuze, often of roguish, but indubitably innocent young girls such as *Mademoiselle Sophie Arnould* (p. 245), are the reflections of a taste no less artificial than that of the court.

Jean Honoré Fragonard was the last of the 18th-century painters of *fêtes galantes* and boudoir decorations. He was a favorite with the nobility, royal mistresses, and popular actresses for whom he painted the provocative and erotic scenes that are his best-known work. In such paintings as *The Swing* (p. 246) there is a memory of Watteau and a continuation of Boucher, with added elements of humor and spontaneity.

Not all of Fragonard's paintings are in such a frivolous vein. He had spent almost five years in Italy and later studied the 17th-century Dutch masters. These studies together with his own intuitive response to nature produced a number of landscape drawings and

paintings that are among the finest of the 18th century. *Fête of St. Cloud* (p. 247) is both a romantic and a vigorous view of nature. The human figures are dominated by the billowing trees and soaring fountain, and in the contrasts of light and shade an atmosphere is created that is far removed from purely topographic representation.

Hubert Robert was a contemporary and friend of Fragonard, and the two worked closely in their early Italian years. Many of Robert's landscapes tend to be contrived and overly decorative, but his views of Paris and its environs are direct and vivid. The atmospheric sky at sunset in *Le Pont du Gard* (p. 248) is memorable, and the combination of the monumental bridge with the world of nature is eloquent.

Jean Baptiste Chardin

By design Jean Baptiste Chardin has been taken somewhat out of chronological order, since he stands apart from other 18th-century painters. He was born in 1699, four years before Boucher, so for practical purposes the two may be considered contemporaries. There is no need to underline the contrast between Chardin's *Skate* (p. 236), with its bloody, gutted fish, and Boucher's sophisticated creations (pp. 239, 240) or Oudry's unblemished fruit and elegant tableware (p. 233).

Although *The Skate* is not Chardin's first still-life, it is an early one and, to a marked extent, typical. The frugal display is arranged simply and naturally, not for show, and his response to the various textures of the objects is characteristic. The not entirely successful cat among the oysters betrays the early period of the painting, and this kind of anecdotal episode seldom appears again, nor does the aggressive realism of the repellent, grinning fish. In later still-lifes Chardin became increasingly preoccupied with the underlying geometry of shapes, and with the organization of their proportions and colors into an integrated pattern. It is this structural quality that makes his pictures more contemporary today than other 18th-century painting.

Chardin's genre pictures of intimate domestic scenes have much the same quality as those of the 17th-century Dutch masters in the full volume of the figures, generally austere backgrounds, and attention to detail. But Chardin has a lighter, more elusive touch and a subtle coloring that are characteristically French. As in *Le Bénédicité* (p. 237), he catches his figures in moments of stillness, not in the lively scenes that attracted many Dutch painters.

Poor health and failing eyesight led Chardin to change from his meticulous oil painting to pastel. His *Self-portrait* (p. 238) has little of the virtuosity of Latour or Perronneau. It is a completely unsentimental portrayal of himself with no illusionistic tricks, but with great firmness, solidity of form, and subtlety of color, qualities that were uniquely his own.

The inevitable reaction to the frivolity of the French court that came in the last decades of the 18th century showed itself in a stiffening of moral, political, and artistic standards and in the birth of a new sense of democracy that was to result in the Revolution. Archaeological discoveries at Pompeii and Herculaneum stimulated a renewed interest in classical antiquity and the political solidity of republican Rome.

Jacques Louis David

In art the Neo-Classic movement, headed by Jacques Louis David, reverted to the monumental logic of Poussin, which had been weakened by Lebrun's formulas and forgotten in the Rococo fantasies of the earlier 18th century. This new classicism, however, differs from the cultural splendors of Greece and Rome that inspired Poussin, and from the entertaining mythology of the Rococo painters. There are stern moral and political implications in the theme of *The Oath of the Horatii* (p. 249), which had been used by Corneille in the previous century as the subject of a play. The Horatii were Romans of the republican period, sworn to kill their enemies the Curatii, even though a daughter of the Horatii family was in love with a son of the Curatii. Thus virtue and courage in ancient Rome are used to express the ideals of patriotic duty that inspired the incipient revolutionaries of the 18th century.

The portrait of *Madame Sériziat and her Child* (p. 250) was painted when David was 21, some years before his enthusiasm for Poussin and the classical ideal developed. There is a reflection of Boucher, a distant relative, but also of his own fundamental realism, and the clarity of form he was to achieve in later work.

From 1789 to 1794, David took an active part in promoting the Revolution but lost his revolutionary fervor after his imprisonment following the fall of Robespierre. In 1798 he met Napoleon and became an ardent Bonapartist. *The Coronation of Napoleon and Jose-*

phine in Notre Dame, of which a detail from the central portion is shown (p. 251), was commissioned by Napoleon and painted in the early years of the 19th century. It is filled with portraits of those present at the ceremony, and the huge canvas is distinguished for its formal organization, careful execution of details, and rich color.

Until the Battle of Waterloo, David was the unchallenged head of the official school in France. As a teacher he attracted many young painters to his studio, and his influence on the second generation of French 19th-century painters was enormous. His most important contribution lay in the social content of his painting, which reflected the attitudes of a new order and returned to French painting a seriousness that had been lost in the decorative Mannerist styles of the 18th century.

Pierre Paul Prud'hon was a contemporary of David, and like him spent considerable time in Italy. He was not a part of the Neo-Classic movement, however, and his mythological and allegorical scenes are closer in spirit to Correggio than to Poussin. He painted many portraits, mostly of women, such as Empress Josephine (p. 252). There is a touch of Rococo in its mood and sentiment, and the pose and background reflect his admiration for Leonardo.

Other Neo-Classic painters

The most notable of David's pupils were François Gérard, Antoine Jean Gros, and Jean Auguste Dominique Ingres; of these, Ingres developed the most personal idiom. Gérard painted mostly portraits, an occupation that did not endear him to his master who regarded all portraits as trivial, including his own. Isabey and his Daughter (p. 253) is an early work in the simple classical style and restrained color of David. Gérard was not affected by political change, and with the restoration of the Bourbon monarchy he secured a court appointment. He employed many assistants to help with the glossy, stylish portraits that brought him success as a fashionable painter.

The Pesthouse at Jaffa (p. 254) was painted by Antoine Jean Gros on commission from Napoleon. Its modern subject matter and heroic treatment are in the Neo-Classic spirit. The monumental size of the composition as well as the modeling of the nude figure suggest the large-scale painting of Michelangelo and Rubens for whom Gros had great admiration.

Gros' portrait Napoleon at Arcola (p. 255) is even more reminiscent of Rubens' color, and shows less of David's stiff precision. The air of heroic bravado about the figure anticipates the Romanticism of the next generation of French painters.

Ingres was as conscientiously classical as David but, except for a short period, failed to achieve the popularity of his master and spent much of his time in Italy until he was about 60. His early portraits, such as Madame Rivière (p. 258), have vitality and charm, and the linear rhythms provided by drapery and gestures characterize all his work.

The Bather of Valpinçon (p. 256) depends almost entirely on line for definition of space and volume. There is no modeling of the figure and little variation in tone, yet the three-dimensional effect is complete. The sensuous appeal that texture and color provide is absent; the figure is not provocative, idealized, or symbolic of any human emotion or characteristic. It is primarily an exercise in linear design, abstract in the sense that it makes no attempt to describe the nature of its subject. Although the stylistic differences are apparent, a Chardin still-life and an Ingres nude are alike in treating their subjects as abstract shapes, an attitude more frequently associated with the end than the beginning of the 19th century.

Stratonice (p. 257), though not a large picture, has all the elements admired by the Neo-Classicists—a dramatic and tragic theme, and the accoutrements of classical architecture and costume. It was well received in Paris and made Ingres' return from Italy in 1841 a happier occasion. In his last years Ingres had a large number of pupils who continued to work in the classical tradition despite the increasing popularity of Delacroix and the Romantics.

The Romantic movement

Théodore Géricault was a passionate lover of horses, and his early paintings are of Napoleon's cavalrymen and their mounts. Realistic, dramatic, and full of color, these pictures introduced a new and romantic flavor to French painting.

After a year in Italy studying Michelangelo and other Italian masters, Géricault returned to France in 1817 and began work on his large painting The Raft of the Medusa (p. 259). The Medusa was a French frigate that had been wrecked in 1816 in a storm. Only a few of her crew and passengers managed to survive on a

raft built of timbers from the sinking ship. At the moment pictured, the masts of the rescue ship have just been sighted, barely visible on the horizon. Géricault spent weeks of preparation experimenting with a model raft, interviewing survivors, and making studies in hospitals of the dead and dying.

In terms of style the painting is a conventional composition, the figures forming a pyramid with the apex to the right of center. His study of Michelangelo is evident in the nude figures, though there is a certain hardness in their modeling. It is not the form of the picture but its content that was so revolutionary for its time and caused it to be condemned by official criticism. Here, common sailors are treated with seriousness and on a monumental scale reserved exclusively for the greatest figures of history and legend. For its time, the picture was strongly partisan, since the liberals had made the *Medusa* affair a symbol of the corruption of Louis XVIII's administration. Finally, it substituted a dramatic and powerful appeal to the emotions for the intellectual rationalism and literary connotations of Neo-Classicism.

La Folle d'Envie (p. 260) is one of a series of extraordinarily sensitive facial studies of the insane commissioned by a doctor. The portrait suggests what Géricault might have been able to accomplish had he not died after a riding accident when he was only 32.

Epsom Racecourse (p. 261) was painted during a visit to England, where Géricault was able again to indulge his love of horses that proved so disastrous. He has captured the swiftness and power of the horses in a way that most English painters of horses failed to do.

Eugène Delacroix's *Massacre at Chios* (p. 265) was his first large painting, and like *The Raft of Medusa*, with which it has some affinity, its subject is contemporary. It portrays an incident in the war between Greece and Turkey. As in Géricault's picture, the characters are neither legendary nor noble. The action is intentionally somewhat confused to give the impression that this is only one episode in a much larger disaster, thereby stimulating a stronger emotional response.

The picture is most notable for its vivid color, a result of his exposure to the landscapes of the English painter John Constable. From him, Delacroix learned the technique of applying small strokes of varying shades of a color beside each other rather than mixing a uniform color on his palette, producing a brilliance that suits the exotic nature of the scene.

Although less colorful than *The Massacre at Chios,* the dramatic *Liberty Guiding the People* (p. 266) has many of the same characteristics. It was inspired by the revolution that brought Louis Philippe to the throne. A Baroque treatment of light and shadow as well as the strong feeling of movement and energy add drama and excitement to a subject that in itself is Romantic. The focus of attention is here clearly defined, but, as in the earlier work, there is the suggestion of a wider sphere of action than that shown.

Women of Algiers (p. 267) was painted as a result of a visit to the Islamic countries of North Africa, where the colorful and exotic nature of the people and places appealed to Delacroix's romantic imagination. In this painting, what is fundamentally a quiet pattern in which the figures are at rest is given a sense of movement through color and light alone as strong as any produced by gesture and drawing.

Théodore Chassériau spent his artistic life oscillating between the Classicism of Ingres and the Romanticism of Delacroix. Like Delacroix, he went to North Africa and painted a series of Algerian pictures. Like Ingres he painted oval-faced, languid nudes, and excelled in portraits of women. In *The Two Sisters* (p. 271) both influences are successfully combined.

The Italian countryside and the ruins of Roman antiquity that had been the source of inspiration for Poussin and Claude continued to fascinate landscape painters until the mid-19th century, among them Jean Baptiste Camille Corot. *The Forum from the Farnese Gardens* (p. 262) was painted on the first of three extended trips to Italy. It follows the classical pattern of including small figures and takes full advantage of the opportunities for perspective drawing afforded by the buildings, and of the clear Italian light in which they are revealed.

The Bridge at Narni (p. 263), painted during the same visit, is less precise than the earlier picture and more typical of his later style. It is a study in tonal values, in which black has been added in varying amounts to color to reproduce the effects of shadow and to delineate form. The range of values is not great, but the distinctions are subtle and Corot's ability to define these delicate nuances in pigment gives his painting a sense of living actuality.

Corot's figure paintings are as sensitive as his landscapes. *Woman in Blue* (p. 264), painted almost 50 years after *The Bridge at Narni,* has a similar feeling for

the nuances and subtle harmonies of muted colors. The figure is as realistically and solidly constructed in its setting as his landscapes, and avoids any hint of the idealized or artificial.

19th-century Realism

Honoré Daumier earned his living by the many thousands of lithographs he produced for publication in periodicals. His subjects were drawn from all aspects of contemporary life, ranging from scenes of the daily life of the working poor to scathing political satires that rival those of the Spanish satirist Francisco Goya in their bitter intensity. His comments on the foibles of middle- and lower-class Parisian society are less biting than Goya's, however, and are made in a spirit of sympathetic humor.

It was only toward the end of his life that Daumier was free from the obligations of propaganda and had the leisure to paint. *Don Quixote* (p. 268) is one of a series of paintings based on Cervantes' picaresque novel, and is a typical example of Daumier's oils. The color is subdued, the paint is applied thickly in obvious brushstrokes, and the figures depend upon the heavy line for their definition and solidity. The freedom of his drawing, sketchy in its avoidance of detail, and the way in which the figures blend with the background are effects that are far in advance of their time.

Jean François Millet and Théodore Rousseau formed the nucleus of the so-called Barbizon group of artists who retired to the countryside around Barbizon to experiment in a new approach to landscape painting. Leaving the debate between Classicism and Romanticism to others, the avowed aim of the Barbizon painters was to represent nature and peasant life free of all literary devices and emotional idealism.

Millet's art is concerned with the dignity of peasant labor, an abstraction that is expressed in the simple, generalized figures of *The Gleaners* (p. 269). These are not specific, individualized gleaners, but human types engaged in a human activity. The three figures organized in the deep space of the landscape, and the rhythm generated by their activity, create a pattern that is monumental in its uncluttered simplicity. Although reproductions of *The Gleaners* have been sold by the thousands and owned by many for reasons other than those intended by the artist, the picture is a sincere expression of a deeply felt sentiment, not to be confused with sentimentality.

Rousseau's *Spring* (p. 270) is characterized by an extreme emotional empathy with the subject that expresses itself in the wide all-embracing view of the countryside and great expanse of sky. In later work the themes are simpler and the breadth of vision consciously restrained. Like Millet and others of the Barbizon group, Rousseau sought to describe in paint exactly what he saw, and his pictures have the freshness that comes from painting directly from observation rather than building up a picture from sketches.

Gustave Courbet, partly because he was more aggressively vocal in his denunciation of Romanticism, Classicism, and French Academism, and partly because his range of subjects was wider than those of the realistic painters previously mentioned, is generally considered a pivotal figure in 19th-century painting. Courbet's art was a complete rejection of idealism and demanded the portrayal of all subjects, no matter how sordid and depressing, with unsparing realism. He painted his native Jura, bright clear seascapes, animals, his friends, self-portraits (one of which is shown on page 272), and strong healthy nudes. He was prepared in principle to denounce poverty and political scandal, but in practice his instincts as a painter prevented him from making his art a vehicle for social commentary. Courbet's painting is so closely associated with the emergence of what we call "modern" art, of which Impressionism is the first manifestation, that his work is discussed in more detail in the section on the *Impressionists and Post-Impressionists*.

List of Color Plates

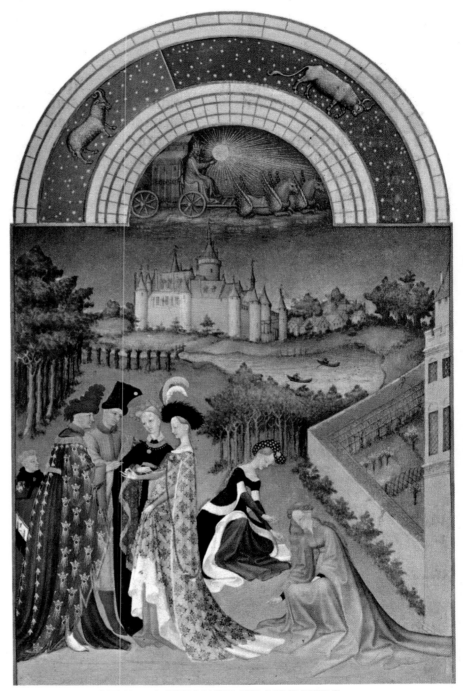

POL, HENNEQUIN, and HERMANN DE LIMBOURG
April, from the *Très Riches Heures du Duc de Berri*, begun 1415 *vellum* $8\frac{1}{4} \times 5\frac{1}{4}$ *in.*
Chantilly, Musée Condé

ENGUERRAND QUARTON The Coronation of the Virgin, 1454 *oil on panel* *72 × 86⅝ in.*
Villeneuve-les-Avignon, Hospice

198

SCHOOL OF AVIGNON (Attributed to Enguerrand Quarton) Pietà, mid 15th century *oil on panel 63¾×85⅞ in.*
Paris, Louvre

HENRI BELLECHOSE The Communion and Martyrdom of St. Denis, about 1416 *oil on panel* *63¾ × 82⅛ in.*
Paris, Louvre

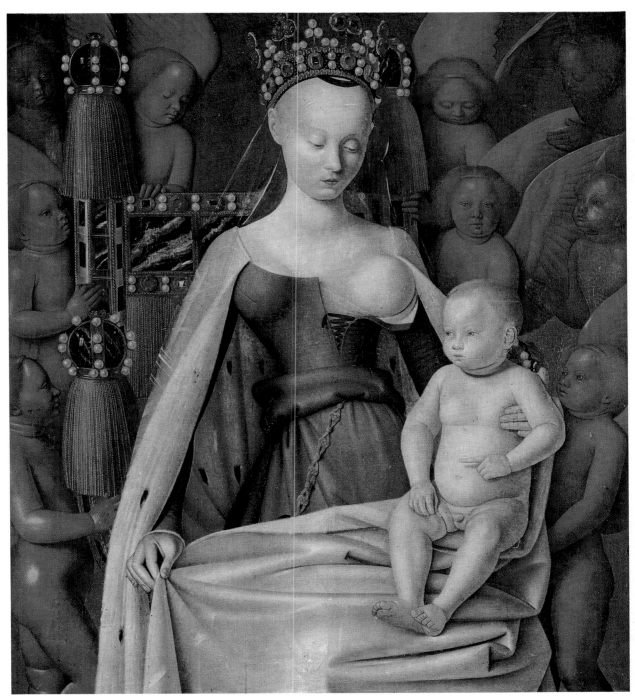

JEAN FOUQUET The Madonna and Child with Angels, about 1450 *oil on panel 37⅜ × 33⅞ in.*
Antwerp, Musée Royal des Beaux-Arts

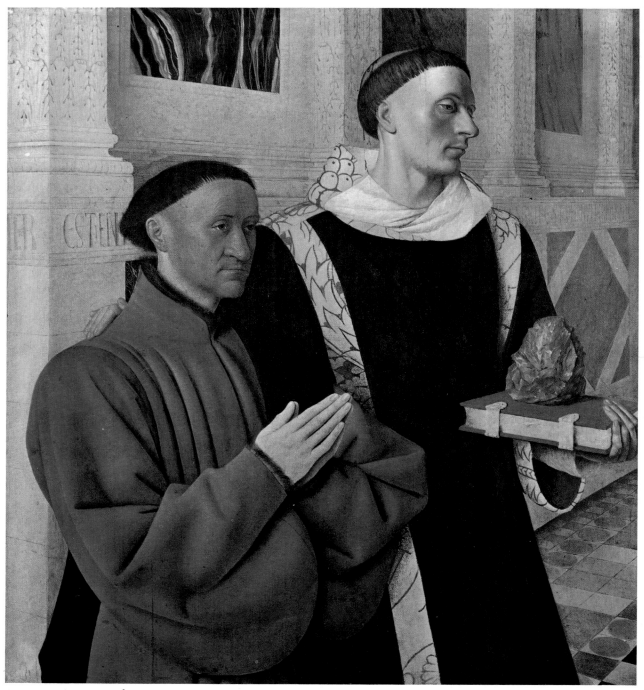

JEAN FOUQUET Étienne Chevalier with St. Stephen, about 1450 *oil on panel* $36\frac{5}{8} \times 33\frac{1}{2}$ *in.*
West Berlin, Staatliche Museen

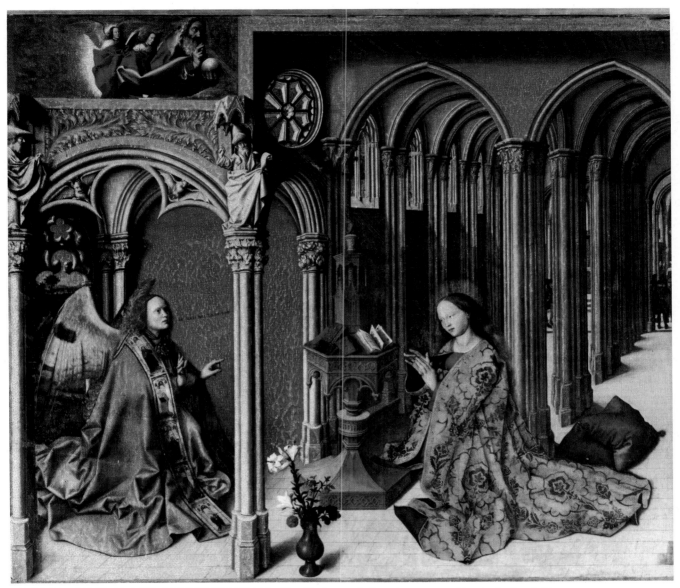

MASTER OF THE AIX ANNUNCIATION The Aix Annunciation, about 1444 *oil on panel* *61 × 69¼ in.*
Aix-en-Provence, Church of La Madeleine

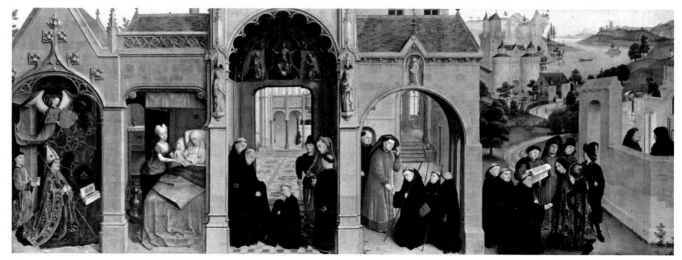

SIMON MARMION The Life of St. Bertin, about 1459 *oil on panel 22 × 52¼ in.*
West Berlin, Staatliche Museen

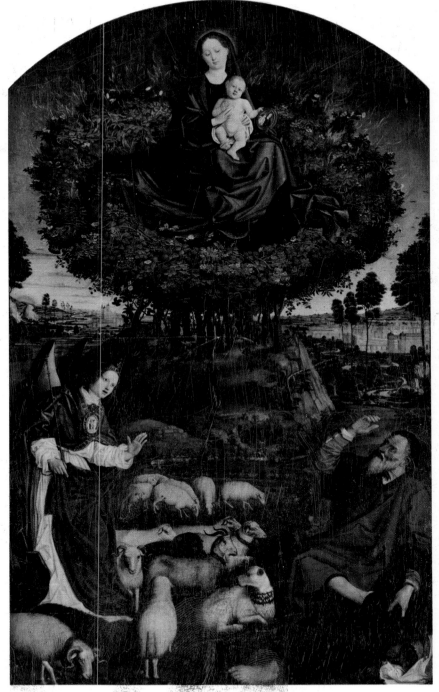

NICOLAS FROMENT The Virgin in the Burning Bush, 1476
oil on panel 162 × 118 in.
Aix-en-Provence, Cathedral

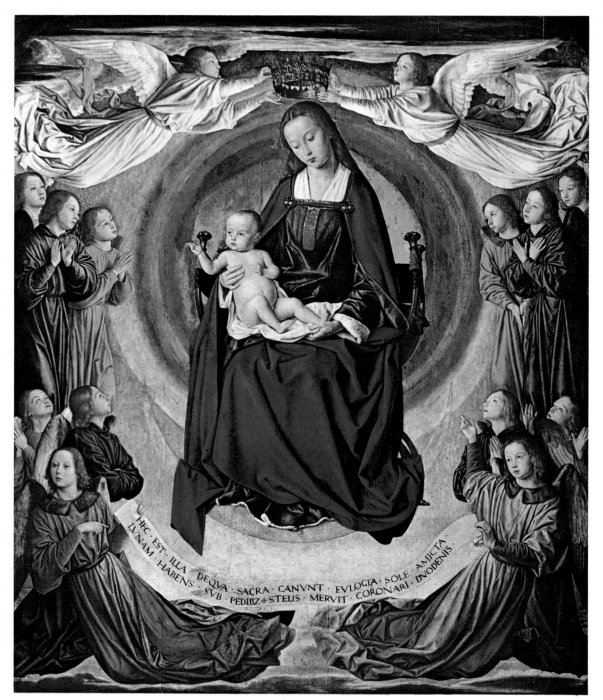

MASTER OF MOULINS The Madonna and Child with Angels (detail) about 1498 *oil on panel*
Moulins, Cathedral

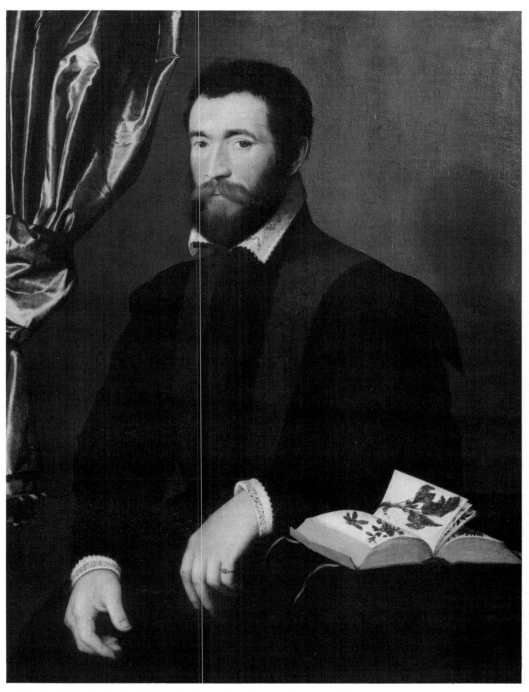

FRANÇOIS CLOUET Pierre Quthe, 1562 *oil on panel* $37\frac{7}{8} \times 27\frac{5}{8}$ *in.*
Paris, Louvre

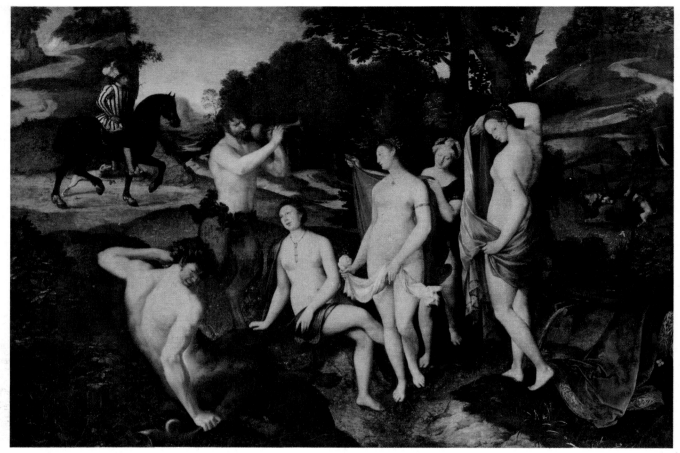

SCHOOL OF FONTAINEBLEAU (Attributed to François Clouet) The Bath of Diana, about 1550-60 *oil on canvas* $52\frac{3}{8} \times 75\frac{5}{8}$ *in.*
Rouen, Musée des Beaux-Arts

SIMON VOUET The Birth of the Virgin, 1615-20 *oil on canvas* $85\frac{1}{4} \times 129\frac{1}{2}$ *in.*
Rome, S. Francesco a Ripa

LE VALENTIN The Four Ages of Man *oil on canvas 38 × 52¾ in.*
London, National Gallery

LOUIS LE NAIN The Peasants' Meal, 1642 *oil on canvas* *38¼ × 48 in.*
Paris, Louvre

LOUIS LE NAIN Landscape with Figures, about 1643 *oil on canvas 21½ × 26½ in.*
London, Victoria and Albert Museum

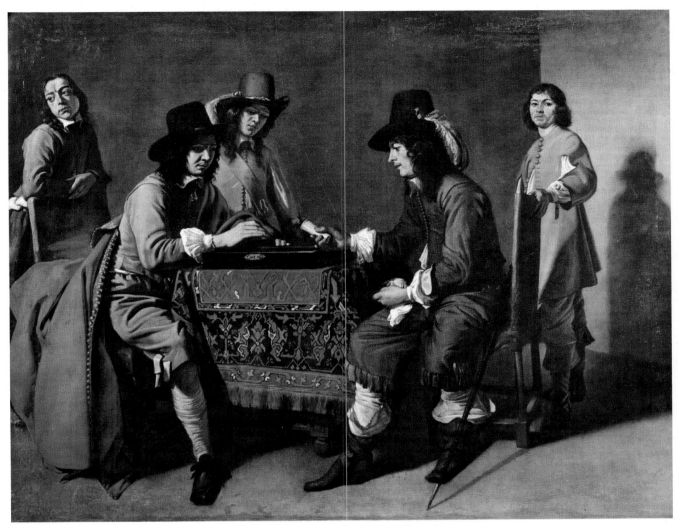

MATHIEU LE NAIN The Backgammon Players, about 1650 *oil on canvas* $35\frac{3}{8} \times 47\frac{1}{4}$ *in.*
Paris, Louvre

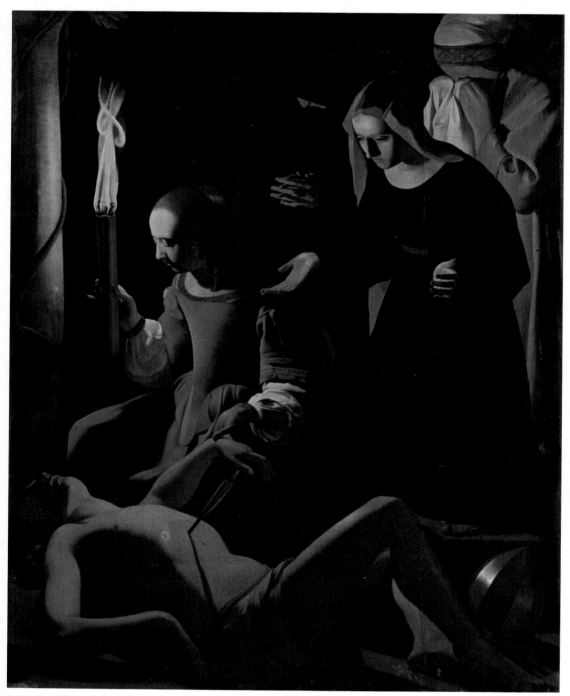

GEORGES DE LA TOUR St. Sebastian Tended by St. Irene, about 1630 *oil on canvas 63 × 50¾ in.*
West Berlin, Staatliche Museen

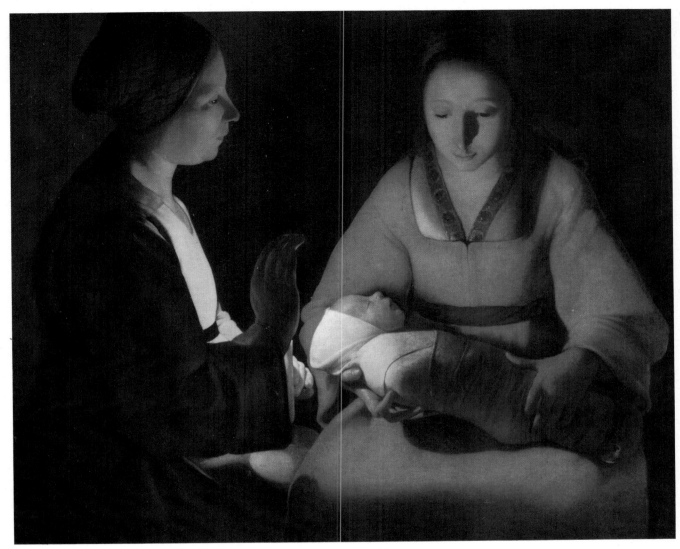

GEORGES DE LA TOUR The Newborn Child *oil on canvas* $29\frac{7}{8} \times 35\frac{7}{8}$ *in.*
Rennes, Musée de Rennes

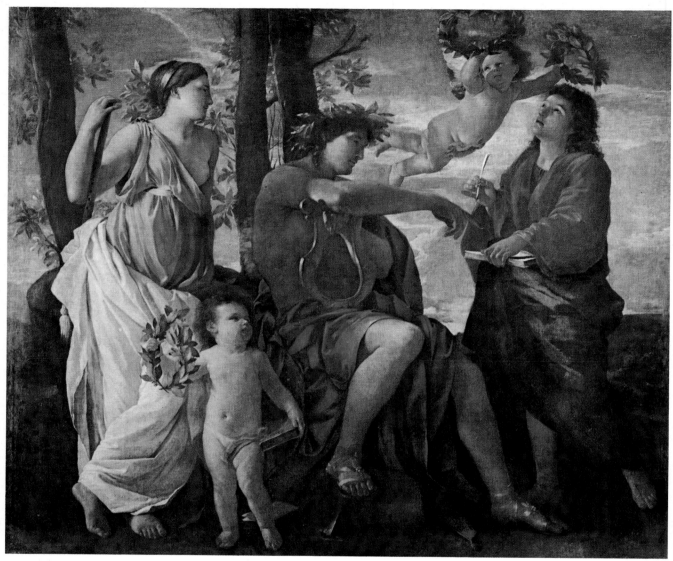

NICOLAS POUSSIN The Inspiration of the Poet, 1629 *oil on canvas* $72\frac{1}{2} \times 84\frac{1}{4}$ *in.*
Paris, Louvre

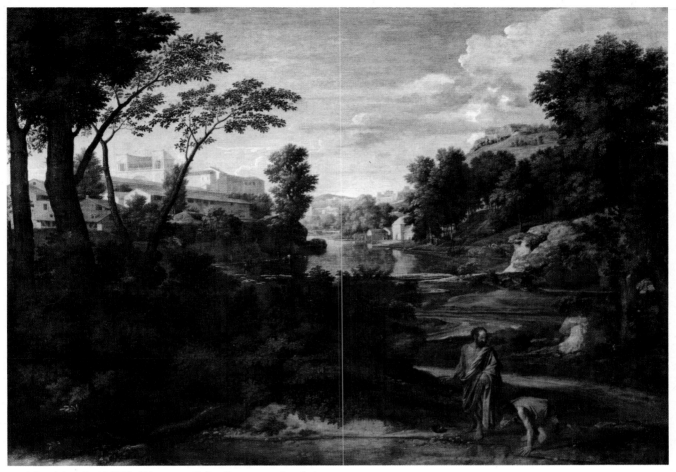

NICOLAS POUSSIN Diogenes, 1648 *oil on canvas 63 × 87 in.*
Paris, Louvre

NICOLAS POUSSIN Apollo and Daphne, about 1665 *oil on canvas 61 × 102¼ in.*
Paris, Louvre

JACQUES BLANCHARD Charity, 1637 *oil on canvas* 41½ × 31¾ *in.*
London, Courtauld Institute Galleries

CLAUDE GELLÉE LORRAINE The Embarkation of the Queen of Sheba, 1648 *oil on canvas 58¼ × 76¼ in.*
London, National Gallery

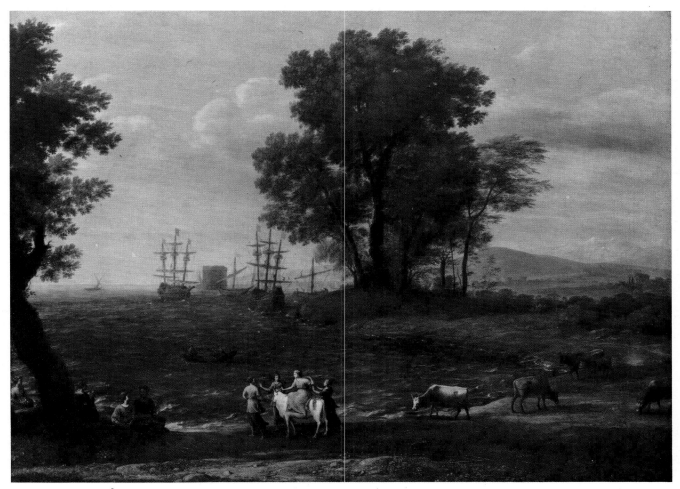

CLAUDE GELLÉE LORRAINE Europa, 1667 *oil on canvas* *40 × 53 in.*
London, Royal Collection

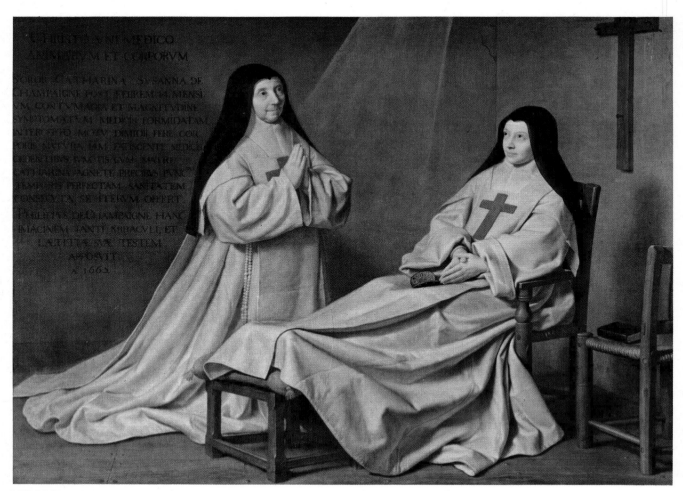

PHILIPPE DE CHAMPAIGNE Two Nuns of Port Royal, 1662 *oil on canvas* *65 × 90¼ in.*
Paris, Louvre

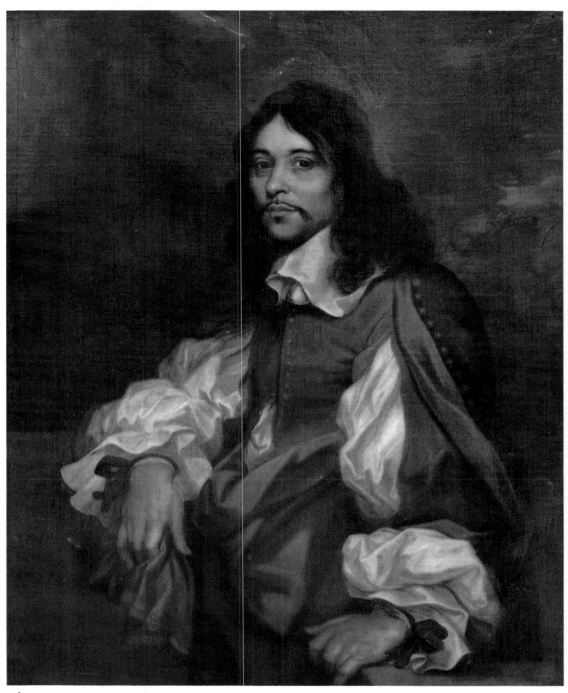

SÉBASTIEN BOURDON L'Homme aux Rubans Noirs, 1655-60 *oil on canvas* $41\frac{3}{4} \times 33\frac{1}{2}$ *in.*
Montpellier, Musée Fabre

EUSTACHE LE SUEUR The Mass of St. Martin, about 1655 *oil on canvas* $44\frac{5}{8} \times 33\frac{1}{8}$ in.
Paris, Louvre

BAUGIN The Five Senses *oil on panel* $21\frac{3}{4} \times 28\frac{3}{4}$ *in.*
Paris, Louvre

CHARLES LEBRUN Chancellor Séguier, about 1660 *oil on canvas 116 × 137¾ in.*
Paris, Louvre

NICOLAS DE LARGILLIERRE The Artist and his Family *oil on canvas* $58\frac{3}{4} \times 78\frac{3}{4}$ *in.*
Paris, Louvre

227

HYACINTHE RIGAUD The Artist's Mother, 1695 *oil on canvas* $31\frac{7}{8} \times 39\frac{3}{8}$ *in.*
Paris, Louvre

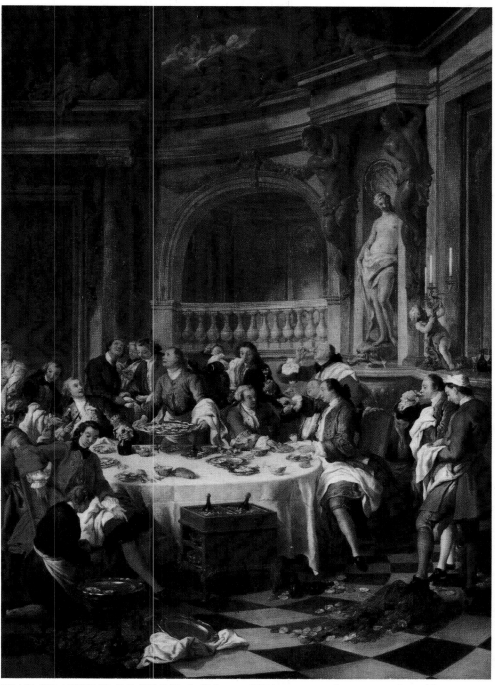

JEAN FRANÇOIS DE TROY Le Déjeuner d'Huitres, 1734 *oil on canvas 70¾ × 49¾ in.*
Chantilly, Musée Condé

ANTOINE WATTEAU The Embarkation for Cythera, 1717 *oil on canvas* $50\frac{3}{4} \times 76\frac{1}{4}$ *in.*
Paris, Louvre

ANTOINE WATTEAU The Signboard for the Shop of the Art Dealer Gersaint, 1720 *oil on canvas* *54¼ × 121¼ in.*
West Berlin, Staatliche Museen

ANTOINE WATTEAU Gilles, 1721 *oil on canvas* $72\frac{1}{2} \times 58\frac{5}{8}$ *in.*
Paris, Louvre

JEAN BAPTISTE OUDRY The Dead Wolf, 1721 *oil on canvas* 75 × 100½ *in.*
London, Wallace Collection

NICOLAS LANCRET Italian Comedians by a Fountain, about 1720 *oil on canvas 36 × 33 in.*
London, Wallace Collection

234

JEAN BAPTISTE JOSEPH PATER The Dance *oil on canvas* *22¼ × 18 in.*
London, Wallace Collection

JEAN BAPTISTE SIMÉON CHARDIN The Skate, 1728 *oil on canvas* $44\frac{7}{8} \times 57\frac{1}{2}$ *in.*
Paris, Louvre

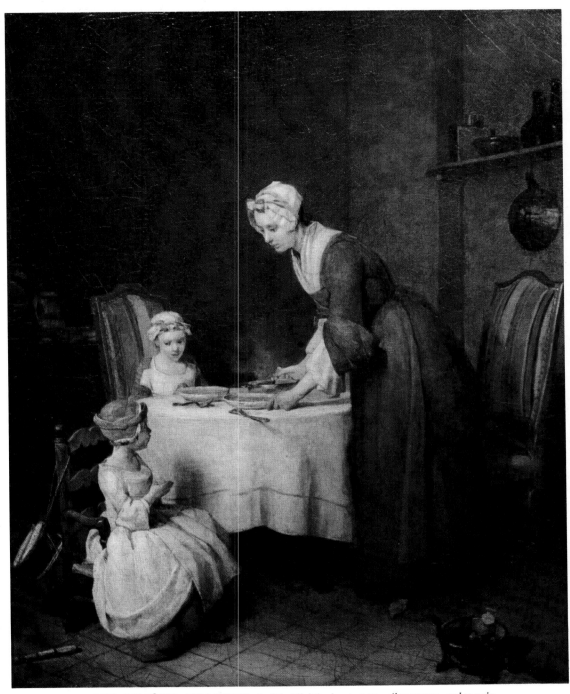

JEAN BAPTISTE SIMÉON CHARDIN Le Bénédicité, about 1740 *oil on canvas* *19¼ × 15 in.*
Paris, Louvre

JEAN BAPTISTE SIMÉON CHARDIN Self-portrait, 1775 *pastel* 18⅛ × 15 *in.*
Paris, Louvre

FRANÇOIS BOUCHER The Toilet of Venus, 1746 *oil on canvas* $38\frac{5}{8} \times 51\frac{3}{8}$ *in.*
Stockholm, Nationalmuseum

FRANÇOIS BOUCHER Madame de Pompadour, about 1757 *oil on canvas* 13¾ × 17¼ in.
Edinburgh, National Gallery of Scotland

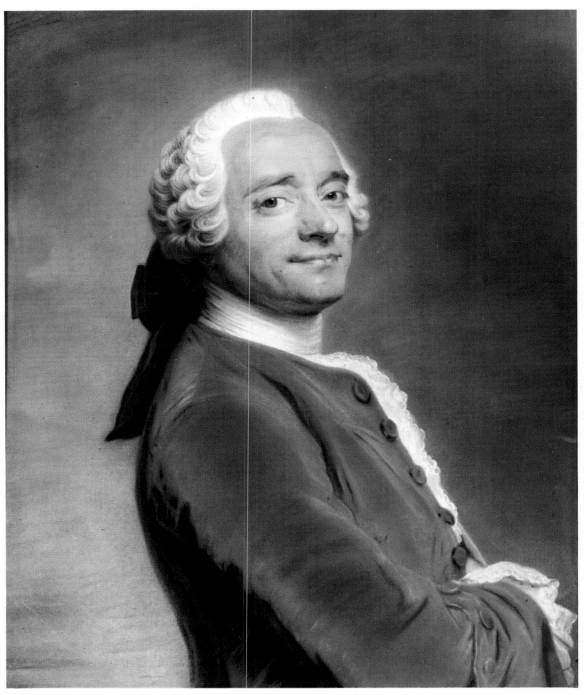

MAURICE QUENTIN DE LATOUR Self-portrait, 1751 *pastel 25¼ × 20⅞ in.*
Amiens, Musée de Picardie

241

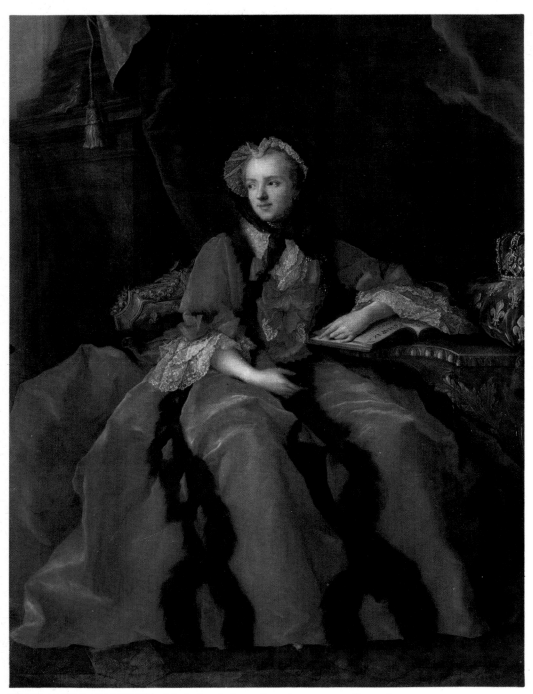

JEAN MARC NATTIER Marie Lecsinska, 1762 *oil on canvas* *76¼ × 57 in.*
Warsaw, National Museum

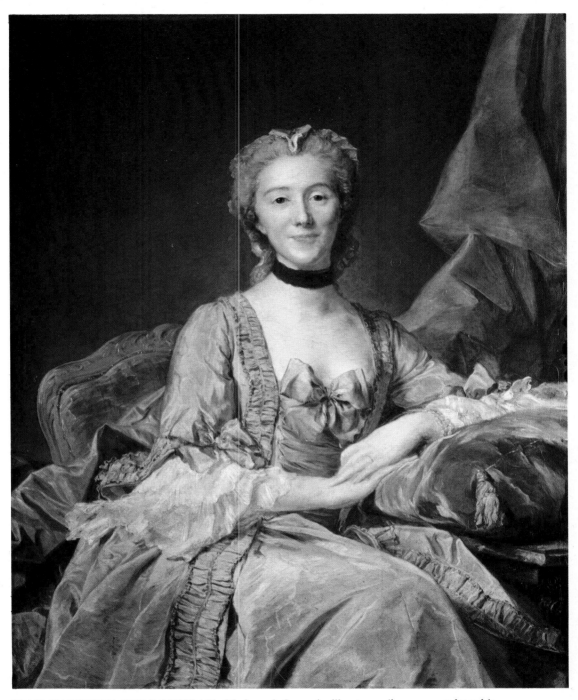

JEAN BAPTISTE PERRONNEAU Madame de Sorquainville, 1749 *oil on canvas* $39\frac{3}{8} \times 31\frac{1}{2}$ *in.*
Paris, Louvre

243

JOSEPH SIFFREIN DUPLESSIS Gluck at the Clavichord, 1775 *oil on canvas 39 × 31¼ in.*
Vienna, Kunsthistorisches Museum

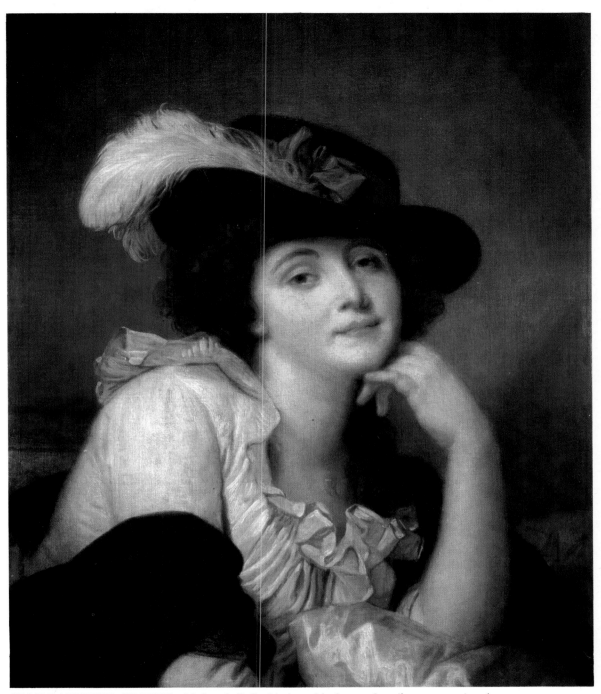

JEAN BAPTISTE GREUZE Mademoiselle Sophie Arnould, about 1769 *oil on canvas 24 × 20 in.*
London, Wallace Collection

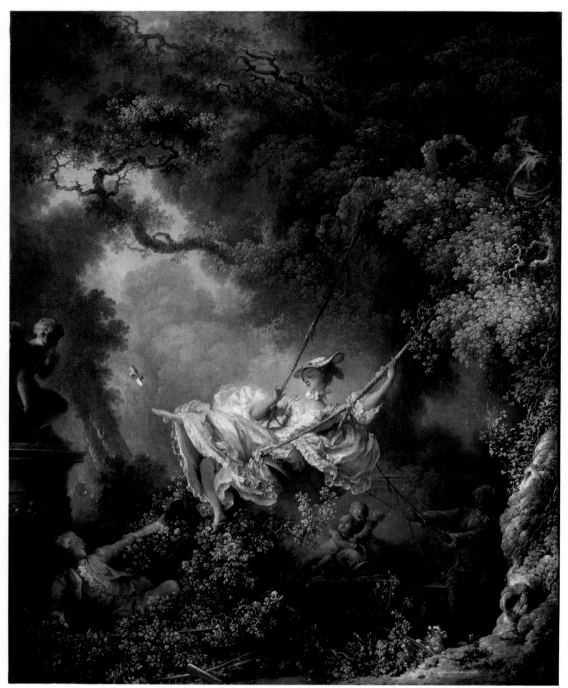

JEAN HONORÉ FRAGONARD The Swing, about 1766 *oil on canvas* *32⅝ × 26 in.*
London, Wallace Collection

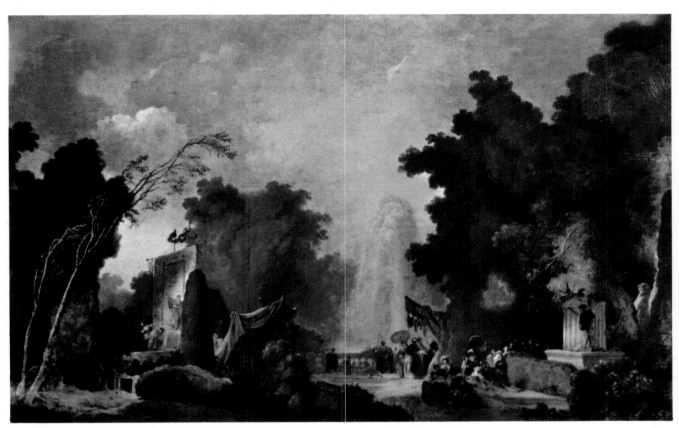

JEAN HONORÉ FRAGONARD Fête of St. Cloud, about 1770 *oil on canvas* *85 × 132¼ in.*
Paris, Banque de France

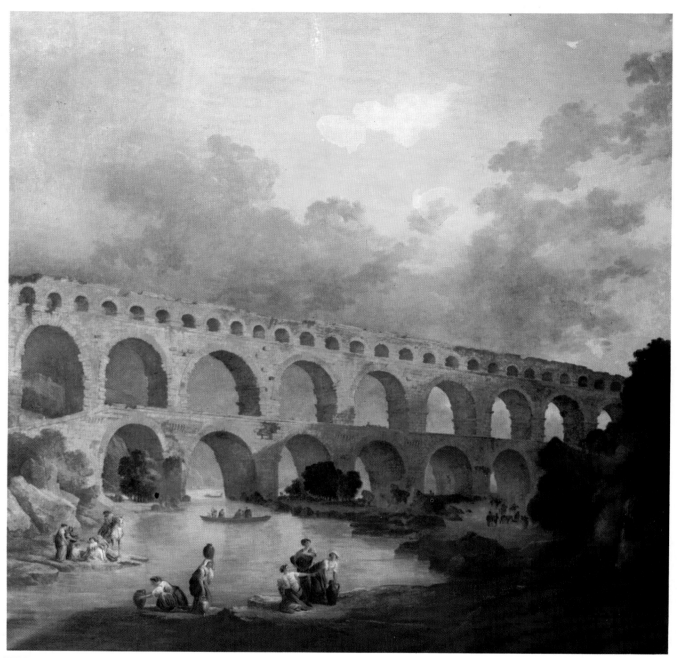

HUBERT ROBERT Le Pont du Gard, 1787 *oil on canvas* $95\frac{1}{4} \times 95\frac{1}{4}$ *in.*
Paris, Louvre

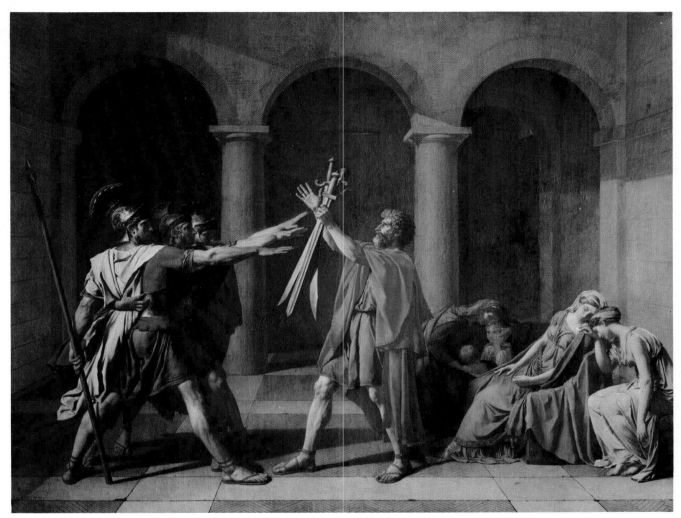

JACQUES LOUIS DAVID The Oath of the Horatii, 1784 *oil on canvas* *130 × 160 in.*
Paris, Louvre

JACQUES LOUIS DAVID Madame Sériziat and her Child, about 1769 *oil on canvas* $51\frac{1}{2} \times 37\frac{3}{4}$ *in.*
Paris, Louvre

JACQUES LOUIS DAVID The Coronation of Napoleon and Josephine in Notre Dame (detail)
about 1807 *oil on canvas 240 × 366¼ in.*
Paris, Louvre

PIERRE PAUL PRUD'HON Empress Josephine, 1805 *oil on canvas* *96 × 70½ in.*
Paris, Louvre

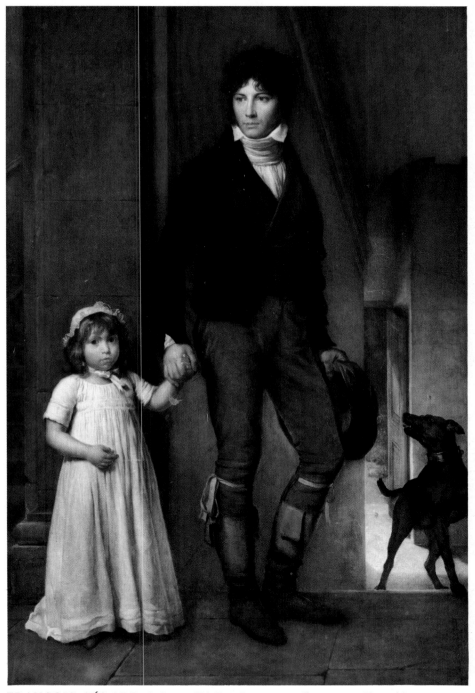

FRANÇOIS GÉRARD Isabey and his Daughter, 1795 *oil on canvas* *76⅜ × 49¼ in.*
Paris, Louvre

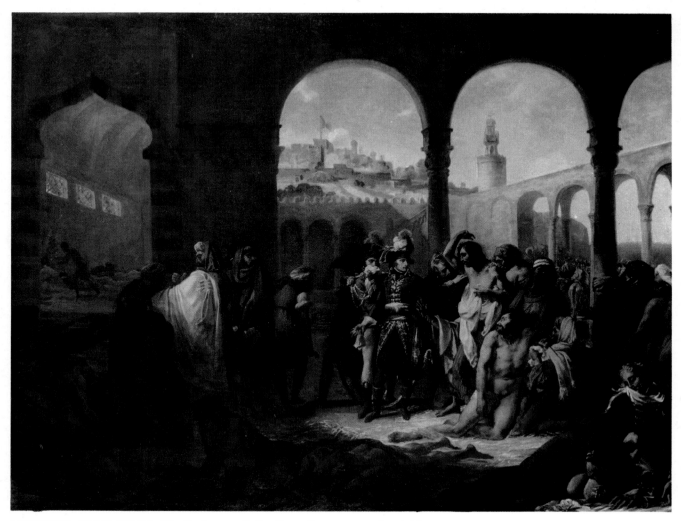

ANTOINE JEAN GROS The Pesthouse at Jaffa, 1804 *oil on canvas 209¼ × 283¾ in.*
Paris, Louvre

ANTOINE JEAN GROS Napoleon at Arcola (detail) 1796 *oil on canvas 28¾ × 23¼ in.*
Paris, Louvre

JEAN AUGUSTE DOMINIQUE INGRES The Bather of Valpinçon, 1808
oil on canvas 56¼ × 38¼ in.
Paris, Louvre

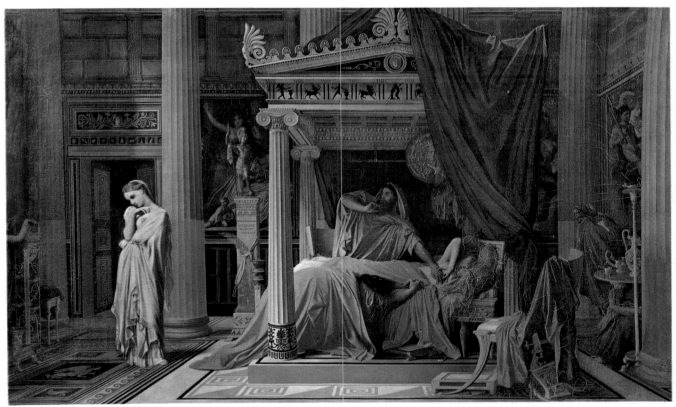

JEAN AUGUSTE DOMINIQUE INGRES Stratonice, 1840 *oil on canvas* $22\frac{1}{2} \times 38\frac{5}{8}$ *in.*
Chantilly, Musée Condé

JEAN AUGUSTE DOMINIQUE INGRES Madame Rivière, 1805 *oil on canvas* $45\frac{5}{8} \times 38\frac{3}{8}$ *in.*
Paris, Louvre

THÉODORE GÉRICAULT The Raft of the Medusa, 1819 *oil on canvas 193¾ × 281¼ in.*
Paris, Louvre

THÉODORE GÉRICAULT La Folle d'Envie, about 1824 *oil on canvas* $28\frac{3}{8} \times 22\frac{5}{8}$ *in.*
Lyons, Musée des Beaux-Arts

THÉODORE GÉRICAULT Epsom Racecourse, 1821 *oil on canvas* $34\frac{5}{8} \times 47\frac{1}{4}$ *in.*
Paris, Louvre

JEAN BAPTISTE CAMILLE COROT The Forum from the Farnese Gardens, 1826 *oil on canvas* $11 \times 19\frac{5}{8}$ *in.*
Paris, Louvre

JEAN BAPTISTE CAMILLE COROT The Bridge at Narni, about 1827 *oil on canvas 14⅛ × 18¼ in.*
Paris, Louvre

JEAN BAPTISTE CAMILLE COROT Woman in Blue, 1874
oil on canvas $31\frac{1}{2} \times 19\frac{5}{8}$ in.
Paris, Louvre

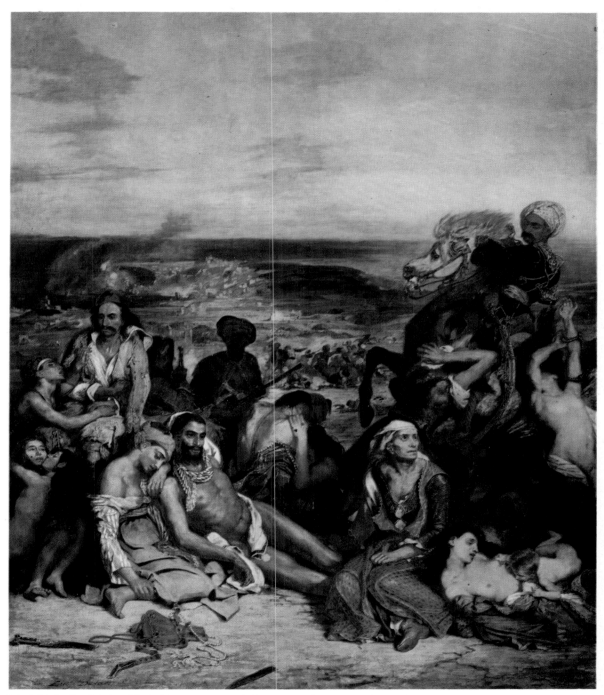

EUGÈNE DELACROIX The Massacre at Chios, 1824 *oil on canvas* *166 × 138½ in.*
Paris, Louvre

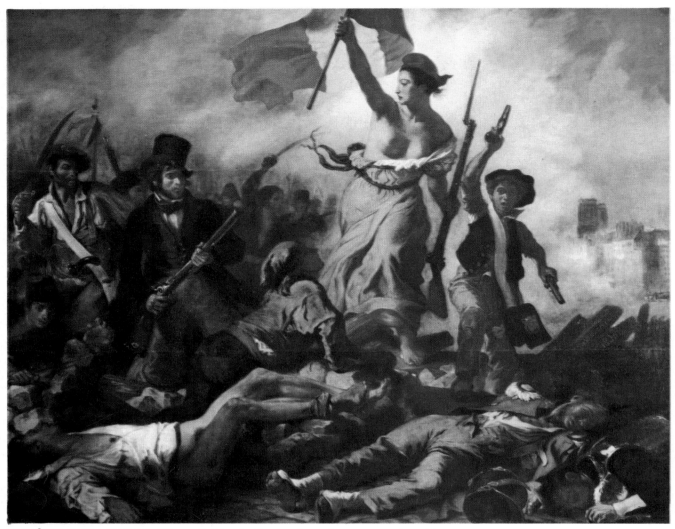

EUGÈNE DELACROIX Liberty Guiding the People, 1830 *oil on canvas* $102\frac{3}{8} \times 128$ *in.*
Paris, Louvre

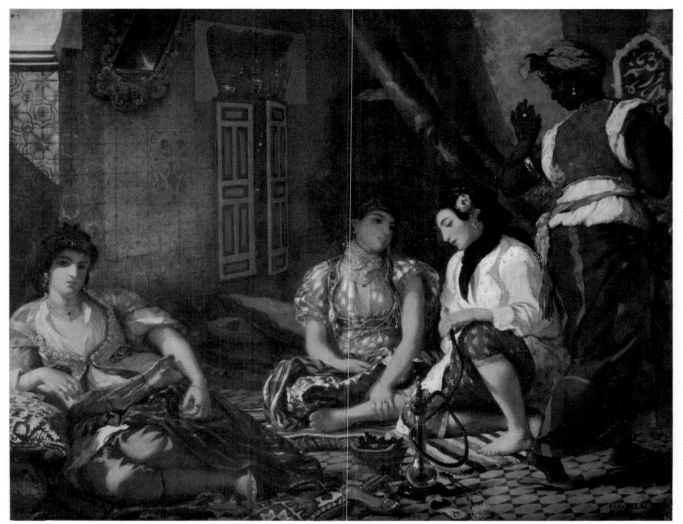

EUGÈNE DELACROIX Women of Algiers, 1834 *oil on canvas* 69⅞ × 89¾ *in.*
Paris, Louvre

HONORÉ DAUMIER Don Quixote, about 1865 *oil on canvas* *39½ × 32 in.*
London, Courtauld Institute Galleries

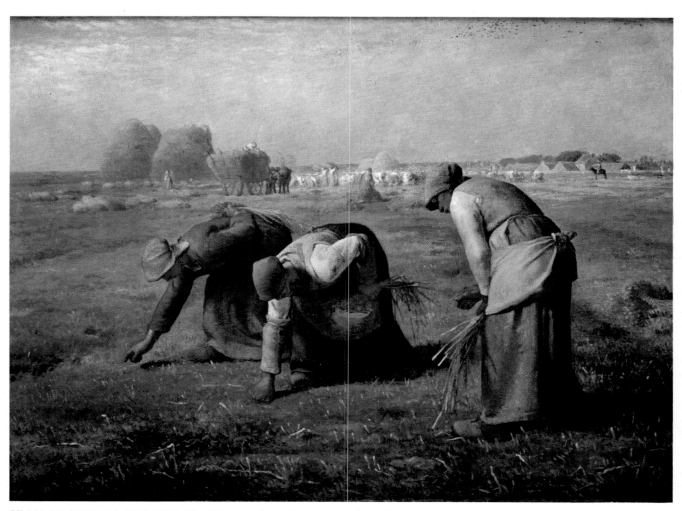

JEAN FRANÇOIS MILLET The Gleaners, 1857 *oil on canvas* *33⅛ × 43¾ in.*
Paris, Louvre

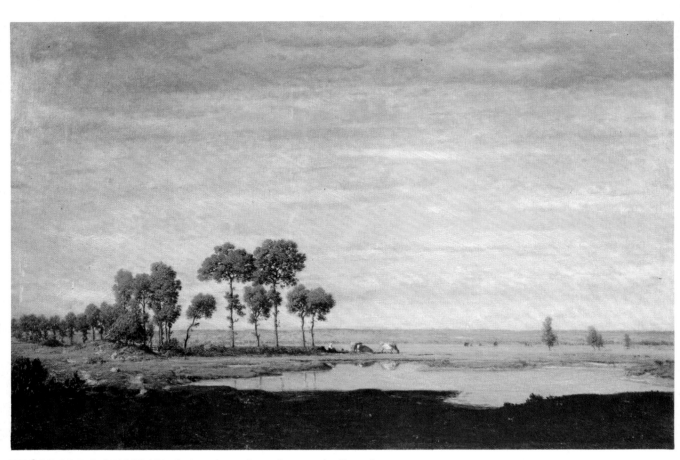

THÉODORE ROUSSEAU Spring, about 1852 *oil on canvas* *16⅜ × 25 in.*
Paris, Louvre

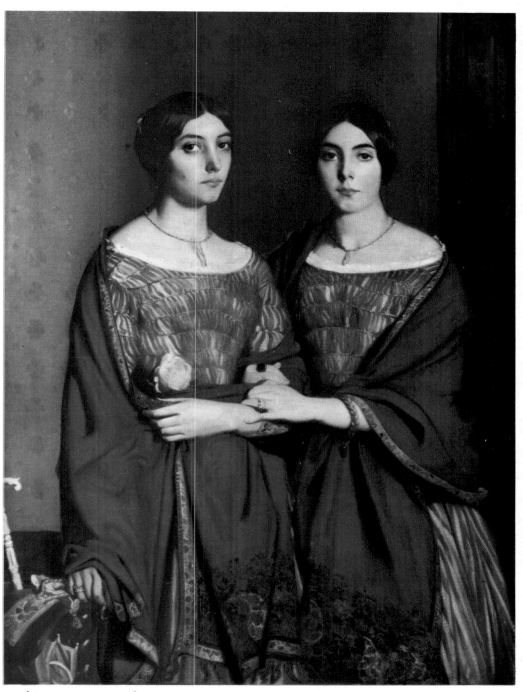

THÉODORE CHASSÉRIAU The Two Sisters, 1843 *oil on canvas* $70\frac{5}{8} \times 53$ *in.*
Paris, Louvre

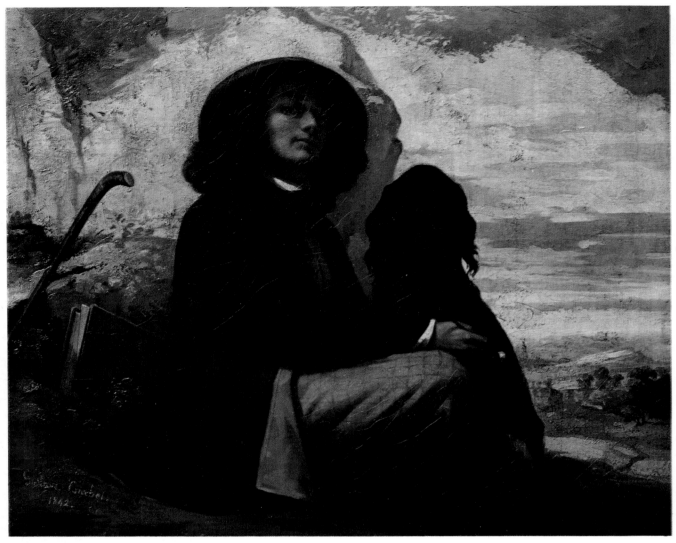

GUSTAVE COURBET Portrait of the Artist with a Black Dog, 1842 *oil on canvas* $18\frac{1}{8} \times 21\frac{5}{8}$ *in.*
Paris, Musée du Petit-Palais

272

BRITISH AND
NORTH AMERICAN ART
TO 1900

BRITISH ART

Painting in England in 1531, when Henry VIII was recognized as head of the Church of England, was still confined to the religious subjects that had occupied manuscript illuminators for centuries. Although the Italian Renaissance had already passed its highest peak and was at that stage in its history known as Mannerism, its influence had not penetrated as far as England. But at about that time, driven by the increasingly serious religious disturbance of the Reformation, a number of European painters emigrated to England, bringing with them the advanced theories and techniques current in Europe. Among these painters was the German Hans Holbein, who was ap-

pointed court painter to Henry VIII and who established the great tradition of English portraiture.

Until the 18th century almost all painting in England continued to be portraiture, and with few exceptions the leading painters were foreign-born. Gerlach Flicke was a German, like Holbein, attached to the court of Henry VIII, and *The Portrait of an Unknown Nobleman* (p. 285) is in the style of his native Westphalia.

Hans Eworth was born in Antwerp, but lived in London for almost 25 years. The portrait of *Lady Dacre* (p. 286) is a mixture of Flemish detail, and an attempt to capture the solidity of Holbein's early por-

traits. Eworth's work is more important as a reflection of the taste of his patrons than for its originality.

Portraiture in the 17th century

The art of miniature painting on vellum had been perfected in the monasteries, and with their dissolution in 1539 the miniaturists turned to portraiture. Nicholas Hilliard was one of the few native English painters; although he is known only by his decorative miniature portraits, he was a central artistic figure in the Elizabethan age. *A Youth Leaning against a Tree among Roses* (p. 287) is representative of his decorative, graceful style, and of its affinity to the French court, which Hilliard is known to have visited.

Isaac Oliver was born in France but was brought as an infant to England by his parents. He was a pupil of Hilliard and, like him, became a miniaturist. The style of *An Unknown Lady* (p. 288) is more prosaic and less poetic than Hilliard's. Oliver's primary objective was a realistic likeness, which he attained by the use of shadow and careful attention to detail.

Daniel Mytens, a Dutch-born painter attached to the court of Charles I, produced a number of royal portraits, many of them for dispatch to foreign courts. *The 1st Duke of Hamilton* (p. 289) is one of Mytens' more notable full-length portraits. Its elegance is a reflection of his study of Sir Anthony van Dyck and other Flemish portraitists.

Samuel Cooper stands with Hilliard as one of the two great British miniaturists. His portrait of *Oliver Cromwell* (p. 290) and those of other prominent figures of the Commonwealth are the most distinguished likenesses in existence. After Van Dyck he was the most sought-after portraitist of the mid-17th century.

William Dobson is the first native painter of considerable stature to appear in England. His color derived from the Venetian painters and the traditions of the High Renaissance, but his most original side is shown in his groups of half-length figures, such as that of *The Artist, Sir Charles Cotterell and Sir Balthasar Gerbier* (p. 291). Both Van Dyck and Dobson were painting in London in the 1640's, but Dobson's style remained independent of Van Dyck's. His figures were less elegant and more robust than Van Dyck's, and his paint was less smooth and polished.

Mrs. Claypole (p. 292), a portrait of Cromwell's daughter, reflects Michael Wright's antiquarian interests. He was in fact antiquary to the Archduke Leo-

pold William in the Netherlands for a time, but the style of this portrait derives from a prolonged visit to Italy. It is full of Italian symbols, including a relief of Minerva issuing from the brain of Jove, presumably a reference to Mrs. Claypole's relationship to Cromwell. The miniature castle and laurel branches are symbols of chastity. Although he was a more sensitive portraitist than Sir Peter Lely, he never achieved Lely's popularity.

Sir Peter Lely was born in Westphalia of Dutch parents, and arrived in London in the early 1640's. He became a fashionable painter and adapted his style to changing social and political conditions. In the 1660's and 1670's his work was so much in demand that he established production-line methods in his studio and much of the work was done by his assistants. This efficient but unimaginative studio procedure has been followed in producing official English portraits to the present day. *Sir Frescheville Holles and Sir Robert Holmes* (p. 293) is characteristic of the rich color, Baroque gesture, and dexterity of Lely's technique.

18th-century painting

Lely's successor was a German, Godfrey Kneller, whose enormous output portrayed the fashionable world of a court that had little artistic taste. Kneller's studio was run in much the same way as Lely's, with "specialists" for wigs, drapery, backgrounds, and other accessories. He was the first British painter to treat the portrait as a documentary likeness, rather than as a work of art, and the engravings made from the paintings of his famous contemporaries have been used to illustrate countless books on English history. Although much of Kneller's work is artistically inferior, a portrait such as *Sir Isaac Newton* (p. 294) is direct and incisive, qualities that are characteristic of the best of his painting.

Pamela Tells a Nursery Story (p. 295) is one of a series of 12 paintings that Joseph Highmore made to illustrate Samuel Richardson's *Pamela*. There is some resemblance in this grouping to paintings of Highmore's contemporary Hogarth, but Highmore's mood is gentle and relaxed, not satirical.

William Hogarth, 1694-1764

Although William Hogarth's ambition throughout most of his life was to paint historical pictures, he actually made very few of these. It is on his "conversa-

tion pieces," which are his own invention, and on his portraits that his fame rests.

"Conversation pieces" were relatively small pictures in which the figures of a group are linked in a simple psychological or anecdotal situation. *Marriage à la Mode*, of which *Scene II* (p. 296) is a part, is a series of conversation pieces designed to expose the weaknesses of high society. While its tone is satirical, it is not one of moral indignation. It is presented more in the spirit of a comedy of manners that might be expected to appeal to, rather than repel, the level of society at which it was directed.

Hogarth seldom made preliminary drawings but improvised as he went along. He was also of an impetuous and ambitious nature, and the combination of these traits sometimes got him into artistic difficulties. There are some 24 figures in *The Wanstead Assembly* (p. 297), which is less than 3 feet long, and the figures at the back are crowded together in a desperate attempt to get them all in.

Hogarth's portraits are not of the elegantly costumed aristocrat intended to hang in a palace, or the country gentleman of means surveying his holdings, but are direct and vigorous portrayals of middle-class subjects. *The Painter and his Pug* (p. 298) is typical of the vitality of his portraiture. He painted directly on canvas without recourse to tonal underpainting, and his sensitivity to the texture of paint is clearly evident.

Samuel Scott, a contemporary of Hogarth, is known primarily by his paintings of men-of-war and other sailing vessels. In 1746 the Venetian painter Canaletto arrived in London and established a vogue for pictures of the Thames and views of the city. Except for the solid British masonry, *Part of Old Westminster Bridge* (p. 299) might have been painted in Venice.

During the first years of his career Arthur Devis traveled around England painting small-scale portraits of country landowners posing in their fields and gardens. Later he made his headquarters in London, painting the conversation pieces Hogarth had made popular. Devis' style never changed, and the widely spaced, stiffly posed figures of *Mr. and Mrs. William Atherton* (p. 300), painted in clear colors and with sharp definition, are typical of all of his pictures. He was a very minor figure in English painting of his own day, but today his naiveté is considered rather refreshing and his pictures have become collectors' items.

Allan Ramsay's training took place in Italy. He brought back a taste for the Grand Manner of portraiture that was expressed in an air of cosmopolitan elegance and became immediately fashionable.

In his early 40's, Ramsay abandoned the earlier Grand Manner for a more graceful and delicate style. The portrait of *Mrs. Martin* (p. 301) reflects his new style in the muted colors, delicate flesh tones, and soft lighting. Toward the end of his life Ramsay stopped painting altogether and turned his studio into a factory for making copies of earlier royal portraits.

Both Ramsay and the Welsh artist Richard Wilson, were born in the same year, 1713. Both were given a sound classical education as painters in Italy, and both returned to England bearing in different ways the imprint of their Italian experiences.

Wilson was temperamentally unsuited to portraiture and, after a second visit to Italy, turned entirely to landscape painting. He made a great many sketches of the campagna around Rome from which he painted a series of pictures on his return to England. *Lake Albano and Castel Gandolfo* (p. 302) was painted in Italy, however, and is in the classic style of Italian landscape. The foreground is dark with small figures, and dark masses of trees are on each side, while the eye is led into the sunlit distance to the Castel.

Wilson's paintings of his native Wales are true to the colors and topography of the countryside, and, as in his Italian views, he has sought those aspects of the subject that fitted into the classical pattern. *Valley of the Mawddach* (p. 303) is a fine example of a formal and foreign tradition applied to a native scene.

Reynolds and the Royal Academy

Sir Joshua Reynolds believed that all painting should be high-minded and noble, based on the idealized human figures of Raphael, Michelangelo, and the Venetian Renaissance painters, as well as on the antique sculpture in the Vatican Gallery. This intellectual traditionalism was symbolized by the founding of the Royal Academy with Reynolds as its first president. His academic precepts influenced several generations of English taste and were responsible for a great deal of serious and extremely dull painting. Nor did Reynolds himself escape the detrimental effects of such eclecticism, for his numerous historical pictures are mannered and unconvincing.

However, Reynolds was a gifted and cultivated man, living in the midst of a period in British history

that was exceptionally active both politically and artistically. His portraits of the men and women of his time are penetrating and, because his sitters were drawn from a broad stratum of society, cannot be matched for variety. *Nellie O'Brien* (p. 304) was a renowned beauty, and she is painted with a sympathy and tenderness that is enhanced by the silvery colors. It is representative of the intimate type of portrait in Reynolds' early work.

In *Garrick between Tragedy and Comedy* (p. 305) the quiet perfection of *Nellie O'Brien* is replaced by a more rhetorical manner and an obvious classical reference as a modern interpretation of the theme of Hercules between Virtue and Vice.

Colonel St. Leger (p. 306) is an example of the kind of informal full-length portrait that Reynolds painted following the highly classical manner of his middle period. He has abandoned the antique drapery of his classical style and returned to contemporary dress and the more human values of his early work.

Unlike any of his contemporaries, George Stubbs was totally uninterested in the art of the past, and he approached painting through the study of anatomy. All of nature absorbed Stubbs. He was as interested in trees and plants as in animals, and particularly in horses. If at times his pictures lack complete integration of all the parts, the accuracy of the drawing and the flowing rhythm engendered by the curves of animals and landscape compensate more than adequately for the occasional faulty composition. *Mares and Foals in a Landscape* (p. 307) is as typical of Stubbs' anatomical accuracy as it is of the affectionate regard in which he holds the animal world.

Thomas Gainsborough, 1727-1788

Sir Joshua Reynolds had only one serious rival in the field of portraiture, and that was Thomas Gainsborough, who preferred painting landscapes to portraits. The majority of his work, however, is in portraits. He was not especially interested in the psychology of his sitters and is at his best with those who have no particular character. He treats them with lightness and gaiety, interested always in the momentary effects of light and shadow or the flickering highlights of a silk dress. Unlike Reynolds and Ramsay, he painted all his portraits himself without the help of assistants. He had a sensitive feeling for color, and it has a richness that Reynolds never achieved.

Mr. and Mrs. Andrews (p. 308) is an early work in the "conversation piece" tradition, but with a difference, for here the figures and the landscape are of equal importance. The picture has a freshness and naturalness untouched by any consideration for fashionable taste.

Unfortunately, most of Gainsborough's clients did not care to be pictured in their native environment, and he was forced into the kind of artificial landscape that forms the background for *Mary, Countess Howe* (p. 309). This is a typical life-size portrait, light and airy and rich in color and texture, with more than a hint of French rococo but tempered by natural English restraint.

The Harvest Wagon (p. 310) is one of the great English landscapes. In the grouping and movement of the human figures and the horses, and the play of light and shade upon them, Gainsborough creates a rhythm that is at once natural and graceful. Social distinctions and fashions have no part in this lyrical expression of the beauty of the English scene.

Joseph Wright lived in Derby in the Midlands, surrounded by a society devoted to the scientific experiments attendant on the industrial revolution. Thus Wright's absorption in the pictorial effects of artificial light was the natural result of his environment, and he was the first English artist to give expression to this new and intense scientific spirit.

Experiment with an Air-pump (p. 311) combines Wright's scientific propensities with his talents as a portraitist to produce a painting that is not only highly complex in formal organization, but also gives natural expression to a variety of human emotions. It is one of the most successful and original paintings of its kind in British art.

George Romney was another fashionable painter of London society but not of the stature of his contemporaries. He neither penetrated to the secret personality of his sitter, as in the best of Reynolds, nor imposed on them his own artistic imaginings, as did Gainsborough. His sitters did not demand a strong likeness; they wanted health, youth, good looks, and an easily recognizable position at the top of the social scale. He is at his best with young, good-looking, finely dressed people. *Lady Hamilton in a Straw Hat* (p. 312) is one of many pictures that Romney painted of her from direct sittings, sketches, and memory.

Johann Zoffany, a German, gained his first success

in England through his association with the actor David Garrick as a painter of theatrical conversation pieces. Garrick had a flair for publicity and saw in engravings made from these theatrical illustrations a way of advertising his stage productions. The vogue for Zoffany's theatrical paintings lasted for about eight years and then apparently died out, for he turned to domestic conversation pieces. Pictures such as *The Dutton Family* (p. 313), in which the paintings on the wall, the bric-a-brac on the mantel, and the design of the carpet are all as carefully delineated and as identifiable as the family members themselves, were always in demand by those who could afford them.

Benjamin West was an American of Pennsylvania Quaker stock, who, after several years in Italy, set himself up as a portrait painter in London. He also began to paint small historical pictures, and it was in this vein that he became really successful.

In the English tradition of historical painting even contemporary events required classical costume. *The Death of Wolfe* (p. 314) was the first painting to commemorate a contemporary event in contemporary dress, and it was an immediate success, although it can lay no claim to historical accuracy or to any high standard of artistic excellence.

Later, West turned to medieval subjects presented in medieval dress, and these paintings too, were successful. In 1792 he succeeded Sir Joshua Reynolds as president of the Royal Academy, a measure of the esteem in which he was held.

Francis Wheatley painted mostly small portraits and conversation pieces, and later a series of somewhat sentimental pictures extolling the picturesque and virtuous qualities of the poor. In large canvases filled with figures, such as *Lord Aldeburgh Reviewing Troops* (p. 315), he reveals a feeling for landscape effects.

All the known works of John Robert Cozens, most of them watercolors, are landscapes based on two Italian journeys. English scenery did not stimulate his imagination, which was of a romantic cast. *Gardens of the Villa Negroni* (p. 316) and some of his other Italian scenes introduced a new note into landscape painting in England, and his work was admired and studied by most of the 19th-century landscapists.

Sir Henry Raeburn was the leading portrait painter in Scotland in the last decade of the 18th century and into the 19th. At one time he intended to move to London, but realized that his style was not suited to London taste. He developed a broad, fluent brushwork, painting directly on the canvas without underpainting, that was well suited to conveying the robust strength and ruggedness of his fellow Scotsmen. *Mrs. Colin Campbell of Park* (p. 317) is a good example of Raeburn's subtle and restrained color.

The Romantic movement

The Swiss-born painter Henry Fuseli and William Blake were close friends. Both were illustrators and Romantic visionaries, and their work has some similarity. Fuseli is best known for his illustrations of Milton and Shakespeare. *Macbeth and the Witches* (p. 318) is representative of one phase of the early Romantic movement in its highly dramatic presentation and somber mood.

If one man can be said to symbolize the Romantic spirit, he would be William Blake, who was a poet, a painter, and a mystic. Illustrated books of his own poems, Dante's *Divine Comedy*, Milton's *Paradise Lost,* and *The Book of Job* from the Bible were among his most important creations.

As an artist Blake was largely self-taught, learning from engravings after Michelangelo, Raphael, and other Italian artists. Through his training as an engraver he developed an exceptionally sensitive and controlled line. His paintings are seldom larger than *The Whirlwind of Lovers* (p. 319), and some are much smaller. All are watercolors or hand-colored engravings that often achieve a sumptuous richness. Had he chosen a larger format, the deficiencies of his training might have been more obvious, but working as he did, he managed to condense into a small area some of the most powerfully imaginative drawings ever made.

George Morland's paintings are all much like *The Ale House Door* (p. 320)—farm scenes with animals, interiors of stables, and rustic landscapes. They are painted in a fresh, effortless style that owes a good deal to the Dutch school of landscape and genre. Oddly enough, ever since they were painted they have been collectors' prizes, and have continued to bring high prices in England.

Benjamin Marshall belongs to that very English group known as "sporting painters" who were concerned with horses, horse racing, and hunting. The general run of English sporting pictures is better judged by the horse fancier than the art historian, and is generally considered to be very low on the artistic

scale. However, a few painters, of whom Benjamin Marshall was one, can be considered on the same level of seriousness as the portrait or history painter. In the blending of landscape and figures, subtle coloring and excited movement of the dogs, *Francis Dukinfield Astley and his Harriers* (p. 321) is an integrated and well-composed picture that perfectly expresses the spirit of an English hunt.

19th-century landscape painting

John Crome and Thomas Girtin were both landscape painters of some note at the turn of the century. Crome's pictures, such as *Mousehold Heath, Norwich* (p. 322), were broad, serene views of the Norwich countryside, painted in a clear light and straightforward colors.

Girtin was a fellow student with Turner, and both were impressed with the work of John Cozens. Most of Girtin's paintings, such as the watercolor *Kirkstall Abbey* (p. 323), were broad, simple landscapes that included a castle or monastery. The watercolor technique that he developed had a significant influence on all 19th-century landscape painters in this medium, especially Turner and Constable.

As a student in the Royal Academy school, Thomas Lawrence was a devoted disciple of Sir Joshua Reynolds and longed to paint historical pictures in the Grand Manner. Unable to achieve it, he turned to portraiture. *William Lock* (p. 324), an early portrait painted while Lawrence was still under Reynolds' influence, suffers from an overly theatrical pose resulting from his efforts to emulate the Grand Manner. *Mrs. Wolff* (p. 325) is representative of the more mature and elegant style that ensured his popularity. The portraits of his later years show a keener perception of his subjects' personalities and a more subtle presentation.

Turner and Constable

Joseph Mallord William Turner and John Constable were contemporaries, and their names are often linked as the two most important landscape painters in the history of English art. Yet two more different styles can scarcely be imagined. Constable's paintings are the result of patient observation of nature, of trees and plants, of the shifting pattern of shadows on fields and hills, and the changing forms and movements of clouds. Turner's paintings are the result of a romantic imagination that searched for the most dramatic and spectacular aspects of nature and portrayed them in a way calculated to arouse the strongest possible emotional response in the viewer.

The three paintings *Buttermere Lake* (p. 326), *The Bay of Baiae* (p. 327), and *The Slave Ship* (p. 328) form a good index to the development of Turner's art. *Buttermere Lake* is in the stormy mood of the early Romantic school, and shows some influence of the work of Thomas Girtin (p. 323). *The Bay of Baiae* was painted after Turner's first visit to Italy, which resulted in a brighter palette, a developing interest in the effects of light and atmosphere, and an appreciation of Richard Wilson's landscapes (p. 303). By 1840, when *The Slave Ship* was painted, Turner had become immersed in the study of light and color, and evolved the technique by which lower layers of pure color filter through the upper layers and create the luminous glow in which his forms are enveloped.

For Constable as for Turner the search for effective pictorial equivalents of light is the primary problem in landscape painting. A comparison of *Stratford Mill on the Stour* (p. 329) with *The Leaping Horse* (p. 330), painted five years later, shows the manner in which Constable developed his solution to this problem. Although the overall tonalities of the two paintings are much the same, the color in any one area of *The Leaping Horse* is made up of varying tones of that color, applied side by side in short strokes that fuse at a distance into one hue. This is what gives to the dark areas the luminous quality that is lacking in the earlier painting. Constable also discovered that when light is reflected from a glossy surface the color is momentarily destroyed—hence the flickering highlights that came to be known as "Constable's snow."

Watercolor

Old Sarum (p. 331), being a watercolor, is constructed in a very different manner from an oil painting. It is built up of sensitively graded tonal washes, the lighter ones being the most luminous since the medium is transparent and the paper reflects light through the thin film of color. Unlike the oil technique of this time in which a picture is built up from the darkest tones through gradually lighter values, with highlights put in last, watercolor painting is done in reverse, starting with the lightest tones. It is a more difficult medium to control since no overpainting is possible. Such English watercolorists as Cozens, Girtin,

Blake, Turner, Constable, and Cotman gave to watercolor its distinguished position in the history of European art.

John Sell Cotman in his early work was influenced by Thomas Girtin with whom he went to Wales. He later broke away from Girtin's influence and developed a watercolor style of his own. *The Ploughed Field* (p. 332) is an example of this personal style, which consisted basically in a pencil sketch tinted with color washes, the salient details being picked out with a reed pen. He was never as successful with oils, and his early watercolors are his best work.

David Cox was also a watercolorist and made his reputation with small, highly colored, and intricate rustic scenes. He later became an able painter in oils, but many of them are repetitions of earlier watercolors. *Rhyl Sands* (p. 333), though painted in oils, retains much of the quality of a watercolor.

Sir David Wilkie was born in Edinburgh but attended the Academy school in London. He is best known for the genre paintings that made his reputation. The result of his study of Rembrandt and the Dutch genre painters is evident in *The Blind Fiddler* (p. 334).

Although he painted a number of historical and genre pictures, the largest portion of William Etty's work consists of nude studies. The Baroque style of *The Storm* (p. 335) derives from Titian and Rubens. Etty was one of the very few 19th-century English painters to specialize in the nude.

Most of Richard Parkes Bonington's work was done in France where his family had settled. His work in both watercolor and oils aroused considerable interest in Paris, and since he painted directly from nature, he was much admired by the Barbizon School of outdoor painters. *Le Parterre d'Eau, Versailles* (p. 336) is a good example of Bonington's fresh, bright color and apparently casual composition.

Sir Edwin Landseer was undoubtedly the most popular animal painter in his own time that England ever produced. Unfortunately it was a time when popular taste was for the trivial, the anecdotal, and, above all, the sentimental. Landseer showed an early aptitude for animal painting, and his first works had considerable vitality. When he was 22, he had the misfortune to paint, and exhibit, a picture that was received with wild acclaim. For the rest of his life Landseer's popularity neither waned nor was questioned. *The Challenge* (p. 337), sentimental as it is, is one of the least offensive of his works. To many of his animals he attributed human characteristics and represented them as typical Victorian characters, thereby degrading both animal and man.

Samuel Palmer's first paintings were conventional Romantic landscapes influenced by Cox and the early works of Turner. Somewhat later he fell under the spell of William Blake's world and painted a series of pastoral and mystical landscapes. *Coming from Evening Church* (p. 338) is one such visionary scene of rural peace. His later landscapes, while never undistinguished, lost the visionary quality that made his earlier work unique.

The religious paintings by which William Dyce is known were inspired by his contact with the Nazarenes, a group of Italian artists who attempted to revive the spirit and techniques of medieval painting. The small *Gethsemane* (p. 339) is as much a Romantic landscape as a religious subject.

Apart from his portraits of eminent men, which are often unusually searching interpretations of character, the work of George Frederic Watts suffers from the temper of his time. His many allegorical paintings, however sincere in their desire to be uplifting, too often lapse into sentimentality. *The Wounded Heron* (p. 340) is a very early work painted while his style was still unformed.

William Powell Frith began his artistic career as an illustrator and painter of historical and literary scenes. He became interested in the possibilities of painting contemporary life, but was apprehensive about their acceptance—unnecessarily, since one of the first of such paintings was bought by Queen Victoria. *The Railway Station*, of which only a detail is shown (p. 342), is a large and ambitious canvas, filled with figures and full of incident.

The Pre-Raphaelite Brotherhood

The Pre-Raphaelite Brotherhood was a revolutionary art movement that began in the mid-19th century as a protest against the artificiality of the Grand Manner, which, according to the members of the group, originated with Raphael. This led them to a study of earlier Italian and Flemish art, and since it was impossible to recreate the spiritual environment of that period, it was the detailed realistic manner of the early Flemings that had the strongest influence.

Sir John Everett Millais and Holman Hunt were the leaders of the Pre-Raphaelite movement, and Ford Madox Brown, Dante Gabriel Rossetti, and Arthur Hughes were all devoted members while the movement was active.

Hunt's *The Scapegoat* (p. 341) disregards all the academic rules of design and color, has a genuine symbolic meaning, and is a clear and accurate representation of nature—all of which were characteristic of the Pre-Raphaelite conception.

The honest, detailed, unidealized *Work* (p. 343) of Ford Madox Brown is an expression of his political leanings, regarded as radical at that time. The painting is very much in the Flemish realistic tradition, and is one of the finest of the Pre-Raphaelite paintings.

Rossetti's *The Annunciation* (p. 344) accords with the Brotherhood's ideal of simplicity and realistic painting from individual models. In later works Rossetti diverged from the agreed manner and became more elaborate and idealized his subjects.

Millais' best work was done while he was an active member of the Pre-Raphaelite group, but in 1853 he completely reversed himself and as an associate of the Royal Academy became a fashionable and brilliant painter of portraits, popular themes, and genre subjects. *The Blind Girl* (p. 345), while retaining something of the simplicity of his earlier work, is already degenerating into a facile sentimentality.

Arthur Hughes' delicate and poetic *April Love* (p. 346) was painted during the period of his association with the Brotherhood. He was not an aggressive member, and shortly after this picture was painted he left London and the society of other artists and retired into the obscurity of the suburbs.

NORTH AMERICAN ART

The first painting in the North American colonies was the work of journeymen, most of them not known by name, who traveled from place to place in search of portrait commissions. These artists were entirely self-taught. They knew no anatomy and painted their stiff, oddly proportioned figures without modeling or other indications of three-dimensional form. The charm of these late 17th-century paintings, like that of all folk art, lies in the artist's intuitive sense of color and pattern, and in the simplicity and directness of his communication.

In 1729, John Smibert arrived in the New World, bringing with him the technical and formal traditions of European art. Smibert, although born in Edinburgh, had studied painting in both England and Italy, and was established as a portrait painter in London. However, he lacked the elegance demanded by fashionable society and was not overly successful. When an opportunity arose he came to America and settled in Boston. New England taste was less sophisticated, and Smibert painted portraits of Boston society with great success.

Bishop Berkeley and his Family (p. 348) was one of the most ambitious paintings that had yet been attempted in the colonies. It is a type of group portrait that was enjoying considerable popularity in England at the time. Smibert's group is not very imaginatively disposed, but the personalities of the individual figures are well differentiated.

Robert Feke's *Isaac Royall and his Family* (p. 347) is obviously based on Smibert's Berkeley group. It is an early work, and Feke later developed a distinguished and elegant portrait style that was far more sensitive than Smibert's. He was particularly noted for his vivid and graceful portraits of women, and for the earliest of the innumerable portraits of Benjamin Franklin.

John Singleton Copley's reputation rests on the series of portraits he painted before he left America in 1774 to live in England. *Mrs. Thomas Boylston* (p. 349) is an example of the completeness with which Copley has recorded the character and appearance of his sitter. He worked slowly and had inexhaustible patience in matching on his palette the colors he observed in his model. His drawing is precise, and he saw form as an outline enclosing a plane that was further defined by tints and gradations of color.

In England, Copley turned to historical painting. He chose subjects of contemporary interest involving well-known characters, who served to promote his talents as a portraitist at the same time. *Watson and the Shark* (p. 350) records a youthful adventure of a prominent social and political figure. It was unique for its time in treating a historical subject as romantic and exciting rather than as factual and serious.

Charles Willson Peale is known primarily for his portraits of George Washington and other outstanding men of his time. He was a man of wide interests and maintained a museum of natural history known as Peale's Museum. He was also instrumental in the founding of the Pennsylvania Academy of Fine Arts, one of the first art schools in America. *The Staircase Group* (p. 351) is a picture of his two sons that hung for many years in the portrait gallery connected with his museum.

Like Peale, Gilbert Stuart painted a portrait of Washington, and became famous for his likenesses of prominent people. *Mr. Grant Skating* (p. 352) is one of his few successful full-length portraits. His skill in conveying vitality was almost entirely confined to the face. He painted in quick, short strokes, in an almost impressionistic manner, building up his forms in light tenuous tones of color rather than as outlined forms filled with color. The total effect was a somewhat idealized likeness of the sitter that was quite different from the usual literal American portrait.

John Trumbull served as aide-de-camp to General Washington, and his army experience inspired him to paint scenes of important episodes of the Revolution, one of which is *The Battle of Bunker's Hill* (p. 353). After a period in London as a moderately successful portrait painter, Trumbull returned to America and was commissioned to paint four Revolutionary War scenes for the rotunda of the Capitol. However, he had lost his original enthusiasm. Although his work was imposing and dignified, it tended to be flat and lifeless, and was coolly received. In his last years Trumbull was discouraged and resentful of the treatment he had been accorded. Because he made a genuine attempt at accuracy, his historical pictures have been reproduced as illustrations for countless books on American history, and despite their meager qualifications as art, they have become a part of the American tradition.

Washington Allston spent considerable time in training as an artist in London, Paris, and Italy, not returning to America until 1818 when he was 39. *The Deluge* (p. 354) is a large canvas, typical of his European period in which he gave a Romantic expression to the grandeur of nature. After 1818 his work developed a lyrical, dreamlike quality and was much smaller in scale.

Although Thomas Cole was born in England and did not come to America until he was 19, few painters had a stronger love and pride in the country of their adoption. He eventually settled in a small village on the Hudson River and is known as one of the Hudson River School. This is a term rather loosely applied to a number of painters working during the period from 1820 to 1870, who chose panoramic views of mountains and river valleys as their subjects. Cole wandered on foot through the Northeastern states. Wherever he went, he made sketches that he later used as bases for paintings in his studio. Pictures such as *The Oxbow of the Connecticut* (p. 355), with its mixture of subjective mood and realism, had an immediate popular appeal as visual expressions of the vastness of a country that Americans were beginning to appreciate.

Raffling for the Goose (p. 356) is one of William Sidney Mount's pictures of Long Island country life in the first half of the 19th century. Unlike many of his contemporaries Mount had no wish to travel in Europe, and drew his subjects from the many pictorial possibilities offered by the life and surroundings of Stony Brook. Until recently the anecdotal aspect of Mount's work has overshadowed his technical abilities as draftsman and painter. The drawing in *Raffling for the Goose* is full of movement and expression, and the composition as a whole is well balanced. The colors, though not brilliant, are warm and clear, and the effect of the picture is one of unstudied naturalness.

George Caleb Bingham spent his youth in Missouri, which was frontier country in the early 1800's. He was active in politics, and in painting his aim was to describe the "social and political characteristics" of his country. In practice, his subjects were political campaigns and elections, and life along the Missouri and Mississippi rivers. His political pictures are large, ambitious works with many figures, but it is on his paintings of picturesque river life that his fame rests. *Fur Traders Descending the Missouri* (p. 357) is a characteristic scene of frontier life. The figures are as carefully drawn as portraits, and the romantic atmosphere and sense of deep space of the landscape are achieved by sensitive and delicate color relationships. The balance between the figures in the boat, their reflections in the still water, and the trees that recede into the mist creates a formal pattern that is both satisfying and complex. It is one of the best-known American pictures and must have had a particular appeal in its time for the suggestion of a vast unexplored wilderness.

Although George Inness was a frequent European

traveler, and made free use of the technical knowledge he acquired there, he never became an imitator of foreign styles. Except for several years of apprenticeship to an engraver, Inness was self-taught. His early landscapes were in the style of the Hudson River School—tightly painted and topographically accurate observations. He soon perceived the limitations of the Hudson River approach, and his painting gradually became broader and freer, until his last years, when his glowing colors and blurred outlines suggest a kind of Impressionism. *Autumn Oaks* (p. 360) was painted in his early mature period when he was concerned with the movement of clouds and the resulting patterns of sunlight and shadow on the landscape. The brushwork is free, the colors are rich, and, though the details are realistically recorded, the feeling of air and atmosphere combine to produce a reflective, poetic mood.

Nearly all American painters from John Smibert to George Inness were influenced to some degree by the technical or formal traditions of European art. Yet their most interesting work is that which departs from accepted formulas and follows its own inclinations. There is a freshness and vitality in the work of the American painters, as if they saw their world with newer and sharper eyes than their European contemporaries.

For a time after World War I, American painting again came close to prevailing European artistic trends in the development of the Cubist movement and early Abstract painting. But the independence and the creative vitality of the American painter had been established, and in the 1950's, for the first time, America became a leader in world art.

Canadian painting

Although the City of Quebec was founded by the French in 1608, it was not until after the middle of the century that any sustained effort was made to bring settlers to the new colony. Most French Canadian painting until late in the 18th century was done by anonymous local artists and is of interest chiefly to historians. More skilled artists at the end of the century went to Paris for study and brought back the prevailing European styles. Painting was little affected by the establishment of British rule in 1760, and until the middle of the 19th century remained closely attached to French artistic traditions.

Colonization of the English-speaking provinces of Upper Canada and the Maritimes began much later. Toronto, originally the site of an Indian village, was founded in the last decade of the 18th century, and until well into the next century painting was left to local artists, visiting Europeans, and the occasional Yankee itinerant.

One of the first European artists to paint the Canadian scene was Cornelius Krieghoff, a native of Düsseldorf, who settled in Quebec in 1833. Many of his paintings, such as *Merrymaking* (p. 359), were of drinking parties in roadside taverns—rather stereotyped scenes in the Dutch peasant tradition. They were particularly popular with the English garrison officers.

Antoine Sebastien Plamondon was a French Canadian who studied in Italy and in Paris where he came under the influence of the classical style of Jacques Louis David. Technically Plamondon was an accomplished painter, but except for the subjects of his portraits, such as *Soeur St. Alphonse* (p. 358), he was not an interpretor of the Canadian scene. He painted a number of religious pictures and altarpieces, and they, as well as the portraits, adhered closely to the French academic tradition.

Until 1920 painting in both French and English Canada was produced either by foreign-born artists with their own national traditions, or by native-born painters who acquired their tastes and techniques in Europe, and saw little to interest them in their own country.

In 1920 a group of artists employed in a large commercial engraving establishment in Toronto were drawn together by a common enthusiasm for the northland of Ontario as a source of material for landscape painting. They called themselves the Group of Seven, and their avowed purpose was to break with academic traditions and establish a distinct Canadian style. Each of the group began to paint what he himself saw in the manner he felt best conveyed his vision, not through the eyes and dictates of the past. Like most revolutionary movements the work of the Group of Seven encountered hostility and ridicule before it was finally accepted by critics and the public. The importance of the group is considerable because it freed Canadian art from the dilemma of a country that had no artistic tradition of its own. Since that time the foreign influences that are inevitable in the artistic history of any country have been much more quickly and completely assimilated.

List of Color Plates

Color Plates

1 BRITISH

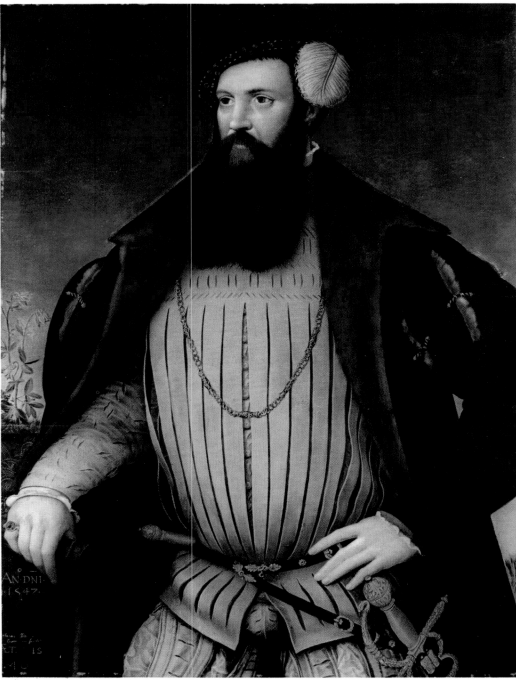

GERLACH FLICKE Portrait of an Unknown Nobleman, 1547 *oil on wood 39¼ × 29¼ in.*
Edinburgh, National Gallery of Scotland

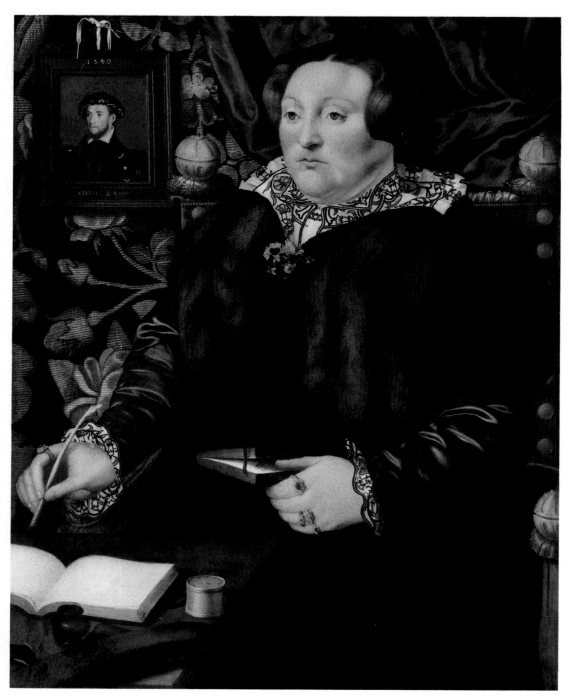

HANS EWORTH Lady Dacre, about 1554 *oil on wood* 29 × 22¾ *in.*
Ottawa, National Gallery of Canada

NICHOLAS HILLIARD A Youth Leaning against a Tree among Roses
about 1588 *watercolor on vellum* $5\frac{3}{8} \times 2\frac{3}{4}$ *in.*
London, Victoria and Albert Museum

ISAAC OLIVER An Unknown Lady, about 1605 *watercolor* *diameter 5 in.*
Cambridge, England, Fitzwilliam Museum

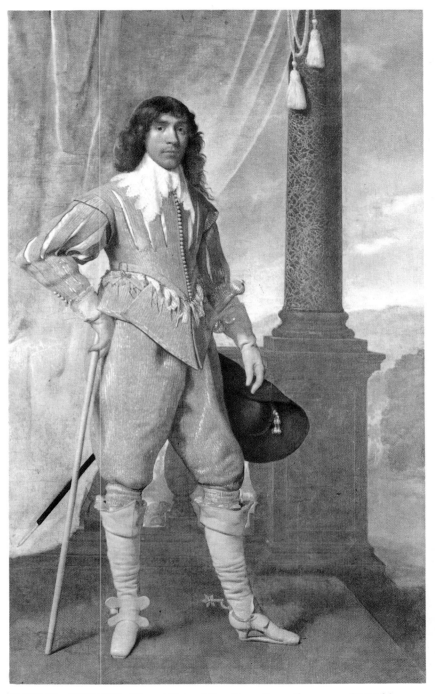

'DANIEL MYTENS The 1st Duke of Hamilton, 1629 *oil on canvas 85 × 53¼ in.*
Edinburgh, National Gallery of Scotland, collection the Duke of Hamilton

SAMUEL COOPER Oliver Cromwell, 1657 *watercolor $3\frac{1}{4} \times 2\frac{1}{4}$ in.*
Drumlanrig Castle, Scotland, collection the Duke of Buccleuch and Queensberry

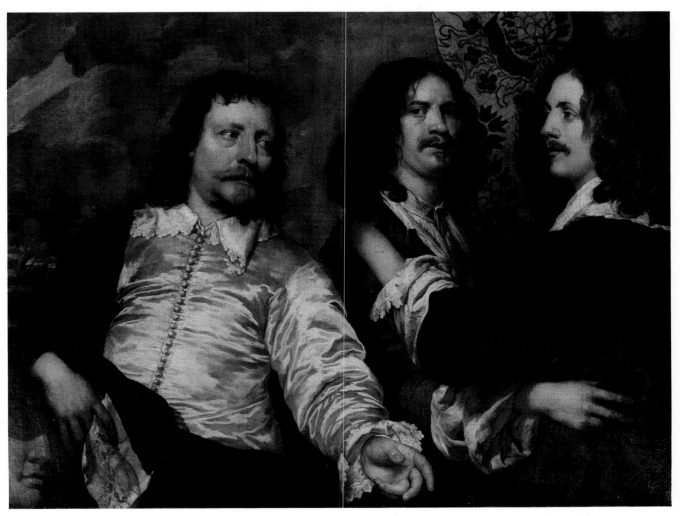

WILLIAM DOBSON The Artist, Sir Charles Cotterell and Sir Balthasar Gerbier, about 1645 *oil on canvas* $38\frac{1}{2} \times 49\frac{1}{2}$ *in.*
Albury Park, Guildford, England, collection Helen, Duchess of Northumberland

MICHAEL WRIGHT Mrs. Claypole, 1658 *oil on canvas 21 × 17½ in.*
London, National Portrait Gallery

292

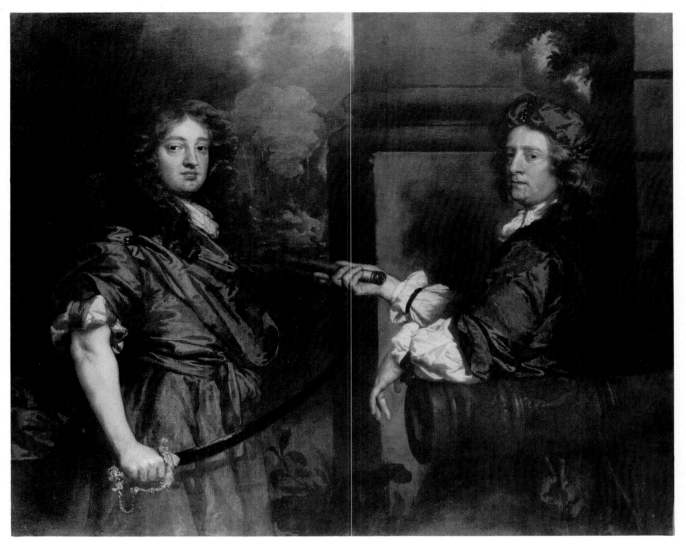

SIR PETER LELY Sir Frescheville Holles and Sir Robert Holmes, about 1670 *oil on canvas 52 × 64 in.*
London, National Maritime Museum

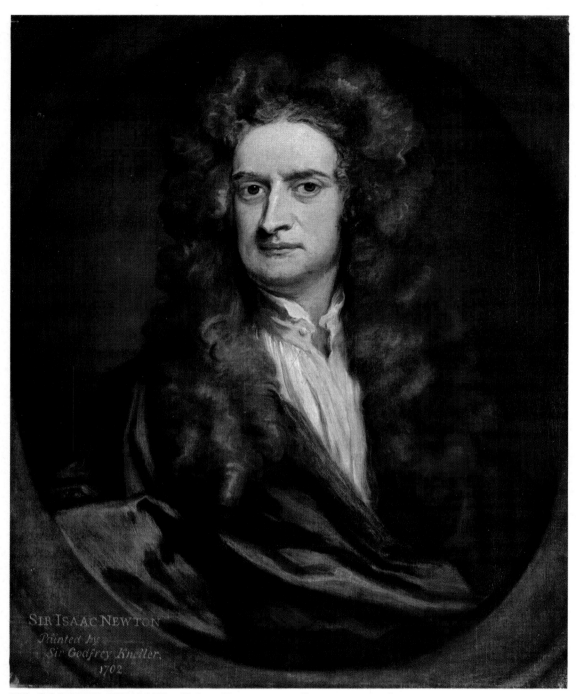

SIR GODFREY KNELLER Sir Isaac Newton, 1702 *oil on canvas 30 × 25 in.*
London, National Portrait Gallery

JOSEPH HIGHMORE Pamela Tells a Nursery Story, about 1744 *oil on canvas 25 × 31 in.*
Cambridge, England, Fitzwilliam Museum

WILLIAM HOGARTH Marriage à la Mode, scene ii, 1743 *oil on canvas* 27 × 35 *in.*
London, National Gallery

WILLIAM HOGARTH The Wanstead Assembly *oil on canvas* *25 × 30¼ in.*
South London Art Gallery, Camberwell Borough Council

WILLIAM HOGARTH The Painter and his Pug, 1745 *oil on canvas* $35\frac{1}{2} \times 27\frac{1}{2}$ *in.*
London, Tate Gallery

SAMUEL SCOTT Part of Old Westminster Bridge *oil on canvas* $10\frac{3}{4} \times 15\frac{1}{2}$ *in.*
London, Tate Gallery

ARTHUR DEVIS Mr. and Mrs. William Atherton, about 1747 *oil on canvas 36 × 50 in.*
Liverpool, England, Walker Art Gallery

ALLAN RAMSAY Mrs. Martin, 1761 *oil on canvas 50 × 40 in.*
Birmingham, England, City Museum and Art Gallery

RICHARD WILSON Lake Albano and Castel Gandolfo, 1754 *oil on canvas 30 × 39½ in.*
Port Sunlight, Cheshire, England, Lady Lever Art Gallery

RICHARD WILSON Valley of the Mawddach *oil on canvas* *$39\frac{3}{4} \times 42$ in.*
Liverpool, England, Walker Art Gallery

SIR JOSHUA REYNOLDS Nelly O'Brien, 1763 *oil on canvas* *49¾×39¼ in.*
London, Wallace Collection

SIR JOSHUA REYNOLDS Garrick between Tragedy and Comedy, about 1761 *oil on canvas 58×72 in.*
England, Private Collection

SIR JOSHUA REYNOLDS Colonel St. Leger, 1778 *oil on canvas 93 × 58 in.*
Waddesdon Manor, Aylesbury, England, National Trust

GEORGE STUBBS Mares and Foals in a Landscape, about 1760-69 *oil on canvas* *40 × 63¾ in.*
London, Tate Gallery

THOMAS GAINSBOROUGH Mr. and Mrs. Andrews, about 1750 *oil on canvas* *27½ × 47 in.*
London, National Gallery

THOMAS GAINSBOROUGH Mary, Countess Howe, about 1760
oil on canvas 96 × 60 in.
London, Kenwood, Iveagh Bequest

THOMAS GAINSBOROUGH The Harvest Wagon, about 1767 *oil on canvas* *47½ ×57 in.*
Birmingham, England, Barber Institute of Fine Arts

JOSEPH WRIGHT Experiment with the Air-pump, about 1768 *oil on canvas* *72×96 in.*
London, Tate Gallery

GEORGE ROMNEY Lady Hamilton in a Straw Hat, about 1785 *oil on canvas 29½ × 24½ in.*
San Marino, California, Henry E. Huntington Art Gallery

312

JOHANN ZOFFANY The Dutton Family, about 1765 *oil on canvas 40×50½ in.*
Farley Hall, Reading, England, collection the Hon. Peter Samuel

BENJAMIN WEST The Death of Wolfe, 1771 *oil on canvas* *59½ × 84 in.*
Ottawa, National Gallery of Canada

FRANCIS WHEATLEY Lord Aldeburgh Reviewing Troops, 1782 *oil on canvas* *61 ×94½ in.*
Waddesdon Manor, Aylesbury, England, National Trust

JOHN ROBERT COZENS Gardens of the Villa Negroni, 1783 *watercolor* $11\frac{1}{2} \times 15$ *in.*
England, collection Commander H. L. Agnew

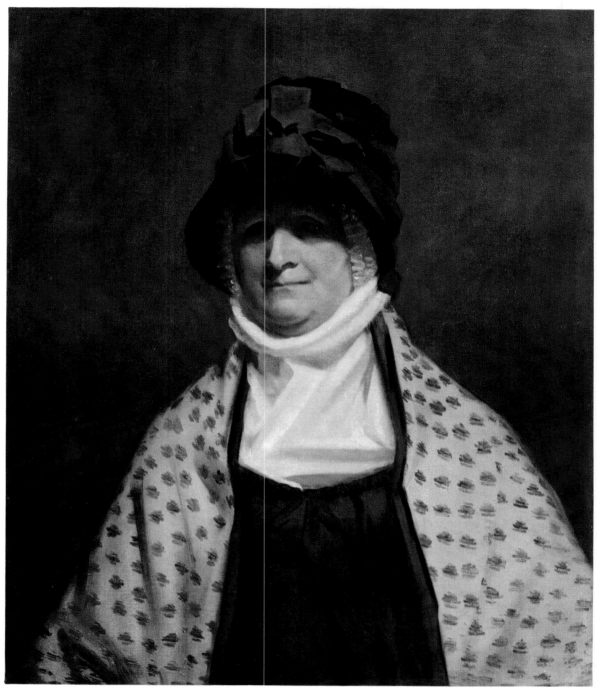

SIR HENRY RAEBURN Mrs. Colin Campbell of Park *oil on canvas 30 × 25 in.*
Glasgow, Art Gallery and Museum

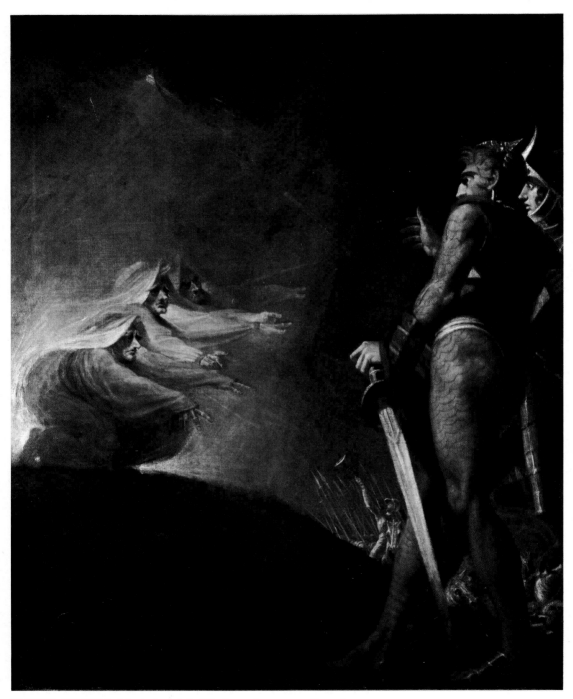

HENRY FUSELI Macbeth and the Witches *oil on canvas 66 × 53 in.*
Petworth House, Sussex, England, Petworth Collection

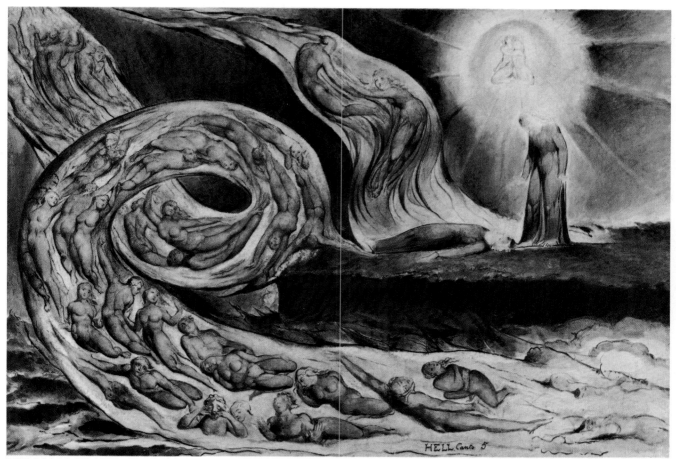

WILLIAM BLAKE The Whirlwind of Lovers, about 1824 *pen and ink with watercolor* $14\frac{3}{4} \times 20\frac{7}{8}$ *in.*
Birmingham, England, City Museum and Art Gallery

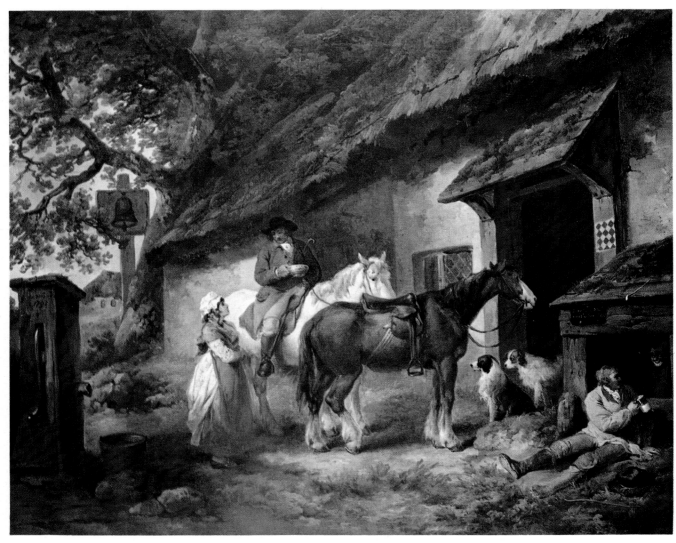

GEORGE MORLAND The Ale House Door, 1792 *oil on canvas* *24¾×30 in.*
Edinburgh, National Gallery of Scotland

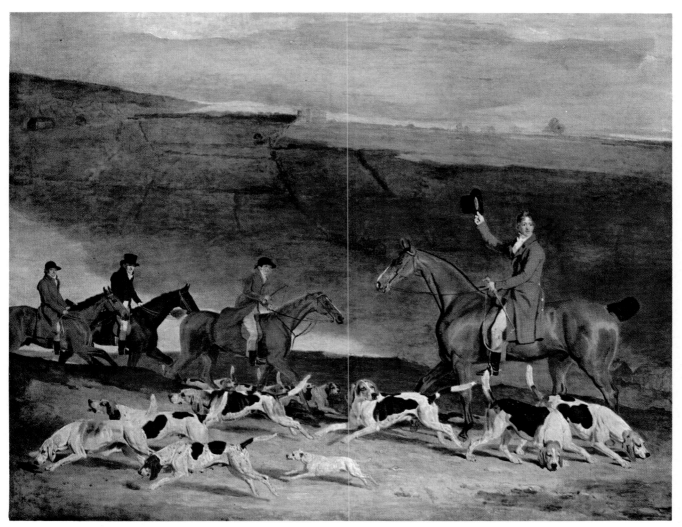

BENJAMIN MARSHALL Francis Dukinfield Astley and his Harriers, 1809 *oil on canvas* $39\frac{1}{4} \times 49\frac{1}{4}$ *in.*
Upton House, Banbury, Oxfordshire, England, National Trust

JOHN CROME Mousehold Heath, Norwich, about 1820 *oil on canvas* $43\frac{1}{4} \times 71\frac{1}{4}$ *in.*
London, Tate Gallery

THOMAS GIRTIN Kirkstall Abbey, about 1801 *watercolor* *12 × 20⅛ in.*
London, Victoria and Albert Museum

SIR THOMAS LAWRENCE William Lock, 1790 *oil on canvas* *30 × 25 in.*
Boston, Mass., Museum of Fine Arts

SIR THOMAS LAWRENCE Mrs. Wolff, completed 1815 *oil on canvas 50⅜ × 40¼ in.*
Chicago, Art Institute, Kimball Collection

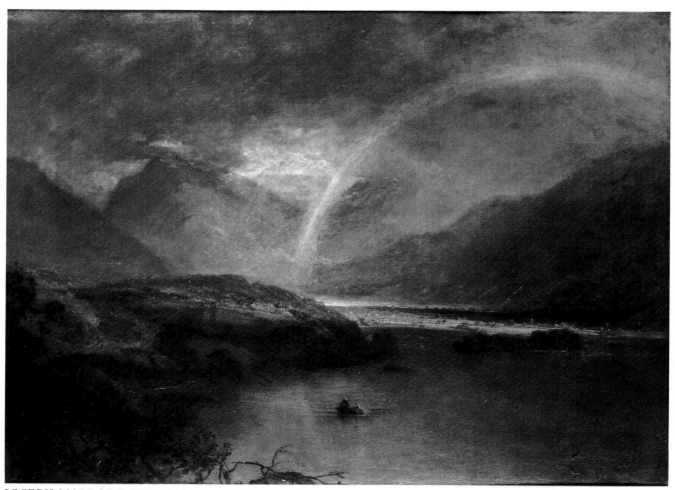

JOSEPH MALLORD WILLIAM TURNER Buttermere Lake, with part of Cromack Water, Cumberland: a Shower,
about 1798 *oil on canvas 35 × 47 in.*
London, Tate Gallery

JOSEPH MALLORD WILLIAM TURNER The Bay of Baiae, with Apollo and the Sibyl, about 1823
oil on canvas 57½ × 93½ *in.*
London, Tate Gallery

JOSEPH MALLORD WILLIAM TURNER The Slave Ship, 1840 *oil on canvas* $35\frac{3}{4} \times 48$ *in.*
Boston, Mass., Museum of Fine Arts

JOHN CONSTABLE Stratford Mill on the Stour, 1820 *oil on canvas 50 × 72 in.*
Cottesbrooke Hall, Northampton, England, collection Major and the Hon. Mrs. Macdonald-Buchanan

JOHN CONSTABLE The Leaping Horse (study), about 1825 *oil on canvas 51 × 74 in.*
London, Victoria and Albert Museum

JOHN CONSTABLE Old Sarum, 1834 *watercolor* $11\frac{7}{8} \times 19\frac{1}{8}$ *in.*
London, Victoria and Albert Museum

JOHN SELL COTMAN The Ploughed Field, 1810 *watercolor* $9\frac{1}{4} \times 14$ in.
Leeds, England, City Art Gallery

DAVID COX Rhyl Sands, about 1854 *oil on canvas* *18 × 24½ in.*
Manchester, England, City Art Gallery

SIR DAVID WILKIE The Blind Fiddler, 1806 *oil on wood* *23 × 31 in.*
London, Tate Gallery

WILLIAM ETTY The Storm, 1830 *oil on canvas* $35\frac{1}{2} \times 41\frac{1}{2}$ *in.*
Manchester, England, City Art Gallery

RICHARD PARKES BONINGTON Le Parterre d'Eau, Versailles, 1826 *oil on canvas* $16\frac{1}{8} \times 20\frac{1}{4}$ *in.*
Paris, Louvre

SIR EDWIN LANDSEER The Challenge, 1844 *oil on canvas* *38 × 83 in.*
Lesbury House, Alnmouth, England, collection the Duke of Northumberland

SAMUEL PALMER Coming from Evening Church, 1830 *tempera on canvas* $12 \times 7\frac{3}{4}$ *in.*
London, Tate Gallery

WILLIAM DYCE Gethsemane, about 1860 *oil on board* $16\frac{1}{4} \times 12\frac{3}{8}$ *in.*
Liverpool, England, Walker Art Gallery

GEORGE FREDERIC WATTS The Wounded Heron, about 1837 *oil on canvas 36 × 28 in.*
Compton, Surrey, England, Watts Gallery

WILLIAM HOLMAN HUNT The Scapegoat, 1856 *oil on canvas* $33\frac{1}{2} \times 54\frac{1}{2}$ *in.*
Port Sunlight, Cheshire, England, Lady Lever Art Gallery

WILLIAM POWELL FRITH The Railway Station (detail) completed 1862 *oil on canvas* $45\frac{1}{4} \times 98\frac{1}{4}$ *in.*
Egham, Surrey, England, Royal Holloway College

FORD MADOX BROWN Work, 1852-65 *oil on canvas* 53 × 77½ *in.*
Manchester, England, City Art Gallery

DANTE GABRIEL ROSSETTI The Annunciation, 1850
oil on canvas mounted on wood 28½ × 16½ in.
London, Tate Gallery

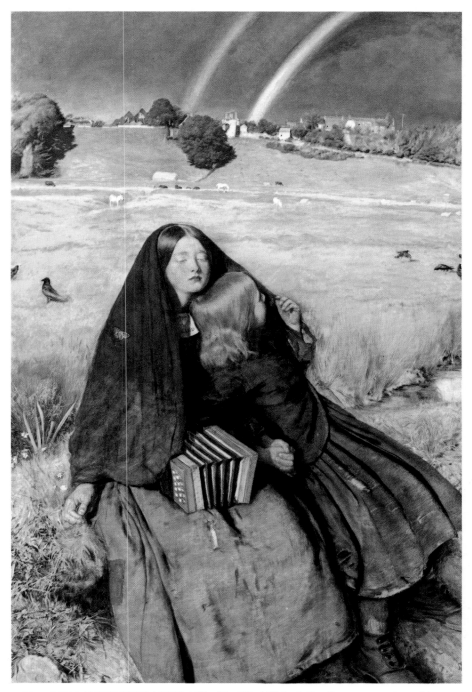

SIR JOHN EVERETT MILLAIS The Blind Girl, 1856 *oil on canvas 32¼ × 24½ in.*
Birmingham, England, City Museum and Art Gallery

ARTHUR HUGHES April Love, 1856 *oil on canvas* $35 \times 19\frac{1}{2}$ *in.*
London, Tate Gallery

ROBERT FEKE Isaac Royall and his Family, 1741 *oil on canvas 54⅜×77¾ in.*
Cambridge, Mass., Harvard Law School

JOHN SMIBERT Bishop Berkeley and his Family, 1729 *oil on canvas 69¼ × 93 in.*
New Haven, Conn., Yale University Art Gallery

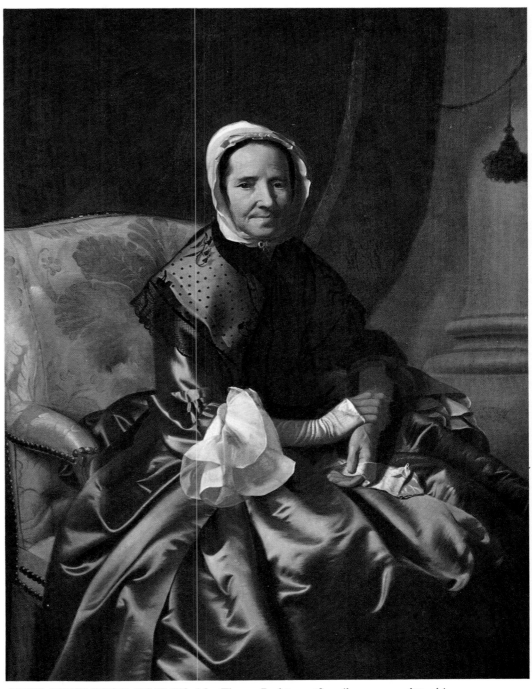

JOHN SINGLETON COPLEY Mrs. Thomas Boylston, 1765 *oil on canvas* $50\frac{1}{4} \times 40\frac{1}{4}$ *in.*
Cambridge, Mass., Fogg Art Museum

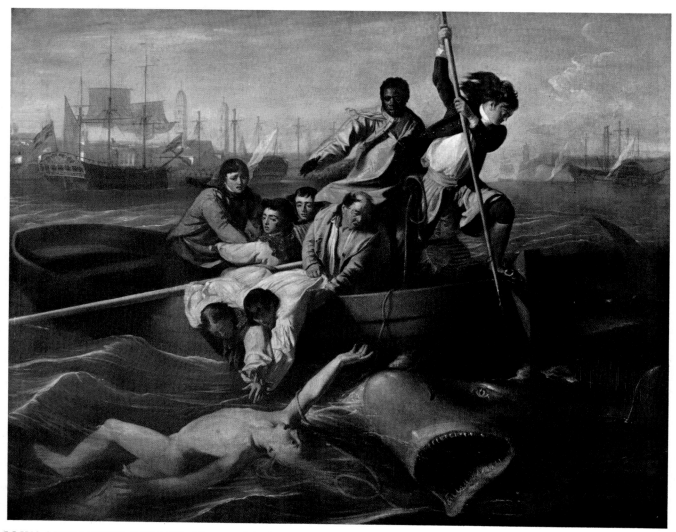

JOHN SINGLETON COPLEY Watson and the Shark, 1778 *oil on canvas* 72⅛ in.
Boston, Mass., Museum of Fine Arts

350

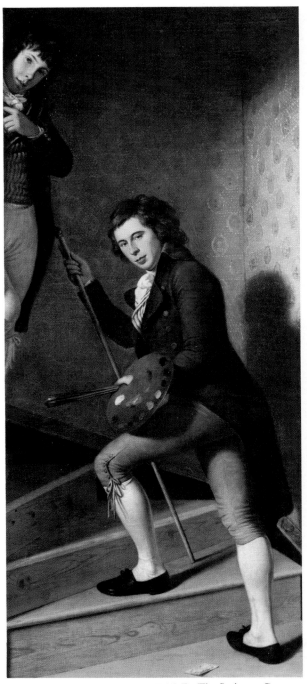

CHARLES WILLSON PEALE The Staircase Group
1795 *oil on canvas 89 × 39½ in.*
Philadelphia, Pa., Museum of Art, George W. Elkins Collection

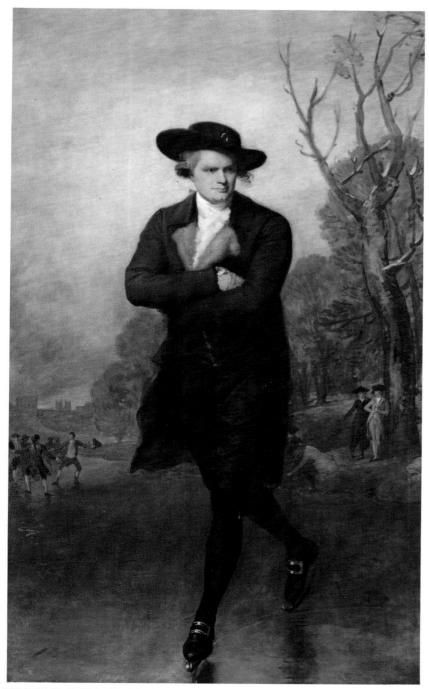

GILBERT STUART Mr. Grant Skating, 1782 *oil on canvas* 95½ × 57⅛ *in.*
Washington, D. C., National Gallery of Art, Mellon Collection

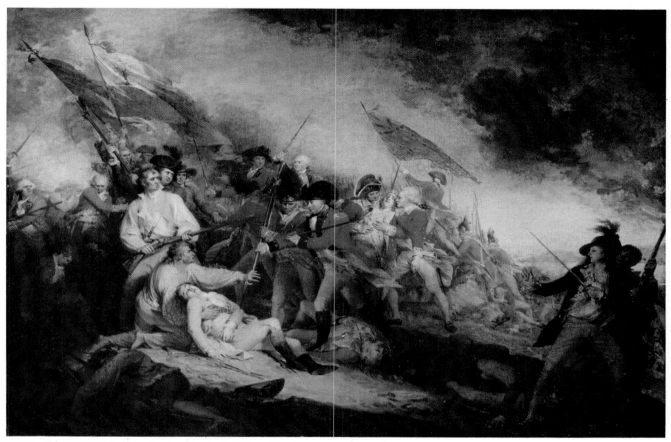

JOHN TRUMBULL The Battle of Bunker's Hill, 1786 *oil on canvas* *25 × 34 in.*
New Haven, Conn., Yale University Art Gallery

WASHINGTON ALLSTON The Deluge, 1804 *oil on canvas* *48 × 65¾ in.*
New York, Metropolitan Museum of Art, Gift of William Merritt Chase, 1909

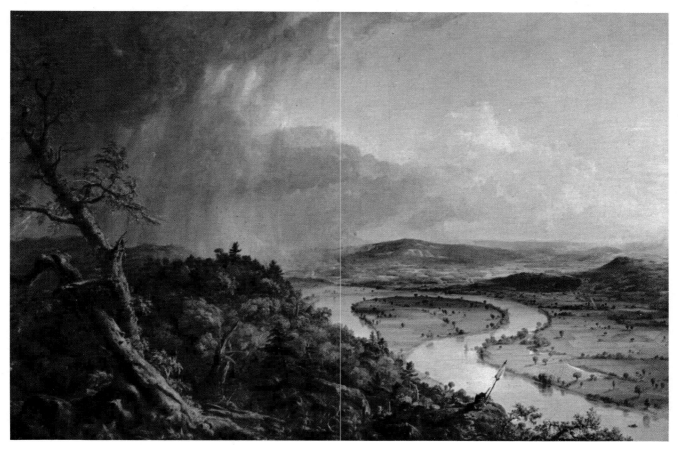

THOMAS COLE The Oxbow of the Connecticut, 1836 *oil on canvas 51½ × 76 in.*
New York, Metropolitan Museum of Art, Gift of Mrs. Russell Sage, 1908

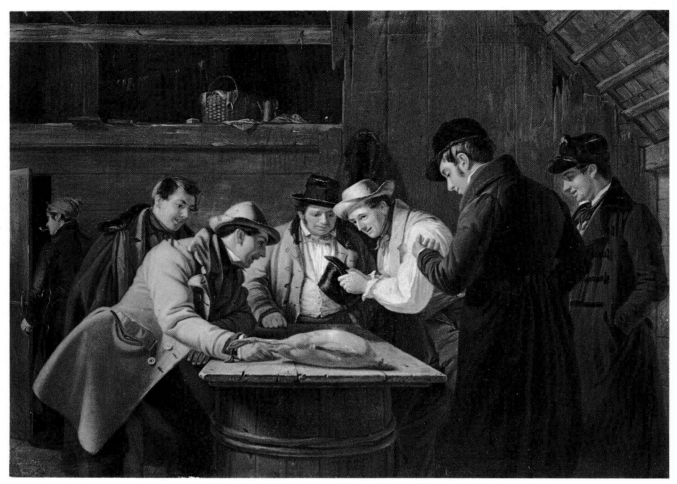

WILLIAM SIDNEY MOUNT Raffling for the Goose, 1837 *oil on wood* *17 × 23⅛ in.*
New York, Metropolitan Museum of Art, Gift of John D. Crimmins, 1897

GEORGE CALEB BINGHAM Fur Traders Descending the Missouri, about 1845 *oil on canvas* *29 × 36 in.*
New York, Metropolitan Museum of Art, Morris K. Jesup Fund, 1933

ANTOINE SEBASTIEN PLAMONDON Soeur St. Alphonse, 1841 *oil on canvas 36 × 28¼ in.*
Ottawa, National Gallery of Canada

CORNELIUS KRIEGHOFF Merrymaking, 1860 *oil on canvas* *34½ × 48 in.*
Fredericton, New Brunswick, Canada, Beaverbrook Art Gallery

GEORGE INNESS Autumn Oaks, about 1875 *oil on canvas* *21⅛ × 30¼ in.*
New York, Metropolitan Museum of Art, Gift of George I. Seney, 1887